The Hanging Gardens of Split Rock

by Mike Faloon

D1462003

The Hanging Gardens of Split Rock

by Mike Faloon

GORSKY PRESS
LOS ANGELES • CALIFORNIA
2010

Published by
Gorsky Press
P.O. Box 42024
Los Angeles, CA 90042

ISBN 0-9753964-8-X

cover photograph
by Allison Glassman

cover design
by Sean Carswell

Portions of this book were previously published in *decomP*, *Go Metric*, *Now Wave*, *Razorcake*, *Roctober*, and *Syndicate Product*.

Acknowledgements

Thanks to Sean Carswell, Todd Taylor, Mickey Hess, Brian Cogan, Michael Galvin, John Bowie, Steve Reynolds, Brett Essler, Jennifer Whiteford, Tim Hall, Ken Wohlrob, Pat Helikson, Alex Harvey, Kari Hamanaka, family, friends, and bandmates who contributed to these stories and essays in one way or another, and most of all Allie, Maggie, and Sean.

Table of Contents

Newton's Cradle: An Introduction

I knew this week would come and I want to leave work soon. I'm not trying to sneak out. I just want to put up Monday's schedule and leave unnoticed. The classroom is quiet. My second graders are long gone and the CD player is on but I don't want to put in another disc because then I'm likely to stay and do more work. I've been telling myself that for the last half hour. I've also been telling myself that I'd leave right after school today. It's the weekend. I'm a first year teacher and I've finally made it through a week without any major mishaps. It's time to go home.

I check the schedule, each subject written in my neatest Denelian print, color-coded to make it more visually appealing. My finger is on the light switch when I notice the blank transparency on the overhead. I've forgotten about my math lesson. It's in my head but it's not written out. I could do it Sunday night or Monday morning but a few more minutes now means a clear conscience for the weekend and a clean slate to start next week. I put marker to plastic and outline the lesson. I'm nearly done when I'm paged over the school's public address system. The principal, Mr. Coleman, wants to see me.

This is unusual. I've worked at the school for two months and Mr. Coleman has barely spoken to me. I still address him by his surname. I can recall only one conversation with Mr. Coleman

since my interview the previous spring. It was the weekend of the annual game between North Carolina State and the University of North Carolina. He asked if I was rooting for State or Carolina. I reminded him that I was new to Raleigh and had no allegiance to either school's football team. I don't think he heard me.

I pick up my room phone and call the main office. Gladys, the school secretary, says that Mr. Coleman wants to see me before I leave. I ask her what it's regarding. She says he didn't say. I should have left sooner.

My first weeks as a teacher were rough. One of my second graders threatened to kill himself. Another brought a razorblade to class. A third sparked a wave of concerned phone calls when he told his classmates at lunch one day that everyone's parents use shaving cream during sex. My colleagues joke that I'm teaching the advanced class.

Walking to Mr. Coleman's office these incidents flash through my mind but they don't stick for long. They could happen to any teacher, as Mrs. Hill tells me. She's the school's vice principal. I address her by her last name too but she's very approachable. She helps me sort through each of the trouble situations, offering to communicate with parents or arrange times for the kids in question to meet with the school psychologist or social worker. "It's your first year," she says each time we sort through an event that requires paperwork. "We want you to want to come back next year."

I walk to the main office. My footsteps echo in the stairwell. I'm used to crowds of kids. My heart skips a beat when the door slams shut behind me. Now I'm thinking about the other phone calls. Not the ones about what my students have done. The ones about what I have done. The two parents who called Mrs. Hill after the first day of school to say that I was too strict. The parent who called the next day to say that I was too lax, not preparing her son for the challenges that await him in the real world. Another parent reported that her son broke down crying on the car ride

home. He was upset because I refer to our grammar book by its proper title rather than by the subtitle like his older brother's second grade teacher did three years before. If issues as trivial as "Writer's Express" versus "Skills Books" lead to phone calls, then it's clear that I haven't earned much trust yet. I have some public relations work to do.

Mrs. Hill dismisses the calls. She assures me that I'm doing well. She says that Mr. Coleman agrees with her. Being called to his office late on a Friday afternoon does little to ease my doubts.

I walk down to the first floor. It's even quieter as tile gives way to carpet. I see Gladys typing at the end of the hallway but I'm too far away to hear anything. It's too much like that Burgess Meredith episode of *The Twilight Zone*, too still, too fragile. I want some noise.

The teacher who had my room last year quit with two months left in the school year. I heard that parents wanted her out and Mr. Coleman caved to that pressure without hearing her side. I also heard rumors that he's the superintendent's heir apparent. The general consensus among staff members is that he is an impatient man with one foot out the door.

I'm not sure where this leaves me. I don't know what's prompted this visit to Mr. Coleman's office but I'm on the defensive. If it's a complaint and it has merit I'll wade through the consequences. I'm not that far removed from the world of temp jobs. I can get by if I'm fired but I don't want to lose this job. It's taken me a long time to find one that I care about and I think I have potential. I've heard that it takes six or seven years to feel comfortable as a teacher. I want to test this theory. I don't want to be misjudged. I want my say.

Gladys smiles. She waves me into Mr. Coleman's office.

"Come in. Sit down," he says.

I assume he'll start the conversation. Instead he eyes the Newton's cradle on his desk, five silver balls at rest, suspended above a miniature platform, waiting to be put in motion.

He opens his mouth. There's a small sound but no words. He's still looking at the toy. I can't tell what he's thinking. He makes the small sound again. Then he gently pulls back one of the silver spheres and releases it. "It's a hell of a thing, you know?"

Gary Shouldice:
Candidate for the Board of Education

Hello. I'm Gary Shouldice, though I'm pretty sure you all know that much by now, and I would like to thank you all for this opportunity to speak tonight—parents, taking time away from your busy lives at home; teachers, staying late here at school on an already-long day; and last, but not least, everyone serving on the current board—thank you. These are exciting times for the Split Rock School District and I'd like to share with you my views, to give you a better sense of what you can expect from Gary Shouldice, concerned citizen and candidate for the board of education.

The Shouldices have a long history in Split Rock schools, some of it well-publicized. My wife, Carly, and I met as juniors at the high school and, as parents, we've had students in the district for nine years now, ever since Bethany, our oldest, first started at Togetherness Primary. For those of you who know Bethany, she's at the middle school now, eighth grade, and doing great. We take so much from her. Carly and I call Bethany our North Star.

But this isn't about my children, it's about my candidacy. Why should you choose Gary Shouldice on next week's ballot? It's simple: I believe in our public schools. Carly and I like to joke that

we decided against sending Bethany to Manlius Country Day so we could save $25,000 a year in tuition. But that's not true. We are confident that our children are best served attending public schools. If money were the issue, we would have settled for Brunswick! Kidding aside, when you vote for Gary Shouldice you get two for the price of one. Carly and I are a team, a team that's weathered mighty storms, a team that's active in the community, and a team that appreciates what our teachers do. We don't complain when our kids don't get the roles they deserve in school plays. I'm not even going to bring up last year's *School House Rock* fiasco. We turn off our cell phones during parent/teacher conferences. And we encourage our kids to be patient when enduring questions from culturally naïve teachers, like last week when Holden, our fifth grader, was asked, "Where *do* you play water polo in February?"

Bake sales, book fairs, field trips; we're there. The faculty may remember Carly's contributions to last year's teacher appreciation week. Ordering smoothies for every teacher in the district wasn't easy, but Carly did it. She ordered those 350 smoothies from Soup and Smoothies over on Gulf Road, and she arranged to have those smoothies delivered to the teachers in their classrooms. Carly and I stayed up nights working out a schedule to insure that every teacher, from shop to calculus, had a fruit-flavored "thank you" brought to his or her desk. A few teachers, and we won't name names, were a bit miffed when we asked to pull two dozen kids during finals to deliver the smoothies, but you have to understand. We were on a mission to show our teachers how much we care, and Shouldices don't back down. I was swamped at the office the day of Operation: Smoothie and Carly couldn't be there herself. Bethany—who does interpretive dance in addition to all of the honors classes and the golf team—had to be downtown by four o'clock for dance rehearsal, and we all know what afternoon traffic's like on the beltway. We were busy, but we knew we couldn't let the teachers down. Sure, we could have just left the

drinks in the teachers' lounge, but it wouldn't have been the same. A true Shouldice never backs away from a challenge.

Now, let's talk about issues, shall we? The first one I'd like to address is standardized testing. I believe in the value of testing. It's a competitive world and we deserve to know where our children stand in relation to the rest of that world, but we have to cut back on the number of standardized tests our kids take. Iowas, SATs, DRPs, OLSATs; tests in the fall, more tests in the spring. It's too much, friends, and it's taking its toll. One day last fall, the market closed early and I caught the 12:30 train home, tossed the clubs in the Lexus, and picked up Bethany early from school. When she saw the clubs she said, "Dad, I don't feel like golf today." *Dad, I don't feel like golf today.* Her words really stung, especially coming from a young lady who consistently drives the ball 250 yards. No thanks to her coach last year who tried to convert Bethany to the David Leadbetter school of thought. Listen, a Leadbetter swing might work for Michelle Wie and Ernie Els, but Bethany developed the worst slice. But, hey, this isn't about Bethany's swing, which rebounded quite well, thank you. I could tell something was troubling her, and, you know, we have to talk to our kids, especially when they're in those troubling teen years, so we stopped off at Starbucks and Bethany opened her heart to me. She stopped sipping her coffee of the day, a delightful sun-dried Sidamo, and said, "Dad, I'm tired of the tests. We've been doing it every day for, like, two weeks." A tear snuck out from behind her Bolle's, and I decided then and there that something needed to change. As a member of the board of education, I will push to eliminate all standardized tests administered in the fall. I know this is a controversial position, but I want what's best for Bethany and for all of our children and I believe that the tests taken in the spring will tell us all we need to know.

Let's give our teachers a chance to teach. We have wonderful instructors across the district and I want to encourage the best teachers to stay in Split Rock schools. That's why I advocate paying

competitive salaries. As a member of your board of education I promise to keep Split Rock salaries on par with neighboring districts. At the same time, I believe in keeping teachers accountable and rewarding the best and the brightest. That's why Gary Shouldice believes in merit pay. Let those who deliver the best results reap the benefits of a job well done, sometimes very well done.

I've told you a lot about Gary Shouldice, the candidate, and now I'd like to speak about Gary Shouldice, the husband, the father, the little league baseball coach who may have made mistakes. I know what some of you may be thinking and maybe it'll help to hear my side. Did I want the best for my players? You bet. Was I driven to succeed? Guilty. Did I injure an autistic child to get my team into the Little League World Series? Yes and no.

Last spring was my son Holden's final year in the division. The two previous years his team had come within one game—one game!—of making the World Series and last year was a special opportunity with so many returning players. The team had an offense like the '27 Yankees and some pretty good pitching, especially if Holden could take advantage of his pinpoint control. The boy's got an arm like Sandy Koufax, but the heart of a hairdresser. He's a flamethrower until he starts worrying about hitting batters, then his velocity drops off completely and he can't keep his pitches down. He's always thinking too much. *What if I lose control? What if I hit someone in the head? What if I break someone's arm?* His mind prevents his arm from doing what it can do, what it *needs* to do. Anyway, with hitting and pitching in place, our Achilles' heel was defense. And yes, here I'm referring to Toddy Murillo. Nice boy, but a real liability in the field. Toddy cost us a shot at the World Series two years in a row. I could have benched him or sent him the wrong schedule, like his t-ball coaches used to do, so he wouldn't show up at the right time. But no, I put Toddy in the games and I paid the price. And so did each and every one of my players and each and every one of their families. You should

have seen the looks of disappointment when Toddy threw the ball over the outfield fence allowing the winning runs to score. I still have nightmares about it. A routine pop fly falls in front of Toddy in right field. We've seen this before and we've worked out a plan. All he needs to do is pick up the ball and throw it in the general vicinity of the infield and we hold them to a run—two, tops—but Toddy starts whirling around like he's in a blender and hurls the ball into the bleachers. The bases clear, we lose the game, and our World Series dreams evaporate. Once was painful. The second year it happened was devastating. I merely did what the other parents wanted to do: I removed the weak link from a team with championship potential. There are times when the good of the many outweighs the good of the one. Think of it this way, friends, if you had to sacrifice one person to save a planeload of passengers, you know you'd reach for the nearest pen knife in a heartbeat.

To save my team, I turned to my family: I offered my son $500 to hit Toddy Murillo during batting practice; the head, the groin, the elbow, didn't matter. 'Just keep him out of the game,' I said, 'and we'll finally make the World Series.' And maybe, I hoped, Holden would overcome his personal fears and tap into his amazing potential. I never made it past junior varsity, but I want the best for my son, as we all do. Holden agreed to the plan. He took the money…and then he got someone else to do his dirty work, paying one of his teammates who, under the advice of my lawyer, shall remain anonymous, $400 to hit Toddy. I was betrayed by a son who, as always, backed away from a challenge. This is the same boy who didn't want to enter the talented and gifted program at school because there would be too much homework; the same kid who is still afraid of going to sleepaway camp. And it didn't help that Holden's foolish teammate spent the entire $400 in one shopping spree, treating 10 of his classmates to copies of X-Men Legends 2. When 10 kids come home from school on the same day with free games for their X-Boxes, parents ask questions.

17

Most of what I've shared thus far is a matter of public record, but what the papers never mention, what you don't hear about on TV is that Toddy Murillo is barely autistic. He has Asperger's Disorder, which barely qualifies as a "pervasive developmental disorder." I should know. I looked it up on WebMD. And let me tell you, Asperger's Disorder is certainly no handicap in the classroom. You should hear that kid conjugate verbs he's learned in Spanish class or reel off his spelling words. He'd be standing in the on-deck circle practicing "onomatopoeia" over and over again. In the end, Toddy got a bruised thigh and made a full recovery within three days, so no one really got hurt and even though we were disqualified and denied World Series glory yet again, I'm willing to put the whole thing behind me.

I could go on, telling you about my stance regarding full funding for our sports and music programs, but Gary Shouldice isn't the kind of guy who overstays his welcome. He is, however, the kind of guy who wants to be part of a board of education that works with educators and parents to insure that the best is yet to come for our Split Rock schools. A vote for Gary Shouldice is a vote for a better tomorrow. Thank you.

The Hanging Gardens of Split Rock

It wasn't the sweaty kid's arm that made the security guard relax his grip. It was the lack of resistance. He was expecting a hell of a fight. Kicking, yelling, making a fuss, something. The kid wasn't tall but he was solid, like five-and-a-half feet of brick. And the music was so angry, anti-social. Who could understand those lyrics? But the kid didn't struggle, just came along with a big dumb grin on his face.

The kid was called Pocket Hercules, former wrestler, heavyweight, two-time state runner-up. He'd been working at Tape City, the Split Rock mall's finest outlet for cassettes and cassette-related products, saving money to move out west with his girlfriend, and he liked it not at all. The Muzak that coursed through the mall like anesthetic, the notes his boss taped to the cash register, the transaction times he was hassled about, the scripted spiel he was supposed to give every time he answered the phone. None of it. He felt like he was always on display for anyone who remembered him from high school, the guy who couldn't finish. Split Rock was the last place Pocket Hercules expected to discover one of the world's great wonders.

Moving west had been his second plan to leave Split Rock and it came to a heartbreaking halt the night before. He and Linda

had been on and off since junior year. As he dialed her number he thought they were a couple. This was the first of his mistaken assumptions. Since moving back after college they'd hung out every night throughout the summer, aside from the previous weekend. They were leaving on a cross-country trip in two months, bound for Seattle, planning to move in together. He thought she was at home or at least in the general area. This was the second of his mistaken assumptions. Pocket had not anticipated talking with Linda's roommate, Wendy. Nor had he expected to learn that Linda had left town for New Orleans with Danny Wicker. They used to make fun of Danny because of the time he got pulled over for driving home from school backwards. Pocket thought she only politely tolerated Danny. This was the third of his mistaken assumptions.

Wendy shared none of Pocket's surprise. She was thinking of the last time her roommate abruptly left town. Having Linda out of the apartment was a relief. As Pocket absorbed the news, trying to file the incongruous information in his mind, he pinched the phone receiver between his chin and collar bone and jabbed the air, silently mouthing a torrent of curse words. The stillness surprised Wendy. She asked if he was still there. He declined her offer to leave a message.

The next day there were three people waiting outside Tape City when Pocket Hercules opened the store. Richie was the one leaning against the gate.

"I heard about Linda and Danny Wicker."

"Already?"

"I saw them at a party the other night. I heard he was selling his four-wheeler but I got there too late."

"Don't you have a store to open, Richie?"

Pocket lifted the gate. Richie followed him in.

"Which one?" He jangled the key collection in his pocket. "Put on something good before I go. This elevator music is killing

me already."

"I just opened the store. Ease up." Pocket moved behind the counter, read his boss's note before throwing it away. "*I'll be late. Call in special orders.*"

"I know you're bummed about Linda, that's why I stopped by," Richie said. "Three words before I go. Live Donkey Kong. Saturday. Be there, man."

Pocket and Richie were friends from back in high school. They spray painted speed limit signs, editing "30 mph" to read "80 mph." They hosted live Donkey Kong tournaments, zigzagging across the hill in Richie's backyard dodging a barrage of sticks and rocks, snowballs packed with ice during the winter. But that was over four years ago. There may have been advantages to hanging out with Richie at this point in Pocket's life but they weren't immediately apparent.

"Seriously, stop by on your break," Richie said.

Pocket waved the two customers in. The woman pointed and her son entered, clutching a plastic bag. He took out four cassettes and set them on the counter. They were not wrapped. "*Returns,*" Pocket thought, "*what a pain in the ass.*" The kid wore a Canadian Tuxedo, double decker acid wash, jeans and jacket. His shoulder length hair was feathered and obscured any expression that might have been on his face. Pocket inquired why he was returning the tapes. Double Decker looked through the store's front window, making one last sheepish plea. His mother's raised eyebrows and ever-widening eyes did the talking: *ass whooping imminent, return those tapes.* Pocket looked at the top cassette again. This time he noticed the cover art. A priest shackled in heavy chains, battered by rough seas, cowering at the sight of a freakishly large, whip-wielding demon.

"Do you want store credit or cash?"

"Cash. Receipt's in the bag." Double Decker sounded defeated.

Pocket was in a foul mood but he saw no need to drag

Double Decker down with him. He spared the kid additional questions about the tapes.

Double Decker pulled his hair back. He looked up at Pocket inquisitively. "You used to go out with Linda Stevenson, right? Didn't she split for L.A. with Danny Wicker?"

Pocket nodded. Apparently he *was* the last to know.

"I heard he's going to get his pilot's license."

"Thanks for shopping at Tape City. Have a nice day."

The kid's unlaced hi-tops slapped the tile floor as he left. Pocket stood behind the counter. He watched infants pushed past the storefront in strollers. He watched seniors walk by in matching sweatsuits, oversized headphones plugged into outdated Walkmans. The place never felt less hospitable.

A half hour later Pocket pulled out a merchandise return form. He made no effort to conceal his grumbling from the handful of customers browsing the racks. Slightly more difficult to hear were the sounds of tearing fibers as he gouged pen into paper. He tore the form in half and started again.

When he filed the second form in the back office he saw another note from his boss taped to the back of the door. "*Read the note on the register.*" Pocket wadded it up as he returned to the counter. The latest in-store sampler played, announcing sale prices on the new Top 40 acts being promoted by the home office in Albany. In his mopey state Pocket caught himself walking to the beat of the latest syrupy soundtrack ballad. The day was only getting worse.

He looked at Double Decker's cassettes again. Four Dio tapes. He was pretty sure he had heard Dio before. Heard the name at least back in high school, hanging out in the back of the bus going to tournaments.

The middle age couple in the jazz section looked up when Pocket played *Holy Diver* through the store's sound system. He didn't pay much attention to the music at first. He was busy stewing, his arms crossed, pressing his tie and blue Tape City vest

tight against his gut. He watched the custodians setting up chairs for a weekend fashion show.

Across the way a pyramid had emerged in the front display case of the Westwood Bakery. It was about two feet tall. A more astute connoisseur of baked goods would have recognized that the French bread base supported layers of Italian bread, club rolls, and dinner rolls with a cherry Danish on top.

He was still considering the pyramid when his boss, Dale, entered.

"Turn down the music, Pocket," Dale said slightly exasperated. He was well qualified to manage a music store. He was good with numbers, compliant, and punctual. His shortcomings were limited to two areas. He disliked music and he wasn't very fond of people, especially people looking to purchase music. Music was interruptions and distractions. Pep bands squawking away when he was watching college basketball or his wife's kitchen radio weeping sensitive soft rock. He didn't hate music. He didn't care enough about the stuff to hate it. It was like selling shoes. It just assaulted a different sense.

Dale returned from the back office flipping through a handful of envelopes.

"I hear you're not moving to San Francisco."

"Seattle," Pocket corrected.

"Right," said Dale, snapping his fingers.

Dale leaned over the counter and tossed the envelopes into the garbage. He reached for a pen and note pad. Pocket watched him scratch out a message before affixing it to the top of the register. "*Back after lunch. Keep it down.*"

In the coming days Pocket sold cassingles and listened to more Dio. He also watched a new sculpture take shape at the bakery. Shish kabob skewers held together a statue with apple fritter feet, a challah bread torso, and a frosted sugar cookie face. The figure stood over a boat holding a swizzle stick. Pocket would

later learn that it was an edible version of the Colossus of Rhodes, a statue built by the Rhodians around 300 BC to celebrate the defeat of Demetrius I.

Pocket Hercules gave little thought to the digits he punched into the phone. The battle for his attention pitted a piece of the bologna sandwich he'd just brought back from the food court, now wedged between his back teeth, and the phone calls he was making to customers informing them that Tape City would hold their orders for 10 days. The bologna held the upper hand until he looked over at the bakery. His eyes volleyed between the challah bread statue and the customers crowded three deep at the bakery's counter, seemingly oblivious to the prominently displayed curiosity.

"Westside Bakery, how can I help you?"

Pocket scanned the order form for the customer's name, then looked back at the bakery, in particular, the tall girl behind the counter, ashen-faced and black haired. "Is, uh, Andy there?"

"I'm sorry. I can't hear you," answered the person on the other end of the line, who was, not coincidentally, named Andy, the tall girl from the bakery.

Andy thought she heard her name but the music coming through the phone was too loud. Glancing over at Tape City she saw Pocket on the phone. She waved.

"I'm calling from Tape City," Pocket said.

"I see that."

"Right. Hi. Sorry." There was a pause before his internal monologue leaked out. "How do you make a bad bologna sandwich?"

"What?"

"The cassette you ordered is in," Pocket said.

"Thanks. I'll pick it up later."

Both parties hung up confused.

According to the clock above the mall's main entrance Andy

entered Tape City an hour later.

Pocket tried not to stare. The flour in her hair, pulled back in a ponytail. The way she itched her nose with the back of her hand because of the bits of dough. He didn't know what to say. The words called for in this particular situation, "Here's your tape. With tax that will be $9.50" had spun to the back of his mental Lazy Susan. He liked Andy instantly, though he did not say anything to that effect. He stifled the urge to talk about his recent discovery of Ronnie James Dio. He assumed it was unlikely to enhance the situation.

He was surprised to hear himself tell two lies. "I'm moving to Seattle, I can't get involved right now."

Andy, meanwhile, was unsure about a number of things. What had the Tape City guy said about a girlfriend in Seattle? Was she drawn to this strange, squat bowling ball of a guy, symmetrical yet off balance, or was she just intrigued? Was it unfair to assume that he spoke conversational Klingon? And why the impulse to talk about the old board games she'd been gathering to poster her apartment?

Pocket remembered what to say when Andy smiled and pointed to the cassette.

"That's nine fifty."

He handed her a Tape City bag with one hand and dropped two coins into her palm with the other.

Her "thanks" overlapped with his "have a nice day."

Andy smiled again, took a step back before turning to leave. Pocket's smile was just emerging when his step backward knocked a Judy Garland box set to the floor.

Pocket couldn't make the trip alone. His car would never survive a coast-to-coast drive. Plus, he didn't have enough money saved. He and Linda had been planning to split costs on the way out and then stay with her sister until they found a place of their own. The night he learned about Linda and Danny he threw out

everything she kept at his apartment—toothbrush, *Vanity Fair*s, two half finished bottles of tomato juice in the fridge. But her stuff kept turning up. Empty cassette cases, chocolate bar wrappers, one of the turquoise sea shell earrings she picked out at Sylvan Beach a couple of years ago. Pocket did a fair amount of sulking and it didn't sit well with him.

One morning while on break he started toward the bakery. He told himself he just wanted to ask who was making the pyramids and statues. They gave him a good feeling. He wanted to know more. But he detoured, set his sights on the beach chair display at the department store. He wanted to sit down and gather his thoughts. That's when he noticed Andy walking toward him.

Anyone watching Pocket would have described his turn to the right as abrupt. That's certainly how the women offering free massages would have characterized his sudden redirection.

He took off his glasses and slumped into a massage chair. Immobile, practically blind, and hoping that Andy wouldn't notice him, Pocket couldn't remember the last time he felt physically awkward. He still thought like a wrestler. Action, reaction. No delays or deliberations. Shoot, sprawl. Bar arm, roll through. Tie up, break free. He was accustomed to life in the neutral position, decisions predetermined. Things were starting to feel different.

Pocket didn't hear the masseuse encourage him to relax. He was listening for Andy and it was hard to concentrate with the organ store right there and two people trying to remember how to play "Chopsticks."

Andy's voice startled him. She sat down for a massage, greeting the other masseuse, then Pocket.

She remembered his nametag. "Hi. Stephen, right?" *He can't see you.* "It's Andy. From the bakery."

"Everyone calls me Pocket."

"I like Stephen better."

He wondered how long it would be before the bakery girl said she was sorry to hear about him getting dumped. In his mind

he rambled, taking Andy through a typical hour at Tape City. *A couple comes in, just back from a long weekend in Toronto. They saw* Les Mis. *Loved it. Not usually into musicals, especially him, but* Les Mis *they loved—the songs, the costumes, the set design: wow. I walk them over to the soundtrack section, explain that the London cast is the only version we have. They're disappointed but not deterred. Back at the cash register I remember not to push the blank tapes that are on sale, throw out another note from my boss, and wait for my next break.*

The talk between them consisted of lateral moves, nothing building or moving forward. Despite this they felt at ease in each other's company, even when they were being massaged by eavesdropping strangers.

"I just had to get out of there," Andy said referring to the bakery. "I had the most bizarre conversation with my boss. The Coast Guard rejected him after high school. I just assumed that if you could get yourself aboard a boat, then you were in. He told me he can't swim. Why would he even think about going into the Coast Guard? Why does he think I want to know?"

The fumbling "Chopsticks" continued. Pocket felt the masseuse's hands kneading his neck and shoulders and watched the kaleidoscopic images swirling on the backs of his eyelids. Listening to Andy reminded him of his own boss and the notes. He wanted to take back the lies he'd told the other day.

Andy said she had to get back to work. A moment later Pocket felt a couple of quick pats on his back. Massage over. He looked up, put on his glasses, and squinted to follow Andy's fuzzy form as his eyes adjusted to the mall's fluorescent lighting.

"C'mon, man. Zone? Really? Get your head out of your ass, Boeheim. How many times do you have to get burned from downtown before you go to man-to-man?"

Dale yelled at the basketball game on the television. His speech was slurred. The bartender turned to look at the screen, avoiding eye contact with Pocket's boss.

"When is Boeheim going to learn? Zone doesn't work against perimeter teams. Here is the problem: the man can recruit but he can't coach."

Pocket sipped his beer. He couldn't take another night at home, flipping the channels, avoiding Linda's favorite shows. Were *Magnum P.I.* and *M*A*S*H* always in reruns? He needed a change. Then the unlikely happened. Dale presented a viable option. His wife was hosting her book club and he offered to pick up the tab if Pocket joined him at Sudsy Malone's, the one place in the mall, other than the movie theater, open past nine o'clock. Pocket figured that unlike a night with Richie he was unlikely to be hit by a rock or end up in the backseat of a police cruiser. The experience was proving to be as awkward as being at work only with an overpriced beer in hand.

"Don't let this become another free throw competition! That's how they lose the close games. Rick Barry these guys are not." For the first time since the half Dale turned to face Pocket. It was unusual having Dale speak to him directly. Pocket started to miss the notes.

"You ever see Rick Barry shoot free throws? Underhand, like a sissy. We called 'em granny shots when I was a kid. But the guy never missed. Best free throw shooter of all-time," Dale continued. "Ninety percent. Shit you not. Only missed once back in '78-'79. Funniest thing you ever saw. You know how guys say think about baseball when they don't want to get a boner? I think about Rick Barry at the foul line." Dale finished his beer. "Works ninety percent of the time."

The more Dale droned on, the further Pocket's mind drifted. He got up to use the bathroom. He noticed the bartender look his way. When he returned there was a note from Dale on the bar. "*Had to leave. Can you open tomorrow?*"

The bartender slid a mug of beer in front of Pocket. "It's on the house." He explained before Pocket could inquire. "I heard about Danny Wicker ditching you, moving to Vegas without you.

Guy never paid his tab."

Pocket was too tired to correct him.

Andy smelled incense as she approached her apartment. She abandoned the search for her keys. Her roommate was home and likely entertaining. Andy rattled the doorknob a bit, making her entrance apparent. Kim was sitting at the coffee table playing chess with a guy. She looked up at Andy. The roommates were well-versed in silent exchanges.

"Who's he?" Andy mouthed.

"Later," Kim responded in kind. She lifted one hand from her coffee mug and waved Andy to go away.

The "he" in question was reciting something in French. Moving across the threadbare Persian rug to her room Andy noticed that his eyes were closed. She considering telling Kim and the French poet that clove cigarettes would complete the picture.

Andy took solace in the sunburnt orange walls of her bedroom. She tried to focus on one of her ongoing projects, the day-glo soup-can robots or the board games but the muffled voices from the other room railroaded her thoughts. That's when she noticed the James Taylor record seeping in. Freshman year flashback. On deck: Bob Marley *Legend*. "American Pie." Maybe some Bad Co. Three rows of vinyl leaned against the wall opposite her bed. She flipped through the records in search of the best antidote.

Holy Diver had two songs that would work. *The Last In Line* had two more. But Pocket didn't think the store's sound system would be loud enough.

It was a weekly indulgence for Andy. Two slices of Twin Trees and an Orange Julius. A token consolation prize for working in a mall. She scanned the crowded food court for a seat, barely noticing the jumble of distant voices floating overhead, gathering

in the rafters like errant balloons. When she saw a seat by the escalators she began working her way through the thicket of tables. That's when she noticed Pocket sitting across from that empty seat. He was munching on fries, topiary plants twisting upward behind him and to his right. He seemed surprised when Andy asked to join him.

After some small talk neither of them spoke for a bit. They looked at their trays like two people who had set down a couch they couldn't fit through a doorway. There was an unspoken agreement that with just a few more moments of inactivity a solution would present itself.

"When I asked if I could sit here I thought we might talk too," Andy joked. "I thought it was a package deal. Is there an extra charge for conversation?"

Pocket asked what she thought about the tape she had bought the other day. Andy said she'd sent it to her brother for his birthday. Another topic fizzled.

"I just got dumped," Pocket said.

"We could talk about your ex, if you want. Not really what I had in mind. Or I could talk about my ex." Despite the bumpy terrain of the conversation, Andy felt the sense of ease she'd experienced with Pocket the other day. "Typical ex. You know, control freak, lying bastard. He's the reason I moved here. He did have great taste in music. I have to give him that. He's never getting his records back."

Pocket smiled. "This is weird."

Andy nodded in agreement. This was as good a time as any. "I saw you sitting on the bench outside the bakery the other day. You're the only person who looks at the sculptures. I started going to thrift stores, buying old puzzles, looking for Rube Goldberg models, making mobiles, then it spilled over into work." Andy saw herself as a builder, not a collector. "At first I was making them just because I was bored but then I wanted to see if people would notice. They're like messages in a bottle, a really big bottle that

hundreds of people manage to walk by every day without picking up. Sometimes I feel like I'm invisible back there, like work is a cloak. You seem interested but you've hardly said a word to me." Andy paused to consider her next words. "It's a weird way of flirting."

Pocket checked his watch.

"Do you have to go some place?" Andy asked.

"Yeah, my break ended five minutes ago but we should talk more some time."

"Yeah."

Pocket Hercules walked back to Tape City. He decided this was the last time work would get in the way.

Pocket and Richie walked toward the mall's main entrance. They took a left just before reaching the doors and stopped outside of the security office. Richie palmed a key to Pocket. "Practice makes perfect." Richie walked back to the main concourse. He looked both ways and gave Pocket the all-clear sign. Pocket unlocked the door and held it open for Richie. Stepping into the room Richie peered around the back of the mall's sound equipment, six units rack mounted in the corner. "This is what you want. It'll be easy, let me show you." Pocket looked at the Dio mix in his hand. He still wasn't convinced.

Pocket returned to the food court a day later. A college friend, Kyle, was passing through town. It had been months since they last spoke, but Pocket sensed a chance to get out of Split Rock.

Last summer Kyle had helped Pocket set up an interview in New York with the promotions department of a film company. This had been the key to Plan A: finish school, move to the city, land a job. Pocket and Linda went down for a long weekend. They stayed with Kyle and his girlfriend in Weehawken. They ate foods they'd never heard of and saw great bands and movies. It was a

weekend of options that weren't even on the menu back home. Monday morning Pocket went to work with Kyle. Pocket swore the interview went well, his responses were casual and specific, thoughtful but not rehearsed. Then they asked him to take a typing test. He failed. A month later he received a letter saying they would keep his resume on file. It was like the state tournament all over again; he could get close but he couldn't finish.

Pocket sat across from Kyle, half listening for his invitation to leave town but also watching for Andy. He heard only a part of Kyle's monologue. He hoped that he was alone in that regard. Kyle was talking about work, the job he'd quit, the freelance "gigs" he was picking up. The job duties were vague and the salary was obscenely high.

Kyle kept talking, acting as if he didn't recognize Pocket's inattentiveness. Largely because he didn't.

Pocket thought about Andy's latest sculpture. Circles of cinnamon rolls stacked one upon another. Towers of mints and a red meringue flame. The image stuck in his mind. The design. The colors. The way it filled the display case. He didn't recognize it as the Pharos Lighthouse but he loved its utter impracticality. But there was something missing. There had been something missing with the other sculptures, too, something flawed. He was surprised how long it took him to recognize the problem. It was the music he heard walking past the bakery. The Muzak. It was all wrong. Unworthy. The original wonders of the ancient world were majestic tributes, colossal in size and intent, reaching up to the gods and across the ages. To be in their presence was to be consumed by them. The music of Ronnie James Dio was no different.

"I hooked up with this girl last weekend," Kyle said, his necktie draped over his shoulder as he pushed food into his mouth. "She didn't have any ovaries."

That caught Pocket's attention. He had two curve balls to contend with, the *who* and the *what*. He thought he knew who Kyle

was talking about. He opted to start there.

"Michelle lost her ovaries?" Pocket asked, inquiring about Kyle's girlfriend.

"No, this was another girl. Me and Michelle are taking a break," Kyle said. "Well, we're going to take a break."

"Should you be telling me this?"

At the next table a woman sat down with a soda and magazine. "Westside Bakery" scrolled across her apron. Pocket recognized her as one of Andy's coworkers.

"Cancer. That's why she didn't have ovaries."

"Please stop," Pocket mumbled. *You're supposed to help me, motivate me to get out of this town, even make me jealous.* He felt another plan evaporating.

"It was cool because I don't want to have kids and she understood that I'm not into relationships. I'm telling you, Pocket, you should move down to the city. I'll hook you up with another interview. I'm going to need a roommate soon."

Pocket made brief eye contact with Andy's coworker. He flashed a smile. Here is what he hoped it conveyed: *unlike my friend here, and I use term "friend" loosely, because he's really changed a lot, or maybe I have or maybe we both have or maybe he's always been this way and I'm just noticing—I haven't sorted it all out—I have a healthy appreciation for ovaries, healthy ovaries. Not an obsession, mind you, just a normal, though appropriately distant, appreciation.* It was a lot to ask of a smile.

Richie had been right. It wasn't easy to admit but the realization came when Pocket was listening to Kyle. It was time to step onto the mat again.

Before leaving Tape City on his afternoon break he marveled at Andy's newest sculpture. The original Hanging Gardens of Babylon were built by Nebuchadnezzar II for his wife Amyitis. She wasn't native to the city's desert climate and missed the mountains of her homeland, so he commissioned the Hanging Gardens, massive and multi-tiered, a man-made oasis in the middle of the

desert, a work of beauty to fill the void.

Pocket left at two o'clock. He passed Richie, who gave him a mock salute, their signal that the security office was unoccupied. Pocket sized up the sound system and patched in a walkman, "headphone out" to "audio in." He would have been pleased to know that no one reacted when the Muzak cut out, replaced by the faint hum of blank tape, two minutes worth, enough time to return to the bakery. On his way out he closed the door and bent the key back and forth until it snapped off.

Andy turned and placed a birthday cake on the counter.

"No," the customer said emphatically. "This is all wrong. I ordered blue with purple trim."

Andy re-read the index card written in her boss's Catholic school script, *Purple icing w/ blue trim.*

Her boss, Marty, walked over. He stood quietly for a moment before asking if Andy had wiped down the display cases.

"I'm with a customer." Andy neither sought nor expected support but she had to point out such things. She could never assume that Marty had absorbed the obvious.

"Who wants a purple cake? It looks like a damn grape! Are you going to be the one to tell my five-year-old son that his cake is screwed up?"

Marty looked, listened, and nodded. "The cases need to be wiped today. I don't want to remind you again."

The customer wasn't done. "What are we going to do about this cake? I have a party in less than two hours."

Before Andy could react some unseen force silenced both of her tormentors. Then she realized it was the music. A sudden blast of metal. Excruciating to most. Just right to Andy. It was coming through the mall's P.A. speakers.

"What's this awful racket?" the customer asked.

"Something's gone wrong, ma'am," Marty replied.

Both comments were faint, lost it the sound and confusion.

Andy looked past the customer. People slowed down, stuck their fingers in their ears, and exchanged bewildered looks. The bass and drums punched the accents in unison, 1-2-3.

The Dio tape had been playing for about a minute when Pocket came into sight. He was a relative blur of motion and color, air-guitaring as he walked. His face lit up when he saw Andy. He dropped to his knees in front of the display case, devils horn drawn, tongue out. More air-guitar. An imaginary pick slide followed by finger tapping. They were an unlikely triumvirate—metal, pastries, and ancient wonders—but in Pocket's mind they fit together.

He continued through the next chorus. People stared. He directed their attention to the bakery's display case and walked over to Andy, still behind the counter.

Everyone within earshot could hear Andy yell "This is strangely awesome" because the song was abruptly cut off. She saw a pair of mall cops two storefronts away. Pocket spoke before Andy could say anything more amidst the confusion.

"I'm going to have to leave in a second," he began, "but do you want to get a bite to eat some time? I mean, plan on doing so, not just run into each other."

Andy smiled. "Only if we both talk. This whole Peter Sellers in *Being There* thing will only get you so far." Someone had finally picked up the other tin cup and pulled the string taught. She wondered what he had to say.

Andy pointed over his shoulder. Dale was talking to the mall cops, looking toward Pocket.

"They probably won't let me in the mall anymore," Pocket Hercules responded, "but that sounds great."

Mrs. Scott's Hot Box

Wayne Burke wiped the sweat from his brow again. Getting in trouble wasn't so bad after all. Here it was the middle of the school day and he could flip through his baseball cards as slowly as he wanted to, examining each player's face. He didn't even have to sneak, leaving the stack of cards right on top of the desk. He had been listening to the guest speaker, but he'd also been looking at his cards, so Mrs. Scott sent him to the hot box.

Ever since he was in first grade Wayne had been hearing about the legendary hot box. Every teacher at Split Rock Elementary was known for something. Mr. Candini let his class stay out for extra recess. Mrs. Kreevich would offer to tie your shoes even if they were already laced. Mrs. Ashburn threw out your homework if it was wrinkled or didn't have your name on it, even though she could tell it was yours from the handwriting. Mrs. Scott was known for two things: collecting more Campbell's soup labels than any other teacher in the district, to help the school earn new playground equipment, and sending kids to the hot box when they got in trouble.

With her glasses hanging around her neck and her hands covered in chalk dust, Mrs. Scott didn't look mean, but she made Wayne nervous, nonetheless, or at least the stories about the hot box did. The hot box was really just a big janitor's closet, complete

with buckets and mops, a shelf of bottles and cleaning rags, and the brightest light bulb ever. It was the hottest room in the building, probably on the planet. Kids came out of the hot box dripping wet, their shirts dark and matted with sweat, their eyelids drooping and their parched tongues hanging out of their mouths. Their first words were always, "Sorry, Mrs. Scott." The hot box was quiet, too, the walls thick enough to block out any sound from Mrs. Scott's or any other classroom. When kids were in the hot box, they were really alone and really bored. The hot box made kids wish Mrs. Scott would just take out a belt or a ruler and go through the old "this is going to hurt you more than it's going to hurt me" routine. The hot box was Mrs. Scott's way of dealing with students she didn't want to put up with, kids who talked back or used the springs in their pens to launch ink cartridges across the room or worse, didn't pay attention to a guest speaker. That drove her insane. That was a capital offense in Mrs. Scott's book. Other teachers sent kids to the office, but Mrs. Scott said the office had enough headaches to deal with.

The hot box got its nickname because of the heating ducts that ran overhead, criss-crossing right above the school desk that sat in the far corner. That's where Wayne sat, sweating, staring at the players' faces on the cards, wiping his forehead on his shirt sleeve, half-heartedly trying to hear what was happening next door.

His class was studying the American Revolution, reading about Paul Revere and Crispus Attucks, taxation and representation. The guest speaker was Mrs. Kerin, a woman from the art museum downtown. She was soft spoken and had short, black hair, and she wasn't much taller than the students. Mrs. Kerin had come to show the class colonial portraits. She talked about how a portrait artist could reveal what his subject was like through the person's facial expression and dress and hair, the way they posed and what was placed in the background of the painting. They used all of these things to show a person's personality and status, along with what they did for a living and what their family

life was like. Mrs. Kerin's example showed a wealthy lawyer wearing a powdered wig and his finest jacket. He was posing in his study, desk and books on display, while the window over his shoulder looked out onto an enormous estate, children playing in the foreground, a horse stable off in the distance.

As Wayne was listening to the woman from the museum, the baseball cards in the front of his desk caught his eye. The card on top was a pitcher for the White Sox, Clay Carroll. He looked mean. Some pitchers wanted to scare hitters a bit, so it'd be easier to get them out. Apparently, Clay Carroll didn't simply want to register outs, he wanted you—the kid holding the card—to tremble in fear. He wanted to hit you with a ball or a bat or a rake, anything he could get his hands on. Wayne realized that this picture didn't capture Clay in the middle of a game. Clay chose to pose this way for his baseball card. He didn't want to just intimidate major league hitters, Clay wanted to frighten the kids who were collecting cards now, the major league hitters of tomorrow. This was a man investing in his future. Wayne was lost in thought, captivated by the cruelty in Clay Carrol's furrowed brow, trying to further decode the player's personality, when Mrs. Scott looked his way.

"Wayne Burke what are you doing?" Mrs. Scott bellowed. Her hand came down hard on the desktop and brought Mrs. Kerin's presentation to a halt.

"Uh, Mrs. Scott, I'm just..."

"Don't you talk back to me! Mrs. Kerin, class, please pardon the interruption, but Mr. Burke's behavior is inexcusable. Wayne, we have a guest in our room and you're looking inside your desk?" Mrs. Scott's sigh was faint but clearly judgmental. "Need I remind you that you're not just representing yourself and this class, young man. You're representing the entire Split Rock Elementary School community, and what kind of impression are you making on Mrs. Kerin and the Edwards Museum of Art?"

Mrs. Kerin gazed at Wayne. The rest of the class was now doing the same, all of them waiting for a good answer.

"But Mrs. Scott, I was just…"

"Enough back talk, Mr. Burke. Go to the hot box! You may rejoin the class when I know, not when I think, mind you, when I *know*, you've learned your lesson!"

Wayne's cheeks were brighter than usual. He felt bad about being yelled at. He didn't like receiving attention at school, from the class, from Mrs. Scott, and he'd never been to the hot box before. Luckily he had another small stack of cards tucked in his shirt pocket.

Wayne took out the cards after closing the door behind him. The top card was Darrel Chaney and normally Wayne would have flipped to the back to study the stats, but today Wayne lingered on the picture, looking at it like a portrait, trying to figure out Darrel Chaney's personality. Darrel Chaney was easy to figure out; he was sad, on the verge of sobbing, like a kindergartener caught in the moment just after his lunch has fallen into his lap and just before he realizes that crying very, very loudly will alert someone to his predicament. Darrel Chaney had the kind of face that invites pity, even from a third-grader like Wayne Burke who'd never had a hit in Little League. More than anything, the expression on Darryl Chaney's face looked just like Mrs. Schneider, Wayne's neighbor across the street. Wayne only saw her in the spring and summer, either kneeling in the flower beds in front of her ranch house, pruning rows of marigolds and sweating over bunches of petunias, or pushing a wheelbarrow full of weeds across the street to the fields where everyone in the neighborhood dumped yard scraps. No one talked to Mrs. Schneider, but Wayne's dad did talk about her. No matter how late at night he walked the dog, Mrs. Schneider was still awake, all the living room lamps turned off and the flashing light of the TV illuminating her curly-haired silhouette. Never Mr. Schneider, just Mrs. Schneider. And come to think of it, Wayne never saw her talking to either of her kids, which was weird because they were always outside when she was, Larry shooting hoops in the driveway and Sue roller skating

around the block. Wayne started feeling bad for Mrs. Schneider. Then he started feeling sorry for himself, stuck in the hot box, so he flipped to the next card.

He found himself looking at Steve Stone, another pitcher for the White Sox, but a guy who probably didn't hang out much with Clay Carroll. Wayne had looked at the card dozens of times but he never realized how much Steve Stone looked just like his dad's old friend, Mr. Zombrowski: the big, curly hair, the gold chain, the unbuttoned shirt and chest hair, the glassy eyed look. Wayne figured that Steve Stone was probably just like Mr. Zombrowski, a big talker who never let the facts get in the way of self promotion.

Mr. Zombrowski was the former town supervisor for nearby Camillus and he'd come to know Wayne's dad because their bands used to play together. Mr. Zombrowski spoke with a slight southern accent, despite being born in Schenectady, and even though people took his stories and promises with a grain of salt, he was still a likeable guy; Wayne's dad called him a "character." Mr. Zombrowski was a regular at Burke backyard barbeques in the summer and he told the same stories every time, like how he helped produce the Monterey Pop Festival back in the sixties and nearly became the Mamas and Papas tour manager. But no one in Split Rock had famous connections—it was such an isolated town—so everyone wondered why a guy who said he'd hung out with Otis Redding and Janis Joplin and watched Jimi Hendrix light his guitar on fire from backstage was working as a small town supervisor and hanging out with teachers and salesmen who played music on the weekends. The summer before, the last time Mr. Zombrowski came over, Wayne overheard his mom ask his dad how much of Mr. Zombrowski's stories were true.

"I think he helped stack chairs at Monterey, I guess they ran short on volunteers at the end of the festival," Mr. Burke said, "and maybe he brought a sandwich or two to Mama Cass. The rest is bullshit, though, just wishful thinking."

Mr. Zombrowski liked nothing more than to talk about his

old band, the Kennesaw Mountain Boys, who nearly got their big break back in 1973, at least according to Mr. Zombrowski. The Kennesaw Mountain Boys, a five-piece country rock band who billed themselves as "the perfect middle of the road experience," were briefly considered by a management company who later signed pop singer Leo Sayer. Mr. Zombrowski assumed Leo's success—the top 10 hits, the concerts, the *American Bandstand* appearances—were rightfully his, so every time "You Make Me Feel Like Dancing" or "When I Need You" came on the radio he'd say, "That should be us! That should be the Kennesaw Mountain Boys on the radio right now! They took food off my table when they signed that clown. And he's not going to last. I'm in the music business and everyone knows American bands always outlast English singers." Then Mr. Zombrowski would explain why it wasn't the Kennesaw Mountain Boys on the radio. "If we'd had our regular drummer the night that management company came to see us, I'd be on the radio now instead of flipping these burgers and dogs. That's money you can count on."

Mr. Zombrowski would go quiet for a few minutes but as soon as anyone spoke to him about anything—the band, the burgers, town politics—he'd start talking about his unfulfilled dream, the project the Kennesaw Mountain Boys were never able to record: *A Candle Burning Bright*, a country rock opera about a day in the life of a Canadian mountie. Wayne realized that every adult had something they repeated at every cookout, a saying or a joke, but Mr. Zombrowski was the only grown up he knew who gave a sales pitch every time. Wayne's parents would roll their eyes and make a quick departure because they'd heard it so many times, but Mr. Zombrowski always gave the speech and always with the same fervor, whether he had an audience of one or a dozen.

"I've got something in the works now, though," he'd say, feigning reluctance and rotating a couple of hot dogs before continuing. "It's kind of like Charlie Daniels doing *Tommy*, you know, by the Who? You got a good thing going there, right? Now

throw in just a bit of the Marshall Tucker Band. This Canadian mountie, you see, he's kind of like the last of the sheriffs from the old west. He's gotta balance those long, lonesome rides in the wilderness with a home life, a wife and kids who miss him. It's all about duty, to your family, to yourself, to the law, and the Mountie never completely sorts it out, but he keeps going, he keeps burning, the whole time. He might flicker, but he won't go out. That's where I got the title, *A Candle Burning Bright*."

Mr. Zombrowski would pause again and tend to the grill. "It's going to be a double album, with a full-color gatefold cover. I can hear side four in my head already." Here he'd close the grill and lean closer, talking faster and quieter, his excitement coupled with his need to have someone else believe in his vision. "Side four, you see, is a suite, one long song with four parts. I was thinking of using a lot of flutes for these songs, but then I thought to myself, wait, flutes are Jethro Tull, I'm going to use fiddles and dobros. This is a *country* rock opera, after all. It's about respect for tradition. So, the mountie, Jim—a common name, you know, something that's easy for people to relate to—he's down at his local watering hole, half way through a bottle of whiskey, and he's thinking about not going home, about moving on to a new life. He's having a crisis of faith, but he does go home and works it out with the Mrs. Then we've got the finale with Jim and his family and the bartender and the ice skater, everyone, and then the side ends with an alarm clock going off. It's the next day and he's back at it, back in the saddle.

"Of course, *A Candle Burning Bright* is all in the first-person, not like *Tommy*, which gets bogged down with so many songs in the third-person. I've thought about this a lot. Might include a poster, too. I've got the artwork back at the house—I can picture the album title arcing across the cover, spelled out with a lariat— but I'm going to wait until I have the money to do the whole thing right, really take my time writing and arranging. This is something to craft and nurture in the studio, no rush job. And I'm going to

get top sessions musicians, guys from Nashville or New York, no one local."

A Candle Burning Bright is why Mr. Zombrowski got fired as town supervisor. He got caught embezzling ten grand from the annual Kings Park Summer Cookout. His plan was to use the money to finance and promote the record, then pay back the town, with interest, once the album went gold. He told Wayne's dad that, really, when you thought about it, he was just investing the town's money. People should have thanked him, it was money they could count on.

By now, Wayne was almost used to the temperature in the hot box and he started wondering if he knew anyone else that had gone to jail like Mr. Zombrowski. He had just flipped to the next card, a player named Dick Pole, one that always made his dad laugh, when Carol Micek knocked on the door.

"Mrs. Scott says you can come back now, Wayne. We're lining up for lunch." Carol left the door open and cool air flowed in.

Wayne leaned forward, separating his sweaty shirt from the back of the chair, popped the cards in his shirt pocket, and started thinking about his apology to Mrs. Scott.

One Last Round for Charlie Dell

Listen up, guys. Can I have your attention, everyone? Difficult day, I know. And it's getting late. Last call's in a few minutes. There are a lot of early flights tomorrow—I know some of you have to be at the airport by 7:20—but I'd like to propose one more toast to the late, great Charlie Dell. We're going to miss the hell out of you, Charlie.

Like the rest of you I've spent the last few days thinking about Charlie. We met just out of high school. A couple of kids from Maine taken in the junior hockey draft and sent to Moose Jaw, Saskatchewan. This was the spring of '61. We were the only Americans on the team and neither one of us had ever been away from home. We didn't know our asses from a hole in the ground or about anything outside of Penobscot County. I was homesick before we got there. I just wanted to go to practice and get room service, but Charlie always knew a better way. What's the first thing that son of a gun asked our coach: Where's the good fishing? Only Charlie.

When I came into Bangor the other day I was thinking about that team. We had this rich kid from Montreal, all stick, no skate. Barely spoke a word of English. His father was in the fur business or some such. Well, the kid threw out every stick he scored a goal with. Didn't matter whether or not it was cracked, he just got rid

44

of it. He figured that every stick was good for a certain number of goals, could be one or fifty or a hundred, but he never knew how many and he never knew when that stick had scored its last goal. The kid thought the only way to be sure was to start fresh, always use a new stick. Dipshit thinking, if you ask me, but Charlie always joked about having enough money to do the same thing with fishing poles, give 'em away once he hooked something. Charlie, I hope you're there, buddy, we're going to miss you.

When I was sitting in church today, listening to everyone talk about Charlie, about what a good man he was, I kept thinking about what wasn't being said, all those Charlie stories that weren't being told. That's why I wanted us to get together. I understand why there wasn't a lot of hockey stories at the service, or moose hunting, but there's one more story I couldn't get out of my head and I'd be a selfish son of a gun if I didn't tell it.

It was the fall before Charlie's first stroke. Three years ago. I was up visiting for the week. He said the fishing was going to be good the next day because he had that achy feeling in his shoulder. Of course, that was just an excuse to be on the water, his shoulder bothered him rain or shine. Anyway, we had his boat in the water by six, me and Charlie and his wife and his dad. It was a beautiful day, had to squint for the sun coming off the water. We didn't fish much. Maybe we caught three trout worth keeping. Just relaxed mostly, floating downstream, sipping beers. Except for Charlie's dad who was nagging him about the cigar smoke.

Not long after lunch Charlie hooks a sucker. Hated the things. Never wanted to eat them because they've got so many bones and they're terrible for the trout because they eat everything the trout feed on. Charlie hadn't caught a thing all day and then he pulls up that sucker. He was pissed. He takes the hook out of the sucker and heaves the damn thing a good eight, ten yards up on the bank. A couple of seconds go by and we hear this floundering, something flopping around in the leaves. Of course, it's the sucker. Charlie's dad points and says, 'It's coming right back into the

water.' Charlie stands up, pulls that .45 off his hip—he always had that pistol with him in the woods, he loved the way it added to the adventure—and he says 'The hell it is,' and he shoots at the fish, fires twice. Surprised the crap out of us. The thing sounded like a cannon. Charlie stared at the bank, watching for that sucker. We couldn't tell what happened to the fish because Charlie made such a mess. Dirt and leaves and branches scattered everywhere. I told him to calm down, remember his blood pressure, and just when he sat back down we saw that sucker flop back into the water and swim away. We started laughing, his dad was making fun of him for missing the fish, but Charlie was still pissed. There never was a dull day with Charlie Dell.

Now like I said, it's been a long day, but I talked a couple of other guys into saying something, and I'm going to turn it over to them. I know Ernie Slater doesn't like to say a lot but he was with Charlie at that Wayne Newton show. Can I put you on the spot, Ernie?

Thanks, Curtis. Thanks, guys. Didn't expect applause. I wasn't planning to say anything about Branson but I was with Charlie at that Wayne Newton show. Funny thing. New theatre. Opening night. Signs all over town. "The Eagle Has Landed." Wayne was new in town. Charlie got good seats up front. This comedian comes out, tells a few corny jokes and then this young girl sings "Michael Row Your Boat Ashore" and "Kumbaya" and shit like that. Night was turning into a goddamn campfire. I'm ready to leave when the band starts playing. Place gets dark, fills with smoke. It's loud and the ceiling starts lighting up, flashing. I look up and see a goddamn space ship. It's a UFO at a Wayne Newton concert. Damn thing starts coming down but it gets stuck, one side's lower than the other. Went on like this for five, ten minutes. The orchestra playing, us sitting in the dark, seats vibrating, those tilted lights up there in the smoke. And then they gave up and brought ol' Wayne out. Thought Charlie was going to

fall out of his seat laughing.

That's not really a Charlie story, though. I just told it because people asked. Listening to Curtis took me back. Reminded me of the orange juice story, when me and Charlie were playing in Minnesota, for the Fighting Saints, in the WHA. We were playing at the old Civic Center in St. Paul and the team's Zamboni was busted. Thing left a dip in the ice about half way between the red and blue lines, right in front of our bench. Coach knew about it but he didn't want to press the issue with management. Didn't want to risk his job. The owner said he'd look into it. Five, six games later he was still looking into it. That dip was something awful and it kept getting worse. Guys started tripping. Charlie was upset.

This must have been '74. We hosted the all-star game that year. It was a big deal. Ten thousand in the stands, live coverage on CBC—a lot more attention than we usually got. Charlie made the starting team that year. Knew there'd be a lot of people watching. I didn't think nothing of it when he snuck some juice onto the bench. Then in between periods he asks me to hand him the carton. He skates over to the dip, gets down on a knee, and pours the juice on the ice. Everyone's looking. Fans. Players. The refs, the announcers, everyone. Instead of spreading out across the ice, the juice collected in that little ditch, which was, I don't know, three or four feet long by this point. We could not stop laughing. Reporters asked a lot of questions after the game. The phones lit up on the call-in shows. The owner never said a word but the ice was smooth for our next game. The only reason Charlie didn't get traded was because he injured his knee a couple games later.

Every year when I open that Christmas card from Charlie and Carol I think the same thing: there was a guy who knew what it took. Thanks.

Ernie, that was a great story. Curtis, thanks for organizing this but next time let me go before Ernie. He's a tough act to

follow. As for the rest of you guys, it's great to see you and it's great to be talking about Charlie Dell. My name's Floyd Blackburn. I know most of you but I see a couple of faces I don't recognize. Like Ernie, I played with Charlie in Minnesota, and I consider myself lucky just for knowing the man. He was a good husband and a good father. He was a good hockey player and became a good sheriff, but at the funeral I got to thinking about something nobody's mentioned yet and that's how darn competitive Charlie was. I don't know if he loved to win or hated to lose, but I do know that in thirty years of hockey the only tooth I ever lost was thanks to Charlie, which I'll get to in a minute.

Charlie was a veteran by the time I came up. We played in Minnesota for a couple of years and those teams went through a heck of a lot together. I remember one time sitting in the locker room after a game, everyone's getting out of their pads, we hadn't even showered yet, and the owner walks in. Remember this was the World Hockey Association. Teams were moving or being sold or going bankrupt all the time and the owners never showed up when the team was just playing good hockey. They would only show up when our checks were about to bounce or when it was time to pack up and move.

Our owner was a guy named Turk Ferguson and this one time he came into the locker room to congratulate us because we'd won three games in a row. Three games is nothing. We knew that. Plus, we were still 12 points out of first place and a longshot to make the playoffs, so we knew that something was up. The Turk said he wanted to talk about something that was going to be in the papers the next day, and he wanted to give us a heads up. There was a rumor about the team going under, which wasn't any big deal. We heard rumors like that every week. He told us times were tight and the team hadn't paid its bills in a couple of weeks and the investors were getting nervous and the team might not make payroll. The investors told him they didn't want to move the team or sell the team but they had to sell more tickets to stay afloat. I'll

always remember what he said, 'I'm turning to you fellows, giving you a chance to save your jobs. If you pool your resources and buy some tickets, just enough to see us through until the end of the season, the team will pay you back.' He wanted us to buy tickets to our own games. I thought to myself: Screw. This. Guy. He doesn't know shit from Shinola when it comes to money and now he wants some of mine? The Turk didn't know which end was up. One day he's sending us to train in Finland, because he thought it would be good publicity, and the next he's trying to save money by sending us out on the road in a school bus because it was cheaper than going coach. I remember more than one time when we had to get off a plane because the team's credit wasn't any good. Another time we had to buy new skates and pads about two hours before game time because our equipment was seized.

Well, after The Turk asked about the tickets Charlie organized a team meeting, players only. I was ready for the most vulgar, obscene language anybody ever heard. I expected Charlie to be on fire. And we all know what that was like. But you know what? He didn't do that. He didn't get upset. He went the other way. He reminded us that even if we didn't have a lot of fans we did have loyal fans that took a chance on us instead of the NHL team across town or the college teams in the area. Charlie took out his wallet, put his money on the table, and walked out. He didn't have to say anything else. That did it. A bunch of us pitched in and bought tickets and fans started coming out those last few weeks and we made it to the end of the season and even though we didn't make the playoffs it was a great ride. The team folded halfway through the next season, but Charlie saved the Saints for a little while.

After that he was picked up by Cincinnati and I wound up in Winnipeg—I'm getting back to the tooth, don't worry—and whenever we had a night off in the same city we'd go out. We were in Cincinnati this one time. I remember I'd just had a big game in Quebec, a couple of goals and three assists, and me and a couple

49

of teammates met up with Charlie and a couple of the other Stingers the night before our game. We went to this place called The Crushed Can because Charlie said they had the best burgers in town. They had cheap pitchers too and after a couple of rounds I had to go to the bathroom. I was walking to the back of the bar when I accidentally bumped into this guy playing pool. I apologized but he got real mad. He said I loused up his shot and cost him money. I didn't even notice him until he was yelling at me and blocking my way. I did notice that the little crumbsucker was bald so I made a joke—called him chrome dome, or something— and tried walking around him. Before I know it the little guy is on one side of me swinging his pool cue and a couple of his buddies, who were much bigger than him—tattoos and leather jackets too—they're on the other.

All of a sudden I see a shot glass come flying out of nowhere and catch the one guy right in the mouth. Should've heard it. It was a perfect shot and he dropped like a sack of cement. I'd been in enough fights to know what was happening so I grabbed the little guy's pool cue. Then his other buddy catches me in the jaw and I'm laid out on the pool table. Anybody who owns a place that caters to bikers and hockey players knows how to protect his bar so the whole thing didn't last long, but it wasn't until the cops showed up that I found out it was Charlie who threw the glass. Not many guys would stick up for an ex-teammate like that. Charlie sprained his finger in the fight, but the team sent out a press release saying that he hurt it making a hobby-horse for his kid or something. I don't know if they believed it, but they ran it. Charlie had a way with the press.

The next day, about half way through the third period, we were playing a tie game and a fight broke out. Charlie didn't start that day because of his finger but he came in later. The benches cleared and me and him ended up near each other. I was still a little hung over and a little bruised from the bar fight, so I didn't feel like getting involved. I figured we'd hold jerseys, just for show, and

then things would settle down. I turned to say something to Charlie, I never got to thank him for bailing me out the night before, and he hits me. The son of a bitch hauls off and pops me in the mouth—with his good hand—and knocks out a tooth. I should have known better. I tackled Charlie but somebody pulled me off before I could get in a good shot. So what happens that night? Charlie calls like nothing happened and asks what I'm doing for dinner. Never mentioned the fight. Life's going to be a whole lot duller without you, Charlie.

Floyd Blackburn, gentlemen. You ought to have a talk show, Floyd. Listen, before I bring up our last speakers I wanted to make sure that everyone had my email address. Real simple: CurtisLaPointe—one word, with an *e*—at loantech dot com. Okay. Our last speakers. We've heard a lot of Charlie's playing days but as most of you know he also served as town sheriff for about 20 years. That's where he encountered the Twomley brothers. Otis and Phil have changed a lot so just hear them out. Otis? Phil?

Thanks, Curtis. When I saw Curtis at the funeral today he said that a bunch of people would be getting together here tonight and I asked if my brother and I could say a few words. I know that's going to surprise a lot of you, but we never got to thank Charlie and it's important to us to do that.

True enough, Charlie's the man who arrested us but we've owed him our gratitude for a long time. Phil and me have gone through a lot. You don't understand what it's like hearing the same questions over and over again, about not wearing masks for a bank job, trying to get away in a donut truck, kidnapping Evelyn Dunne and Artie Browne. Nothing worse than people asking you questions they think they already know the answers to. None of it is quite what you think—we had a good plan that day—but our situation, our lives, especially the eight years we did down in Warren, would have been much worse if it wasn't for Charlie Dell.

When you grow up a Twomley in Penobscot County you grow up hearing about how the sandy beach along the southern end of the lake might bear the Milford name but actually, legally, it belongs to you. Our dad used to take us hiking in those woods, and owling, too. I remember those nights, moonlight trickling through the branches, he'd say we weren't trespassing because the property was really ours. 'The Milfords are a bunch of liars,' he'd say, 'a bunch of cheats. All this was your great-granddad's. It was taken from us and one day we'll get it back. The Milfords can't hide the truth in a safe deposit box forever.'

Our dad went to jail trying to break into that safe deposit box and so did our granddad. But me and Phil had the advantage of being twins. Two heads working together, even if one of those heads is selectively mute, like Phil here.

The day we held up the Savings and Loan the first thing Evelyn Dunne said when we walked up to her window was, 'What took you boys so long?' We just tapped on her window and smiled. She knew why we were there. Everybody knew why we were there. There was pride involved, we wanted people to know it was us. That's why we didn't wear masks. We didn't feel good pulling guns on neighbors but we had to set the record straight.

And we didn't have to say a word about what we wanted. They led us straight to the vault, we took out all the papers and put them in Phil's book bag, and we were out of there in no time. We hopped in our car and took off. The donut truck came later. Escaping wasn't part of the plan. Figured we'd turn ourselves in if we didn't get caught. We just needed time to read that deed, which was old and brittle and broken up along the folds. Kind of confusing, too. We tried looking for names but Evelyn kept interrupting. She was in the backseat. We had to take her along just in case. You don't understand how hard it is to tie someone up and gag them. We didn't hurt Evelyn—she came right up to Phil at the funeral this afternoon—but that day she just wouldn't stay quiet, made it hard to focus on the contents of that bag. I wanted to let

that moment sink in, take just a couple of minutes to think about the burden about to be lifted, but she kept shaking off that gag and Phil would have to stop reading, climb over into the backseat, and tie the gag back on. Then a couple of minutes later she was back at it. All full of gossip, telling us about this nephew of hers who was diabetic but didn't do anything about it for years, so he lost his job and fell into a coma, and now he's back to talking but they don't know about his liver. She was making it really hard to concentrate on driving, never mind figure out what Phil was trying to say. Most of the time him not talking is kind of nice, I get a lot of thinking done. Other times it's like living with a damn mime and I think to myself, just say something already! Of course, it would have been easier if Phil was driving, then I could have done the reading myself. Phil can drive, he's got a license and all, he just doesn't like to. So anyway I'm behind the wheel and I'm driving as fast as I can and then Evelyn's babbling again, this time about a neighbor's son-in-law who got his arm caught up in a wood chipper and Phil's reading and finally he gets to the part where everything turns to shit.

The truth of the matter was simple: Our great-grandfather sold the land. The Milfords didn't lie, didn't cheat. They were right. We were wrong. All those stories? Knocking over the bank? For nothing. Half my life washed away right then and there. We would have done time to vindicate our family but at that point it wasn't worth getting caught.

I can see some of you wanting to laugh. Don't hold back on our account. Hard not to laugh at some of things me and Phil did that day.

So, we turned on this little police scanner we brought with us and they're going on about armed and dangerous, and robbery and kidnapping. They identified Phil's car, too, so we went to our back up plan, pulled into Artie's Diner to change vehicles. We knew Artie left the keys in his truck—or at least he did when we used to work for him—but they weren't in the ignition so we locked

Evelyn in the trunk and went inside. That's when Phil pointed out that we needed money—we didn't take so much as a roll of nickels from the bank—and a diner like Artie's is all cash and no security. Like I said, we don't like pulling guns on neighbors, but Artie played it stubborn, which surprised us. We knew we were breaking the law but we thought people would be on our side, they'd look past what we were doing and see why we were doing it. Kind of like Robin Hood or Martin Luther King. Anyway, we came away with a couple of hundred bucks, a mess of donuts, and a couple of coffees—we didn't get one for Evelyn because of the gag and all. Only problem was that Artie's pick up was almost out of gas, so we had to take his delivery van. You know, the one with the big pink frosted donut mounted on the roof. Not a fast vehicle, but if you think with reverse psychology it was perfect cover. Lucky for us there wasn't anybody in the diner but Artie. I ripped out the phone cord because we knew Artie couldn't keep his mouth shut and just as we're about to leave we see him take out a cell phone— Artie changed a lot when he got remarried. Never did care much for Laura Aaronson. So, of course, we had to take him too.

We're not five minutes down the road when Charlie comes on the scanner and we hear that he's in pursuit of a donut truck northbound on 95. We figure that's us. So we get off the highway and head for Baxter Park. Figured we'd lose them there. We know those trails well but the access roads are unmarked—and it was so hard trying to concentrate with Evelyn and now Artie talking so much and Phil saying so little—we got lost and wound up down by the lake. The van got stuck in the sand and before we know it we're on foot.

We left the back door open to let in fresh air for Evelyn and Artie. Then we made a beeline for the woods. A couple of minutes later we stopped, caught our breath, and realized we'd left the money in the van so we headed back and it turned out we weren't very good at the binding part of kidnapping either because Evelyn and Artie were gone, so we had to split up to find them.

I gave up after a couple of hours. Thought avoiding Charlie was more important than finding Evelyn or Artie. I found cover and stayed put until sundown, planning to move at night. Figured Phil for the same. About dusk I was at the edge of this clearing. I heard one of Phil's birdcalls. I spotted him about a hundred yards away and then all of sudden I saw Charlie standing in the clearing between us. I swear Charlie saw me and I couldn't tell if he was looking to talk or shoot. I don't like pulling a gun on a neighbor but I knew I couldn't take any chances so I fired first. I knew something was wrong as soon as I squeezed the trigger. I heard a second shot just as I saw Phil flinch and drop like a rag doll. I felt this flash of rage at Charlie for shooting my brother just before there was a god awful sting in my shoulder, like a copperhead came up on me, and I realized I'd been shot too. Meanwhile, Charlie? Nowhere to be seen, like he disappeared.

It took me a couple of minutes to get up but somehow I staggered across the clearing—yelling out every move I made because I could only raise the one arm and I didn't want Charlie or whoever else was with him thinking I still had a gun and I was trying to draw attention to myself thinking maybe Phil could get away. I mean, Phil and me look out for each other. We've lived together our whole lives. Always had the same jobs, listened to the same music, liked the same shows, and I got this image in my head of being at the grocery store and Phil not wanting to try one of those cheese-on-a-stick samples unless I did too. Funny what goes through your mind at a time like that.

I made it to Phil and he was lying there pointing first at his gun and then me and I couldn't figure out what he was trying to say—he does his best gesturing with his right hand, which he couldn't move because of the gunshot wound—and I was cussing at him, saying, 'You *can* talk, Phil, and this is one of those times where you damn well better,' and all of a sudden there's Charlie again. He's telling us to keep our hands up, which we couldn't do and he ought to have known why because he was the one who

shot us, or at least I thought at the time, and he was making me nervous, cussing us for taking him on this wild goose chase and scaring poor Evelyn and Artie. He was looking down the barrel of his gun when he came up on us, moving it back and forth between Phil and me.

Then Charlie stopped. I could see the anger on his face. He was seething. There was a long moment where I wondered what he was going to do next. I'd never met the man but I knew about his reputation. I expected him to finish the job. Then I swear I saw him about to laugh. Phil was lying there on the ground, gesturing toward his own gun, and I was standing there clutching my shoulder, couldn't figure out what Phil was trying to say and that smirk came back on Charlie's face and that's when it hit me, that's when the worst day of our lives got worse: Charlie didn't shoot me or Phil. We shot each other. I could have sworn I was shooting at Charlie and Phil was thinking the same thing, but my brother and I shot each other.

Charlie cuffed us and we waited for the ambulance. He didn't say a word the whole time. I never felt such shame and remorse. Just look at Phil's face. You can tell he felt even worse.

But you know what? No one ever said a word about the shootings. We took a lot of guff about robbing a bank without masks and not taking any money from a bank robbery and the donut truck and kidnapping old folks and all the rest of it, but no one's ever said a word about us shooting each other. To this day I have no idea how or why Charlie kept that under wraps, but he let us keep some of our dignity, and Phil and I need to thank him for that. We're not drinking men much anymore but tonight we're making an exception. Here's to you, Charlie.

The Whistle Stop

A mere eighty-one votes separated candidates Frank Tarwater, the incumbent, and Ray Bishop, the challenger, in last fall's Southeast mayoral race. The following week's *Putnam County Gazette* applauded the efforts of the two hundred seventy-three residents who cast votes, those "virtuous Americans" who fulfilled their civic duty. The *Gazette* ran a pair of articles on election day bake sales and the next day devoted a full page to Bishop's official acceptance speech, wherein the mayor-elect made a half-hearted effort to connect with the kids (*"Listen to your parents and your teachers. And if you see someone littering, remind them nicely that littering isn't polite."*) along with a half-hearted attempt to bury the hatchet with his opponent and former friend (*"Frank Tarwater has an impressive knowledge of trees."*). No mention was made of the two thousand eligible voters who didn't vote. The coverage was dull and Mark D'Angelo's absence from the *Gazette* was never more apparent.

D'Angelo was a former columnist and reporter whose byline disappeared from the *Gazette* a month before the election. My wife and I had followed his columns since moving to Southeast a few months before. She nicknamed him The Professor because his photo, which showed him to have deep creases that curved around his mouth like the handles on a pair of pliers, reminded her of a

chemistry teacher from college.

Southeast is a small town about an hour and a half north of New York City. We heard about it through a friend of Allie's. She described it as a one traffic light town where the members of the volunteer fire department walked to the station. Southeast felt right to us, offering easy access to New York while remaining a town in which very little happened. Allie's friend tipped us off to columns of Mark D'Angelo. Initially we mocked them, the articles about birds of prey shows and the editorials about seatbelt safety and the importance of thoroughly brushing off the roof of your car in the winter. But we marveled at how prolific he was—writing upwards of a dozen pieces every week—and the energy he poured into his work. Here was a man who made the girls' high school basketball team, owners of a 5-16 record, seem like they deserved a WBA franchise. We moved to Southeast in September, just as the Tarwater/Bishop mayoral race was heating up.

It was supposed to be the election that put Southeast on the map, if only for a short while, and drew voters out of their apathy. D'Angelo wondered in print who could resist a tightly fought campaign between two colorful octogenarians. Frank Tarwater, the four-term incumbent, was a retired arborist and former circus clown. For two months in the summer of '95, after his apartment on Main Street burned down, he was also known as the only homeless mayor in the country. Tarwater and his wife received many offers of spare bedrooms from supporters but the couple enjoyed their semi-nomadic life and the publicity attached to it, even declining the Red Cross' offer of temporary housing. After a couple of weeks Lucy convinced Frank that their cats were becoming a burden on their hosts. When he and Lucy found a new apartment and regular life resumed, Tarwater went back to landscaping part-time, tending to the town's business, as he saw it, and representing the independent Bulldog party, which was largely comprised of two dozen retirees who had spent the past ten years collecting change from returnable bottles in order to raise funds

for a local hiring hall for day laborers. To date, the group's greatest success was covering the costs of their monthly meetings at Norm's Bar & Grill.

While D'Angelo reported extensively on Tarwater, he supported the challenger, Ray Bishop, a balding lawyer and real estate developer. Bishop was a rarely seen out of doors aside from the weekly laps around his yard on his riding mower. Despite being a recluse, Bishop was well known in town. He used to own a strip club and in recent years his adopted son had landed the family name on the front page when he, Nate, the son, was caught spray painting "666" in the sand traps of the local golf course. Only in a town like Southeast would such a story linger for weeks. Despite his colorful background, Bishop found himself endorsed by the Democrats and the Republicans, along with the ever-nebulous Southeast party.

On a personal level people still liked Tarwater, the current office holder. They enjoyed gossiping about his quirky past and listening to his poetic speeches. But many residents didn't want him in office when the state's $1.2 million funding to improve the water and sewer systems came through; there was too much at stake. As D'Angelo pointed out Tarwater hosted an Arbor Day like no other, but he had done little to improve the village. Under his watch the Boone Dog Café and T.C.'s Pizzeria recently went out of business, and the Cameo Playhouse, the village's movie theater, which had not screened a film since 1999, remained in disrepair, paint flaking from its exterior and its marquee dented from a run-in with a moving truck eight years earlier. The pool hall, popular with the day laborers who lined the streets of Southeast waiting for work, had not turned over its "Sorry, We're Closed" sign in weeks, leaving immigrant workers with one less place to go. There were fewer and fewer reasons to visit the Southeast and a growing number of people held Ray Tarwater accountable.

Tarwater and Bishop were the kinds of colorful characters

who seemed to be elected frequently in the world beyond Southeast—actors in California, wrestlers in Minnesota, porn stars in Italy—but the joys of following the Tarwater/Bishop race were largely lost on the residents of Southeast. Likewise for the wire services that D'Angelo pestered to no avail.

Reading D'Angelo's columns, it was clear he saw Southeast's glass as half full, even if it was chipped and somewhat cloudy from so many runs through the proverbial dishwasher. Still, he was aware of the naysayers, mostly the commuters who rushed through the village every day, riding Metro North trains into Manhattan, yet never straying beyond the path that leads from the parking lots to the train platform. He once quoted a commuter, overheard during morning rush hour, saying, "Southeast is a pathetic place with the potential to become more pathetic."

For most of the commuter crowd, the village's thrift stores and bodegas were rush hour backdrops, fleeting images that passed by their car windows. Southeast, outside of the train station, had nothing to offer them. If they were in need of a used purse or a 40-ounce bottle of beer, Southeast could scratch their itch. If, on the other hand, they needed a new, non-perishable item—a book or a replacement belt for their vacuum cleaner—they were out of luck. There had not been a new consumer good sold in Southeast since the demise of the furniture store, Wooden It Be Nice.

The two-story brick buildings that line Main Street in all of its nearly-the-length-of-a-Canadian-football-field glory tell only a small part of the story. The balance is, of course, told by the people who patronize those stores, a mix of immigrant workers—men from Central America who manicure lawns and carve out man-made ponds for the residents of nearby Westchester County—and crazed cat ladies—women who stock their station wagons with sacks of cat litter, cans of cat food, and stacks of yellowed newspapers, mobile command posts in the fight against homelessness in the Feline-American community.

The crowing jewels of Main Street are located across from the Eagle Eye Thrift Shop of the Putnam Hospital Center Auxiliary. Located beside each other are both Pet Rescue and Thrift Shop, Inc. I and Pet Rescue and Thrift Shop, Inc. II, original and sequel side by side. Pet Rescue and Thrift Shop, Inc., then devoid of the Roman numerals, was formed in the interest of raising money to fund the practice of trapping, spaying, and releasing stray animals. My wife, who works as a veterinarian in the area, heard that the group split when Lucy Tarwater, Frank's wife, who kept eight cats in the couple's two-bedroom apartment, accused Bonnie Bishop, Ray's better half, whose split level ranch on the outskirts of town housed 15 cats, of being an animal hoarder.

Frank Tarwater and Ray Bishop had once been close friends and political allies, but the friendship had been laced with tension for years. The root cause as I'd heard it was the seating arrangement at Tarwater's daughter's wedding. The Bishops felt slighted because they had been seated at a table with out of town relatives in close proximity to the band. The Bishops hadn't been invited to rehearsal dinner either. Lucy's comments about Bonnie's cat hoarding proved to be the final straw. Bonnie took her share of the stock from Pet Rescue and Thrift Shop, Inc. and opened a new store. She intended to move into the storefront next to Ella's Natural Foods in the Stop'n'Shop Plaza on Route 22, but as money tends to be tight in the thrift store/pet rescue business, Bonnie and her fellow secessionists, unable to take on the more expensive rent, had to stay put. Sort of.

Bonnie and Lucy wound up splitting their storefront and their merchandise. Pet Rescue and Thrift Shop, Inc. I catered to the higher end merchandise crowd—fancy headboards and entertainment centers, and the like—while Pet Rescue and Thrift Shop, Inc. II trafficked in three-dollar end tables and waffle makers. The former allies remained neighbors united only in their shared belief that the people across the street at the Eagle Eye

Thrift Shop sold nothing but garbage.

Main Street is also home to the Whistle Stop, as peculiar and underappreciated as any other part of the village. Choosing a seat was easy that Friday night; there were only two empty chairs and only one of those wasn't staked out by a pile of dollar bills and assorted pocket paraphernalia. The bar was full but relatively quiet, conversations easy to conduct over the jukebox and the televisions—basketball on one, Powerball on the other. Walking along the bar, hoping that my wife had received my message, I ordered a beer and took in the haphazard decorations. A parrot dangled in front of one mirror. A clown sat on a swing in front of the other. There was a framed Flann O'Brien poem and an emaciated two-foot Uncle Sam standing next to the cash register holding a charred American flag. I liked the yard sale décor, though this was the first time that I noticed the framed platinum cassette of the Hall and Oates' album *Private Eyes*.

I had at least four hours to wait and could afford only one more beer. It was going to be a long night. I started making up a story about how the framed cassette found its way into a small town bar—a DJ from the local soft rock station, recently fired for playing all of *Numbers*, a Cat Stevens' concept album based on numerology, during afternoon drive, ran up a tab drinking rum and cokes and offered the framed cassette in exchange for debt relief. Then my mind drifted back to the bar, eavesdropping on the two guys arguing to my left.

The louder guy was standing, facing my direction. "Zebra mussels *are* good for the lake." He was tall and skinny and possessed an awning-like forehead, wide and high and sloped. His appearance conformed perfectly to my conception of an English soccer hooligan. In my mind's eye I pressed his face up against a chainlink fence to test the theory.

The quieter guy, heavy set, sat with his back to me. He was peeling the label off of a beer bottle. "That's not true." He conformed perfectly to my conception of the indifferent yet

judgmental record store clerks in New York.

"They eat what's on the surface, which allows more sunlight to reach deeper," Soccer Hooligan insisted, "which leads to more photosynthesis which leads to more plant growth." I watched in the mirror. Soccer Hooligan held out one palm to represent the surface of the water. He simulated sunlight by wiggling the fingers on his other hand perpendicular to his water hand.

"That's not true," Record Store Clerk replied, sarcastically wiggling his fingers in his friend's face.

"Cut the shit, yes it is." Soccer Hooligan swatted at Record Store Clerk's hands.

"Listen, numbnuts, they're aggressive fish. They have no predators in the lake and they're going to eat all the algae and ruin the fishing. You'll change your mind by the end of the summer. I'll bet you ten dollars."

"I'll bet you a hundred dollars."

"Why are you giving me ten-to-one odds?"

"I can do the math. You going to take the bet?"

Soccer Hooligan and Record Store Clerk were shaking hands when I noticed that the guy to my right, the owner of the watch and keys and lottery tickets and Swiss army knife and cigarettes, was back. I looked up and saw his face in the mirror. He looked familiar. The man soon to be known as Impressed by Reenactors spoke to the bartender.

"We were at that Civil War reenactment at the fairgrounds last weekend. It was pretty impressive. I talked Lisa into going and then we ran into some of her friends. We saw the two sides exchange fire and then there was this Confederate soldier on the ground pretty close by, maybe a bus-length away, and he was acting like he'd been shot and our friend's kid, who's five or six, says, 'Is he dead?' They were that good. I interviewed some of the other guys later and they said he was a 'threadcounter,' one of those guys who insists that everything about his uniform is authentic, right down to the number of stitches used on the buttons."

He ordered another beer, picked up his cigarettes, and walked outside.

These are the conversations I retell when friends ask what Southeast is like, slow paced and uncomplicated. At this point, I could feel myself relaxing, drifting away from the fact that I was locked out of my house and that I had just finished an eight-to-eight work day with another one ahead. I took out a book from my backpack and managed to read a paragraph before Devil Sign interjected.

"I love the 80s!" I hadn't noticed the guy standing next to me, the one whose bushy moustache looked like a vacuum cleaner attachment, nor that Pink Floyd's "Another Brick in the Wall" was coming out of the jukebox. Dread saturated my body on a molecular level. At first, naturally, I blamed the Pink Floyd song. Then he flashed a mock devil sign, complementing the gesture with a toothy grin, clenched eye lids and violent head nodding, and, on the off chance that I hadn't heard him the first time, he yelled "I Love the 80s!" again. I stopped blaming Pink Floyd. Devil Sign's pop culture cheerleader act was like a VH1 audition gone bad. On the one hand he conjured the worst aspects of the eighties—the "Don't worry about nuclear war" lecture my sixth grade teacher gave us following the broadcast of ABC's *The Day After*, the smell of chlorine at Camillus Pool that signaled another agonizing swimming lesson, and the taste of those ass-flavored fluoride gel rinses I used to get at the dentist's office. On the other hand, he brought to mind all that annoyed me about Southeast—seeing "America's Full" T-shirts at the grocery store, hearing parents curse at their kids at the playground, the flipside to the simple life.

I tried ignoring him. "Another Brick in the Wall" continued its assault and I went back to the Hall and Oates cassette, recasting the DJ as a guitar tech.

"It's funny," he continued, "because I had my first underage drink to this song." He waited a moment for my reaction. "It was

at this restaurant called Lums, weird place for a first drink, right? It's like getting high in a toy store. Getting baked in the Candyland aisle at Kay Bee doesn't work, you know?"

I felt like the watermelon in a Gallagher routine.

"Anyway, I used my brother's ID, which is so funny because it says he's six feet tall and I'm only, like, 5'9". It's like, hello, Mini Me is using Andre the Giant's ID. Notice anything?"

He ceased riffing for a moment. I could feel his smile burrowing into my head as I sipped my beer.

"I love the A-Team, too. Face. Murdock. They ruled! What did they call Mr. T? I can't remember his name. And how come nobody ever died on *The A-Team*? All that shooting and all those car crashes and nobody ever died? Isn't that weird?"

I was tempted to give my drink to Devil Sign, bring his act to an end, but I took the bait. "B.A. Mr. T's character was named B.A."

The bartender brought Devil Sign's drink.

"I think it stood for Bad Ass," I said.

"No, it was Bad Attitude!"

He took his drink and went back to his friends. He seemed annoyed by what I'd said. His departing scowl reminded me of a meeting I'd had at school earlier that day. The parent was upset that I'd discussed his son's report card with him. I had pointed out to the child where he was doing well and where he could improve. I thought that I had been encouraging. The father said my conversation was "destructive." He also quoted *The Art of War*. My grip on an enjoyable night was precarious at best. I didn't want to think about work or Pink Floyd or *The A-Team*, and right then, thanks to Devil Sign, I wished I wasn't living in Southeast. He was like a low rent Grim Reaper, his powers limited to harvesting the souls of conversations. I needed to clear my head, so I got up to use the bathroom.

When I returned, the framed Hall and Oates cassette was staring back at me. The tale I was weaving was starting to feel like

a movie of the week.

I finished my beer and checked the time. I had at least two hours to go. I contemplated how long to wait before using the last of my money to buy my second and last drink.

"Are you the guy who's locked out of his apartment?" The bartender held his hand over the cordless phone as he spoke to me. My wife was calling from work. She had received my message about being locked out. She laughed when I described my attempt to break into our apartment, quietly hushing our dog who was howling like, well, like a really loud dog startled by the sound of someone trying to pry the screen off the kitchen window. Allie got off work at midnight and could pick me up around quarter to one. As I handed the phone back to the bartender, he slid a mug in front of me. "This one's on the house," he said.

I re-read the Flann O'Brien poem. "When money's right and hard to get/Your horse has also ran/When all you have is a heap of debt/A pint of plain is your only man." I'm convinced those words came to him after receiving a free drink.

I thanked the bartender and noticed that Impressed by Reenactors had returned.

He looked up at the screen, checked his Powerball numbers, and crumpled his ticket. "'Another Brick in the Wall,' that's '79, right, not the 80s?" His tone was curious, not judgmental or sarcastic.

I happened to be looking in the mirror when he asked and that's when I put a name to the face. The pliers handle creases. Impressed By Reenactors was The Professor, Mark D'Angelo, former writer for the *Putnam County Gazette*. He finished his drink and went over to the jukebox. Then the bartender handed me the phone again. Allie was getting out early and could pick me up within the hour.

"Locked out, huh?" D'Angelo resumed his spot on his stool. I replayed my evening for him but not so vividly that a conversation took hold.

The bartender washed glasses. Without looking up he smiled and said, "Nice choice, Mark." I hadn't noticed the Otis Redding playing in the background. I had scoured the jukebox earlier, though, and wondered how I missed the good songs.

"Where did you find this disc on the jukebox?" I asked.

"Do you mind if I tell him, Pat?" D'Angelo asked the bartender.

The bartender shrugged and kept washing glasses.

"The mix CDs on the last page, they each list 15 songs, but they actually have 20 or so. He and the owner don't agree on music so Pat here hid some favorites."

D'Angelo and the bartender joked about the owner, how he insisted on carrying cases of beer up from the basement despite his 70 years and bad back.

I think I was drinking my beer too fast because I found myself asking D'Angelo why he got fired from the *Gazette*. The bartender laughed and walked to other end of the bar to take an order.

"Didn't you say you were getting picked up soon?" D'Angelo looked up at the Powerball screen again. "I wrote an editorial that my editor refused to print. I got pissed off and quit." He looked past me and held up his glass to order another drink. My face must have said "go on" because he did just that. "Actually, I don't mind telling you because everyone in town should know this. You may have noticed that the pool hall is closed. It used to be a dance club, pretty popular one too because it's so close to the train station. College kids could get lit up and not have to drive home. Lots of fights, though. Cops closed the place down and it sat unused until Ray Bishop, who is now our mayor, and his partners bought the place. They rented it to a couple of locals who turned it into the pool hall. The white locals had already given up on the village, so the place was dead until the Guatemalans discovered it—most of those guys out there on Main Street are from Guatemala. You ever notice that there's no gates or barriers over those plate glass

windows at the pool hall? None of the other storefronts have them either. Those guys don't cause much trouble because they don't want to risk dealing with immigration. But a lot of people around here blame them for driving away business from the village. Thing is, everyone you meet in this town is from some place else, could be Guatemala, could be Mexico, could be Danbury." He sipped his beer. "The village is the lowest elevation point in the county. Everything washes through here. Anyway, about a month before the election Bishop was losing ground in the race and I found out that he and his partners were going to raise the rent on the pool hall, basically force the owners out of their lease and give the day laborers one less reason to be in the village at night. I wrote an editorial exposing what Bishop was doing, not many people realize he owns that building. My editor said it was inappropriate. I started a blog after I quit and put the editorial online but no one read it."

D'Angelo guessed that his story was more than I had expected. He was right.

"That'll teach you to ask questions." He slapped the bar and smiled. "Sorry to bring you down but it still gets me fired up." Then he looked over my shoulder.

"Vince, great to see you! I still owe you." He stood to shake hands with Vince. "Vince, have you met... Sorry, I didn't get your name."

I turned and introduced myself to Vince who turned out to be Devil Sign.

"Nice to meet you, Mike." He didn't let on that we'd met earlier.

"The night I quit the paper Vince was working at the Italian place on old Route 22, Benvenuti. Gave me dinner and drinks on the house."

D'Angelo offered to buy a round for Vince and his friends. He asked me to join them.

I may have been quick to judge Vince. D'Angelo, too. If I

tended to see the village as a simple switch system—on or off, good or bad, fishing stories or Devil Signs—flipping it depending upon my mood, then D'Angelo saw it more like an integrated circuit, more complex, more capable, more "and," less "or."

Vince asked D'Angelo what he was going to do now that he didn't work for the paper.

"This is what I've been telling everyone: There's two ways to see the world—walk up and down the riverbed looking for things or stay put and see what comes your way; you can chase or you can wait. I've been chasing for years, and now it's time to wait."

Westchester

Just because I dislike something doesn't mean that I'm immune to it. Mortality. Weight gain. Exhaustion. My aversion to these things isn't enough to overcome them. Prejudice is similar. For me it's not prejudice based on race or culture or religion. It's status. To be more specific, people who have everything done for them. And for a long time I didn't see my loathing for the loaded subsiding, especially after living in Westchester County, just north of New York, for a year. My wife and I were moving back to the area and we wanted to be near but not in New York City. Long story shorter, we moved to a little town in Westchester called Pound Ridge, and my assumptions about the upper crust were substantiated.

The people my wife and I met in Pound Ridge were wealthy and they were nuts. They had so much done for them by other people—servants, tutors, au pairs, gardeners—that they were baffled by the basics of daily life. When George W. Bush was in office there was an infamous incident at a supermarket wherein the Commander-in-Chief marveled over the scanner used by the checkout clerk. I always assumed that there'd been a misunderstanding. I thought that it was unlikely—and hopefully impossible—that the guy with his finger on the The Button was unaware of and impressed by the checkout scanner, a device

typically operated by kids five years shy of their first legal beer. The incident was taken out of context. Nonetheless, moving to Westchester revealed the flaws in my assumptions.

A week after we moved to town, I was waiting in line at the post office. I stood behind a woman wearing a full-length fur coat. She stepped to the counter, held up a magazine-size envelope, and asked the clerk, "Can I mail a package here?"

Not "this" package as in "this package that is dripping" or "this package that is ticking" or "this package that is barking," but "a" package, any package. How detached from reality must you be to pose such a question? Mailing packages of various shapes and sizes is the post office's primary function, and it's not as if they perform this job with such excellence that they have diversified their services. You can't go to the post office for a pedicure or to buy a pack of sausage patties. The postal service is a one-trick pony still ironing out the kinks in that singular trick.

A few weeks later, our landlord told us that her neighbors had the oak tree in their front yard appraised for $40,000. I still haven't figured out which aspect is most disturbing: having a tree appraised, that a tree can be worth forty grand, or that there is sufficient need for tree appraising as to necessitate a local tree appraiser.

These examples weren't limited to life at home. I taught third grade at a nearby elementary school. One afternoon, as a particularly fun and messy class party was wrapping up, I sent a student to the custodian's room to get a vacuum cleaner. Upon his return, his mom insisted on vacuuming. Faced with a flood of things to do before the kids were dismissed for the day, I yielded. When I heard the roar of the Hoover, I assumed all was well and continued wiping off desks. Then I felt a tap on my shoulder. This parent, a millionaire who had once shared with me aerial photos of her vacation estate on the coast of Maine, had turned on the vacuum cleaner but couldn't figure out how to maneuver it, confused by the need to step on the large orange plastic button in

order to release the machine's arm from its upright position.

Another time the kids were planning to sell lemonade to raise money for a field trip. One of the parents suggested building a lemonade stand. This moment of apparent clarity dissipated as the mom said, "Sure, a lemonade stand is a great idea. I'll have my carpenter build one." She actually said, "my carpenter." Not *my husband the carpenter* or *my uncle the carpenter* or *my neighbor the carpenter*, but *my on-the-payroll, always at my beck and call carpenter*.

That was weird and excessive, but at least it wasn't neglectful. That trifecta—weird, excessive, and neglectful—was reserved for the parents who couldn't get their kids to school on time because doing so conflicted with personal training sessions. When parents brought their kids to school late, they had to sign the tardy list in the main office. A number of people had the audacity to write, "ran late—appointment with personal trainer." There was no shame involved. In their world such behavior made sense.

Odd as these experiences were, they paled compared to my wife's. She is a veterinarian. She worked at an emergency hospital in Westchester and she saw it all because history has given us no relationships stranger than those that exist between the entitled and their pets. One night my wife was in the back room filling out charts when she heard screams coming from the lobby. She burst into the room and saw a panic-stricken woman clutching a cat. Keep in mind this was 4:30 in the morning.

"My cat…my cat…my cat has this, this bump on his chin. It's ghastly! Dear god, help me! What could it be? It's cancer, right? My Napoleon is going to die! My muse! My muse is going to leave me!"

My wife looked at the cat's chin. "It's acne, miss, it's just acne. And it's bothering you much more than it's bothering the cat."

A few months later a guy came in with a field mouse in a shoebox. He found the mouse on his doorstep and though it was comatose, the mouse was still alive. And this guy was going to save the mouse come hell or high water. Given that this was an

emergency hospital, there was a $75 charge to see a doctor. My wife reminded the client of this charge and spoke candidly: The mouse was going to die at any moment.

"How can you be so callous?" the guy yelled, "This is a living, breathing creature! What can you do to save this mouse?"

"We could do X-rays, sir, but that will cost $200."

"Fine."

"And that would also require oxygen therapy, which is $60 an hour."

"This isn't about money, *doctor*!"

The X-rays were done and they were inconclusive.

"So, what's next?"

"Sir, in my professional opinion the animal is going to die momentarily. I don't know of anything we can do to save it."

"You're not even trying, doctor. Do you even care? I'll ask again: what else can be done?"

"We could do blood work."

"Good, let's do that."

"I have to let you know up front that the blood work will be another $110."

Again nothing was revealed and again the guy insisted that they press on. They put the mouse on fluids. That was another $100 and another hour on oxygen. Before another course of action could be considered, the mouse, mercifully, died.

The bill came to $700 and the guy handed over his credit card without reservation. Until the end he ranted about how insensitive and uncaring my wife and her staff were, how he would never come back, and how he would tell all of his friends to avoid this inhumane hospital. In hindsight, my wife figured the mouse probably died from eating poison in the guy's garage.

Typically, my wife has noticed, people subscribe completely to the first advice they hear or read on a given subject. Unfortunately, the first person from whom they hear it is usually a pet store clerk or worse, a breeder. One time a mother and

daughter brought in their emaciated pet rabbit. As my wife conducted the preliminary exam, she asked about the rabbit's diet.

"Cardboard," the mother responded, "the man at the pet store told us to feed him lots of cardboard."

My wife continued her exam. "To keep their digestives systems working properly, rabbits should eat a lot of hay. Does he eat any hay?"

"Oh no, the man told us to avoid grasses."

"How about vegetables? Does he get any vegetables?

"We gave him a carrot last week and he loved it! We were so surprised. Should we do that more often: give him carrots and things?"

Stunned that the rabbit was still alive, my wife said, "Yes, feed him vegetables every day, and hay, too. And cut out the cardboard."

My favorite story involves a couple in their mid-forties. He was a stockbroker, she was a lawyer, and they had a fourteen-year-old German Sheppard whom they loved dearly. The dog had a very advanced case of cancer and had been suffering for months. He was blind, barely able to walk, and no longer about able to control his bowel movements. Clearly, they were keeping the poor pooch alive for their sake more than his. Finally, after much deliberation, the couple decided tomorrow, and tomorrow alone, was the time. They also decided that no one but my wife could perform the procedure. They called my wife's hospital only to learn that she was going to be leaving early the next day. Knowing how much the dog was suffering and how hard the decision was for the owners, my wife agreed to come back to work and meet the couple after the hospital was officially closed.

She arrived at 7:30 and saw a moving van in the parking lot. Then she saw the couple step out of the van. They walked around back, raised the door and revealed the entire contents of their living room—couch, tables, chairs, lamps, rugs, the whole nine—which they insisted on setting up inside the hospital. (Ironically,

they unloaded the van themselves.) Could my wife have come to their actual home? Yes. Could another doctor come to their home? Yes. Could they have come on another day? Yes.

All of these options were available, but that's not the way Westchester works. Those with unlimited means slip into unlimited idiocy because there's always someone else to mail their packages, vacuum their floors, and build their lemonade stands. And when they don't, they're rushing their pets to the hospital in the middle of the night because of zits.

Gumballs or Gravestones

I sat in the backseat of the car, fidgeting with the headrest. Then the ashtray lid. I tried crossing my legs but there wasn't enough room. No matter what I did I couldn't get my mind off the fact that while I was trying to avoid another dating disaster I was, in fact, taking Tom's advice, which was usually the best way to detonate an evening. Tom didn't believe in dating, or didn't practice it anyway—not unless your notions of courtship were defined by well-packed bongs and Pink Floyd bootlegs. Then again none of my roommates dated and they were involved in the plan, too.

I stared up at the corner room of the sixth floor, at what I guessed to be the window of Cindy's dorm room, and wondered what was taking Tom so long. I cinched my tie and brushed the shoulders of my dinner jacket. I took a deep breath, trying not to sweat, hoping that Cindy would be amused by Tom's appearance and Amy, who wasn't really Tom's girlfriend, had received Tom's message about borrowing her car. The headrest caught my eye again. Now it looked too high.

My mind was whirring with the unresolved matter of whether tonight was my second, third, or fourth date with Cindy when she and Tom approached the car. Doc Martens, stockings, skirt, and sweater, all black, all a bit too much for a day so warm.

Tom held the door as she stepped into the backseat. Cindy's hair was still damp and it smelled of something citrusy. She greeted me with a "hey there" and handed me a mix tape. I looked at the j-card inside the cassette case, but the letters evaporated before they took shape as words. I put the tape in my shirt pocket. I may have thanked her.

"Hey, Cindy. An evening of cheaply approximated fine dining, what do you think?" That wasn't the best of the opening lines I had rehearsed, but it came out all right. Handing her a rose helped.

"I feel a little suspicious and underdressed but yeah, that sounds good." Cindy leaned forward and sniffed the flower. She glanced at Tom sitting behind the wheel, decked out in a jacket, bowtie, gloves, and chauffeur's cap, and then looked back at me. "Unless there's a ransom note with my name on it, in which case I'm out."

One good line delivered. A successful date underway. Then I thought about the Lilly Wilkey incident.

I had a crush on Lilly freshman year. She was the exception to the late-eighties rule of moussed up, Mount Everest hair and makeup thick enough to yield fossils. Lilly kept it simple. Jeans, T-shirts. No hair spray or cosmetics. She even looked good when she worked at the dining hall, taking orders at the grill, wearing the pea green uniform and one of those paper caps.

Twice that evening I had gone through Lilly's line. Twice I had ordered a grilled cheese and fries, and twice I failed to get past "Did you study for the history test?" or "Are you sick of George Washington too?" I concealed my frayed nerves and anxiety but not the vomit. When I stepped up to the counter for the third time, Lilly said, "Hi," and turned to place an order with the fry cook. She didn't hear my first cough, the one that masked my attempt to ask her out but didn't prevent me from hacking up a partially digested mass into my left hand. She turned around just as I coughed again. Thankfully there was a sneeze guard. It caught

most of the vomit, except for the dollop that landed on her shirt sleeve. Everyone froze in disbelief—Lilly, the fry cook, the people in line behind me, the people at the beverage stand and the breakfast stand and the salad bar. I felt a third wave preparing to launch and quickly walked away before I could apologize.

Greg, one of my other roommates, tonight's maitre d', had reminded me about that fateful night at the dining hall and suggested that I not eat for several hours before my date with Cindy, just in case.

I caught myself drifting away when I realized it was Tom who responded to Cindy's joke as he started the car, reassuring her that she was not being kidnapped. Or at least I assumed that's what Tom said. The only things I heard were Cindy's laughter and response.

"Good, I was starting to worry about how much ransom money my family could scrounge up."

Tom put the car in gear and made eye contact with me in the rearview mirror. "Pardon me, sir, shall we proceed to the restaurant?"

I was living in the freshman dorms when I met Tom Sheppard. Sitting at my desk with the door open and listening to a Kinks record, I was half-heartedly studying for a philosophy test.

"'Sunny Afternoon' is the best song ever."

Tom stood in the doorway, a stranger, curly-haired and cross-eyed. His flannel shirt was tattered and the knees on his jeans were frayed. He held an open can of beer in one hand and a six-pack container in the other.

"Dude, I'll give you a beer if we listen to that song again." I didn't know that we had listened to the song together the first time but accepted his offer nonetheless. Tom introduced himself and broke into the abridged version, however slightly, of his autobiography. He came to school on a French horn scholarship and gave up music when he decided to pursue a life of "wake and

bake." He'd never smoked dope before college and soon discovered that he was really good at it. He dropped out of school and stayed in town. His dad bought him a house off-campus and Tom lived off whatever rent he managed to collect. To keep busy he delivered pizzas part-time and worked on developing a role-playing game called Castle Clash.

Tom did the talking as "Sunny Afternoon" played in the background. I cued up another Kinks song, "Autumn Almanac," and mentioned the song's French horn solo. Tom's indifference toward the song, and the solo in particular, suggested that he had never heard the instrument. Or that he was really drunk. Either way Tom did notice the book I was studying. "Intro to Philosophy? Professor Peters? I never understood a word she said but I got an A in that class. She gives the same multiple choice test every time. They're impossible if you've never seen them before. That's where I can help. I'll trade you one of her old tests for a copy of 'Summer Afternoon.'"

Professor Peters. Cartoonishly unpleasant. The kind of person who tied innocents to railroad tracks and jammed sticks in the spokes of passing wheelchairs. The first day of her Intro to Philosophy class she emphasized two points: she was a shining star in the constellation of intellectuals and her students were several footlights short of dim bulb status. She reeled off her list of publishing credits and named the conferences she had been invited to. Then she put us, her class, in our place.

"You, and by that I do not mean the singular 'you,' I do in fact mean the collective 'you,' will have great, and here I employ 'great' in its quantitative rather than qualitative connotation, difficulty with my class. It has been my experience that students at this hallowed institution do not read well. Nor do they write well. You can draw your own conclusions as to the development of their cognitive skills. The catalog of course offerings provides a number of easier classes, classes you might very well be able to pass. I suggest you consider them."

Professor Peters assigned difficult readings and gave lectures that favored castigation over clarification. Surprisingly, she gave multiple-choice tests rather than essays or papers. Not so surprisingly she had a distinctive style of multiple choice testing that went along the lines of the following:

1) Freedom, in order to be free, must be an absolute—not one possibility (*potentia*) among many. In breaking with the "intellectualism" of the dominant Wolffian School of pre-Kantian *Metaphysik*, Christian August Crusius developed the concept of moral agency which has come to be known as "free will voluntarism," and according to which:

A) Reason (e.g. "rationalism") must function, determinately and practically, as the grounds, theoretical and practical, of action.
B) The foundation of the moral agent's will, his or her motive and/or intent, must be governed, generated and/or given, in accordance with law is the requisite condition of the possibility of freedom.
C) Moral freedom must be subject to a law external to moral freedom.
D) Any one action in isolation (that is to say, without context or correlation) cannot, as such, be recognized as either good or evil.
E) All of the above.
F) None of the above.
G) All but A
H) All but B
I) All but C
J) All but D
K) A and B.
L) B and C.
M) C and D.
N) A and D.

A couple of days after Tom and I met he dropped off a copy of the exam. I didn't trust that Professor Peters would use the same test. I attempted to comprehend rather than merely memorize the answers. But Tom was right. The questions were exactly the same. I squirmed a little as I flipped through the exam. From the sounds of throats being cleared I could tell I wasn't the only one experiencing the same simultaneous sense of relief and disbelief. I read each question two or three times, keeping my eyes glued to the page, fearful that a knowing look exchanged with a classmate would reveal the secret.

Professor Peters sat behind her desk thumbing through a magazine. I figured I had two choices: use the actual amount of time it would take to circle the correct answers and then leave—which was tempting because the rational part of my mind realized that there was little chance of repercussions—or I could yield to the paranoid portion of my mind and fake it, pretending to puzzle over, if not agonize over, each question before circling the proper response. I chose curtain number two, forcing myself to stay for a half hour. I even got the two questions about Descartes wrong to throw Heir Peters off my trail.

I never made the tape for Tom. He changed his mind about owning a copy of "Sunny Afternoon." Over the course of the following year, he stopped by my room three or four times to hear the song. When the pop-ins stopped I assumed that Tom had finally left town. Two years later he called looking for a housemate. He offered cheap rent. "You have to take a chance, like in Castle Clash," Tom said. "You have to lower the drawbridge to get supplies, you'll starve otherwise—but that makes you vulnerable to attack, maybe the Galicans or the Draxtenmaughs. I promise, dude, I'm neither Galican nor Draxtenmagh." Tom's offer seemed like the best choice at the time.

Cindy and I chose to rendezvous in public on three separate occasions—a movie, a concert, and a dinner—but I didn't know if

one, two, three, or none of these events was really a date. Thinking about it was like taking one of Professor Peters' exams. I felt myself slipping into the "just friends" abyss and I wanted to see Cindy again, try something different, something that was undeniably a date.

A friend from the school's radio station introduced me to Cindy. We met in the dining hall. My friend introduced me as "the guy who plays Anthrax and Erasure back to back." He was referring to my show on the college radio station. Behind Cindy's brown eyes was an encyclopedia of the cool music I wanted to know more about. A native of Boston, she knew the local record labels (she'd internalized the Ace of Hearts and Throbbing Lobster discographies) and she knew the lore firsthand (she was at The Rat the night the guy from The Sewerpipes was hauled off in handcuffs for stabbing a bartender). Cindy and I traded music recommendations throughout lunch and as we brought back our trays, we talked about going record shopping. Over the next few months we ran into each other at parties and joked about our pending plans—flirting about whether it was a "get together" or a "date." I never could tell when Cindy was going to come back into my life.

Eventually I suggested a movie, asking about a specific night rather than the ambiguous "sometime." This almost worked. A high school friend of mine showed up unannounced the night of the date. When I called to cancel, Cindy said we should go to the movie anyway. She said it could add to the confusion of whether we were hanging out or going out. We saw an action movie and went out for ice cream. My friend talked a lot about Monty Python, reenacting various sketches using an accent that wasn't so much British as an awkward combination of Irish and Pakistani. Cindy was polite, but it was pretty clear that she wanted to go home. I had trouble following the conversation because half of my mind was devoted to not staring at her lips and the other half was deciding whose life I should take: my friend's for showing up

or my own for failing to leave his Celtic/Pakistani Python-quoting ass back at my apartment.

A few weeks later I bought tickets to an upcoming Robyn Hitchcock show. I wanted to make up for the movie. It was an acoustic set, plenty of potential for conversational asides. Cindy already had tickets so we decided to meet up at the club. During the opening band we hung out with our respective friends and waved to each other across the crowd. I wanted to show that I was confident, comfortable with the distance between us.

Cindy was still several feet away talking with a friend when the opening band announced that they had one more song. I pointed to my cup of beer to ask if she wanted another. I stood behind her during the rest of the show, kind of following the music, kind of following the way her neck gracefully sloped into her shoulders. My whole body tingled whenever she leaned close to tell me which albums the obscure songs came from.

Walking across the parking lot after the show she said we should get together again. About a month later we attempted a dinner date. It became a diner date when the restaurant lost our reservation. It was snowing that night and the diner on State Street was a quick walk. I suggested that we leave the car. Cindy took my hand and we walked in silence watching the snowfall through the light of the street lamps. Over burgers and shakes we talked about our families—her dad owned a company that rented grocery carts to stores on Long Island—and plans for the summer. My crush bloomed but I couldn't figure out how she felt. That's where Tom entered the picture.

Cindy rang the bell on the dining room table just as my roommate Greg, serving as our maitre d', returned with drinks and a basket of bread. The scent of tomato sauce and garlic was making us hungry. I thought I could smell Nick's new bread maker at work, too.

When we pulled into the driveway Greg was standing in the

doorway. He stood with his hands clasped behind his back, striking the classic pose of a dignified servant. His suit was pressed and he was sniffling, as always. There was no expression on his face—though he had trimmed his beard for the first time in months—even as he held the door for Tom who dashed ahead of us. I told Cindy that Tom was going to help in the kitchen but he was really trying to reach Amy, who wasn't really his girlfriend, to tell her where her car was.

Greg, like a method actor buried deep in his role, was stoic, saying little more than "Right this way" and "Your waiter will be with you shortly." After leading us to the dining room, Greg pulled out a chair for Cindy, making sure that she got the one that didn't wobble. He handed us menus and took our drink orders. Then he offered to put Cindy's rose in a vase.

I was surprised that Greg had agreed to help. If Greg ever thought about girls, or guys for that matter, he kept such thinking to himself. He stayed in his room, maintaining a monk-like ambivalence toward sexual attraction. Even after living with him for months the start of each conversation was like getting reacquainted, like cautiously walking along a dimly lit path, waiting for your eyes to adjust to the dark before resuming your normal pace. Greg relished the role of the reclusive genius. He was a business major who talked about economies of scale and John Kenneth Galbraith like most people talked about the weather. He was button-ups and khakis, didn't own denim, wore ties by choice. His ideal Friday night was an hour of laps in the campus pool followed by a pint of Rocky Road and a movie. Once in awhile, though, when the stress of exams got to him, we would find him sitting in the living room chewing his toenails and watching Judge Wopner preside over low-stakes drama on *The People's Court.* That's why we kept Greg's role simple: greet, seat, and bring the menus.

Cindy sipped her beer. I unfolded my napkin and placed it on my lap. The silence was just becoming uncomfortable when Cindy was distracted by something behind me. I looked over my

shoulder. I had forgotten about Lloyd. The question of what to talk about was answered. Lloyd sat on the shelf, bald, arm-less, and leg-less, his head permanently twisted hard to the left.

"That's weird," she said, pointing toward Lloyd.

"Cindy, meet Lloyd, our house mannequin. Lloyd, Cindy. Cindy, Lloyd." I stood and put my arm around the plastic shoulders. "Lloyd came with the house. He's an excellent housemate. Doesn't talk much *and* he always lets you have the remote."

"I guess you never drink alone with him around."

"Doesn't use up the hot water either." I felt at ease. I also felt the urge to launch into a series of Lloyd anecdotes, but very few dates are improved by the rendering of multiple mannequin stories.

That's when Nick, my third roommate and the evening's waiter/chef, entered with salads, his limp barely noticeable. He wiped his hands on his apron—"Kiss Me I'm Italian"—and introduced himself to Cindy.

"Tom and Greg are pretty much the way I pictured them, especially Greg," Cindy said. "He does look like a deep woods separatist. You didn't tell me that Nick was off crutches, though."

Technically, Nick was still on the football team, even though he hadn't played the previous fall. He wasn't on scholarship but he did have one more year of eligibility. He had been sidelined by a knee injury last spring and found God over the summer. He was trying to live a celibate lifestyle but he couldn't resist the attention he received when he went to The Bomb Zone, the local jock bar, wearing his team jacket. That's where he met the girls he studied with. He denied having dates, claiming instead that he had study sessions. That they were always one-on-one study sessions which inevitably turned into prolonged back massages and rounds of grab ass was, he claimed, unplanned.

He was conflicted, part of him ready for family life, part of

him wanting to play out his days as a swinging single. He was trying to deal with his urges fully clothed. Most of the time anyway. When there were no girls in the house he walked around in his boxers playing "Since You Been Gone," the one song he knew, on guitar. He and Tom argued whether it was a Rainbow song or a Deep Purple song, neither caring enough to look it up. Nick also wrote poetry. Since last summer he had nearly filled a notebook with verse. All of the ones he let me read involved someone resisting temptation, choosing not to eat an apple or a peach or, in my favorite, a coconut.

Nick returned with salad dressing. He tapped the upper left of his apron and nodded toward me, cueing me to check my shirt pocket. I had forgotten about Cindy's mix tape.

"I nearly forgot about dinner music. Thanks for the mix tape, by the way. Tonight you've brought…" I paused to read the song titles to myself before reading them aloud. "Overmaster's *Dim the Lights and Gash the Limbs* demo. Subtle. And some Infected Urge. I hope this is their old stuff. They've become so commercial." I looked up at Cindy. She wasn't trying to expand my horizons so much as redefine them. "This is really heavy stuff. Did we arrange a suicide pact?"

Cindy touched my arm when she laughed. "You're not supposed to take the lyrics seriously. They're just for shock. Besides, you can't even understand them. Just listen to the music. You said you were looking for good local bands for your show."

I put down the tape and speared some salad with my fork. Without realizing it I must have grimaced because Nick gave me an intense, raised-eyebrow, "We've talked about this" look. I was lucky to have one of my Cyranos in the kitchen with me. Nick was cueing me not to make "the face." The previous Sunday, during our weekly house dinner, Tom went over everyone's roles for tonight. Nick pointed out that I cringe whenever eating foods I dislike or anticipated disliking. "Don't make that face when you're with Cindy. You look like you're cleaning out a barn."

I said I would pass on the salad.

Nick stood his ground. "Of course you'll eat the salad. This is your home. You can't pass on foods in your own home. If she thinks you're quirky that's ok, but you can't have her thinking you're freakish. Lettuce is eighty five percent water. You can stomach water. Not eating salad is freakish."

"Nick's right," Tom said. "You and Cindy will be eating together, dining, sharing sustenance. It's an act of communion, not a holy communion but, like, a romantic communion. You have to trust things. Say yes to whatever is served. Unless you're playing Castle Clash and you get a dinner invitation from the Ballyfaustens, who will probably behead you and put your head on a spike in the town square."

Like Greg, Nick was not the kind of guy I expected to help out. But when the idea of the dinner date first surfaced, everyone pitched in. It was from living with those three guys that I realized that having similar tastes and beliefs—music, politics, courtship, etc.—wasn't as important as having compatible personalities. I thought about how central casting would describe the people in our house—the born again football player who refused sex; the stoner who refused commitment; the repressed numbers cruncher who suppressed feelings; and the geek intimidated by sex, commitment, and feelings. I pictured a short-lived summer replacement that ABC used to fill in for *Three's Company* in the summer of '78 but was cancelled after three weeks for lacking Jack, Chrissy, and Janet's gritty realism.

After dinner Cindy and I brought snacks and drinks into the living room. I turned on the radio. She spotted the video games and put in Frogger. Lloyd was still making her feel uncomfortable so I put the mannequin in the hall closet. Cindy patted the carpet, inviting me to join her. We sat on the floor, a bowl of chips and the game console between us. The date was going well. Then we heard the front door slam.

"Where is he? Where the hell is Tom?" It was Amy, Tom's not-really girlfriend. She stomped through the living room. She didn't wait for us to respond. "I see my car outside. I need my keys. I need to get to work. Where is he?"

Amy stormed down the hallway. Tom's bedroom door slammed shut. We heard muffled voices arguing.

Cindy and I exchanged shrugs. Mine was disingenuous; I knew Amy was there because we hadn't asked to take her car. Tom said she wouldn't mind. Before starting another game Cindy took a pack of gum out of her purse and offered me a piece. Things were going well enough to overcome the fight being staged down the hall.

"When I was a kid I thought that the world was going to turn into a giant gumball." She leaned to the left as she moved her frog across the screen. Her tongue stuck out the side of her mouth whenever she thought she was about to get hit by a truck or fall off a log. We could hear the shower running and Tom and Amy's voices coming from the bathroom. The argument was over.

"My mom told me that I shouldn't swallow gum because my stomach couldn't break it down, couldn't digest it, and that freaked me out. I had nightmares about my stomach filling up with wads and wads of chewed up gum, all those different colors mixed up. I thought of the gum that I'd see on sidewalks or on the road. The colors fade but the gum never goes away, not completely. I pictured skeletons lying in coffins, wads of gum where their stomachs used to be. Then after thousands of years there wouldn't be anything left on earth except for clumps of gum."

Cindy moved the final frog onto its lily pad and moved to the next level. Her best game yet. She raised her hand for a high five. I obliged. Then Greg came into the room. He had loosened his tie and taken off his jacket. He slumped onto the couch and took off his shoes, missing all signs that he was the third wheel on a date built for two. I feared that his toenails would appear next.

"We're just playing video games, Greg," I said.

"I don't mind watching."

Cindy nodded and resumed her game as well as her story.

"And gravestones. My grandmother lived in Queens. Have you ever looked at a map of Queens? The only green parts are the cemeteries. There are like no parks in Queens, just graveyards. Some parts of Long Island are the same way. Eventually, I thought when I was a kid, it was all going to be one or the other, gumballs or gravestones."

Greg took the hint and left.

Cindy sang along with the radio as she reset the game. She pushed her hair behind her ear and reminded me that it was my turn. My heart felt like a box of crayons on a summer dashboard.

Amy came rushing down the hallway. Her hair was wet. "I'm going to be late for work, Tom. Don't ever take my car again." The comment seemed to be more for our benefit than Tom's.

Cindy could tell I was stuck for words.

"I have to be honest. I noticed all of that stuff with Tom and that girl, I'm not like Rain Man oblivious," she said, "but maybe some other time you can tell me what just happened."

Tom's idea of what to do when hanging out with a girl was very specific: get high and listen to *The Wall*, a bootleg of the movie soundtrack with Bob Geldof singing. This was followed by smoking cigars and, at some point during side three or four of the album, some rather intense sex in the shower. Fortunately for Tom, Amy agreed on how to spend an evening.

Like a lot of people in their early twenties, Tom thought he had it all figured out: he was the realist and I was the romantic.

"You're a senior in college. You'll be moving away in a few months," Tom said during one of our front porch conversations. "You don't even know if Cindy's staying in town this summer. Why would you want to start a relationship when you're moving soon? It's like marrying someone just before they're sent to jail.

The best you can hope for is the conjugal visit of the outside world: the long-distance relationship." He stumbled into the washtub of empty cans when he got up to flip the tape in the boombox we always left outside. "You're just getting started, why tie yourself down? We both want the same thing. Only you have to know what Cindy thinks about you. I don't know how I feel about Amy. I don't know how she really feels about me. We're just having a good time while we can."

I lived with Tom for a year and never saw him and Amy in public together. He would visit her and she would visit him but they were never in transit in tandem. But there was a romantic in Tom, a part of him that felt affection for Amy. Her, too. That's why he felt it was ok to borrow her car for the night.

"Would you do that for a date, bring her over here and have us act like the apartment is a restaurant?" I asked when he first mentioned the idea.

"I think this restaurant idea is excellent but it's not what I would do. I would ask her is she's into stogies and shower sex."

After the video games Cindy and I watched a little television. At the end of the night, I decided not to take Amy's car. I settled for my own, which was small and messy and French and took forever to accelerate, but it was comfortable and I just wanted to set my mind to autopilot and enjoy the short bit of the date that remained.

My heart was beating like a double kick drum by the time we pulled up in front of Cindy's dorm. I didn't know whether to thank her, kiss her, or ask if I could see her again. All the options seemed equal. Cindy chose. She leaned over, kissed me on the cheek, and said thanks for a fun night. The melted crayon feeling returned.

Cindy got out of the car and I watched her walk into the building. I waited for her light to come on. She looked down and waved, then stepped away from the window. There may have been

a thousand other things happening around me but I didn't notice. I reached into my shirt pocket and took out Cindy's mix tape again. This time I opened the case and looked inside. There was a note from Cindy, "Looking forward to this summer!" Tom had it wrong. I wasn't ready for the moment to end so I sat there, staring at the dashboard, the car running, my cheek glowing. I put the car in gear, rolled down the window, let in the sweet spring air, and drove home.

Half Armadillo, Half Sherman Tank

I trusted Leon in a lot ways, but I didn't follow his radical changes in music. I doubted what he had said about folk back in tenth grade and then, senior year, when he got into punk rock, I doubted him again. I had never heard punk, but I dismissed it anyway. I had good reason to hate punk rock. Since ditching Top 40 radio in junior high, I had listened to both kinds of good music: arena rock and progressive rock. Some people will tell you the styles are inseparable. They will cite bands like Kansas and Styx. Never trust anyone who cites Kansas or Styx as an exemplar. Aside from a couple of surface similarities—both camps believed in the intrinsic value of bass solos and gatefold double album sets—arena rock and prog rock weren't different types of music so much as competing philosophies that formed a two-party system with a shared message: rock music was a spectator sport.

Arena rock bands made it clear that I wasn't cool enough to join their ranks. They wrote mindless odes to having a good time relentlessly pandering to the lowest common denominator. Take .38 Special and their 1982 album *Special Forces*, which featured "Breakin' Loose," "Take 'Em Out," and "Rough-Housin'." Either they were trying to save on their typesetting bill or they wanted to show us that they were bad boys 'cause they used bad spellin'. I

doubt, when it came to tallying merchandise sales and gate receipts, that the band's 'rithmatic skills were equally sloppy.

Droppin' all of those "g"s from their verbs was one thing, but how best to accommodate the fan unable to read? Cowbells. Copious amounts of cowbells, clonking out the quarter notes, insuring that anyone, regardless of literacy or sobriety, could find the beat. The rock gods treated their fans like cattle, herding the masses together to boogie down. (That is before "boogie down" developed a disco connotation at which point the industry officially altered the jargon to "rockin' out.")

Arena rock bands loved flashing bravado, or at least that a strange strand of seventies style bravado—pasty, scrawny guys wearing oversized hockey jerseys or leather vests with bouquets of chest hair creeping out, slinging guitars with two, three, or six necks. They put their lifestyle on display, reminding fans that the life of an arena rocker was far removed from ours, anything but pedestrian. Like when Eric Clapton used the inner sleeve of his *Slowhand* album to parade his collection of sports cars. Mildly decadent lyrics about getting high and getting laid were also part and parcel of the lifestyle. Not you, the listener, having sex—there was nothing participatory about the arena rock experience—but the guys in the band scoring with the ladies, typically referred to as "mamas." You were in your parent's basement, alone or with your equally hard up buddies. As a fan your job was to root for the guys in Led Zeppelin or Foghat to get laid.

There was no harm in escapism. I had a lot of good times listening to my arena rock records until I started paying attention to them. That's when the confusion set in. I understood, for example, that Grand Funk Railroad were kidding when they sang "We're an American Band," but why did they feel compelled to pose nude for the album cover? And Journey, were they auditioning for *National Lampoon* when they wrote the song "Hustler":

I get beside women all men desire
Crazy with passion I'll never be tired
Money's no good to me 'cause lovin's my game
I don't need no trouble and I'll show you no pain
I move like a lover, so silent and swift
Screamin' women love me, just can't resist
I can't be bought, your payoff's no good
So lock up your women, like you know you should

I think .38 Special spoke for many in the field of arena rock when they sang "*I ain't no messiah/But I'm close enough for rock'n'roll*" ("Rockin' Into the Night").

It was the first Boston album that confirmed my suspicions that arena bands believed too much of their hype. I think Boston wanted to save us. They told us in songs like "Feelin' Satisfied" ("*Nothin's gonna help you more than rock'n'roll*") and they showed us on their record covers, which laid out the game plan for Boston's cult-like mission. Boston's first album cover depicted the band escaping from an exploding planet, presumably ours, flying across the universe in the Starcruiser Boston. *Earth's too small for us, too confining; Our rock'n'roll necessitates the infinite expanse of outer space—we gotta break free.* Their second album showed the Starcruiser Boston preparing to land in the valley of a new world, searchlights blazing, scanning the surface for squares who might impede on the band's pursuit of a good time. This imagined intergalactic outpost would be a place where the band and a select few—hot mammas, dope dealers, maybe a sound guy or two—could safely rock out, Pilgrims for the modern age, without the mess of persecution or hardships or convictions. As a fan, all I could do was hope to be among those who ascended into the heavens with Boston before earth met its demise.

Progressive rock bands agreed that rock music was a spectator sport, but they varied the message: you lack the talent to do what we do. They took listeners back in time with mystical

lyrics about knights and damsels. Clad in flowing robes, they replaced riffs with interludes and played in the most unconventional time signatures possible. Prog rockers didn't play instruments so much as operate them, twiddling and modulating and monitoring. They resembled NASA technicians as they launched the most cumbersome compositions, eight-minute songs mere preludes to suites that consumed entire album sides and were broken into movements noted with Roman numerals—the song listings reminded me of outlines for high school history papers. Prog rockers were to be taken seriously and I loved them for it, the more complicated their songs the better .

No more grounded than their arena rock brethren, prog rock bands were stranger. They too enjoyed getting wasted and getting laid, but I assumed that there was at least one guy in the band who would stay up late at night studying *The Tibetan Book of the Dead* or setting *Beowulf* to 7/4 time. This was the same guy, usually the lead singer or the flutist, who failed to realize that it wasn't his recitation of Hobbit history that turned on the groupies. *Gather round, ladies, for I've a tale to tell, a tale from the Red Book, a tale of Bandobras Took, son of Isengrim the Second, a mere four feet, five, and yet able to ride a horse!*

Prog rock bands wanted to enlighten audiences with long-winded concept albums. A noble goal perhaps, but their tales were impenetrable. Recognizing that most of their fans were mere mortals, prog rockers offered their version of Cliff's Notes, attempting to provide clarity. Genesis offered a novella expounding upon the intricacies of *The Lamb Lies Down on Broadway*. Yes used their liner notes to connect the dots between their exploration of Shastric scripture and the legendary *Tales from Topographic Oceans*, one movement broken into four parts and spread across four sides of vinyl, including this pithy nugget of a lyric from "The Revealing Science of God":

Dawn of light between a silence and sold sources
Chased amid fusions of wonder in moments hardly seen forgotten

Coloured in pastures of chance dancing leaves cast spells of challenge
Amused but real in thought, we fled from the sea whole.

(Which sounds more like William Shatner every time I read it.) Was this really progress from the days of *"Maybellene, why can't you be true"* or merely a clumsy regression to Gregorian chant? The most perplexing of the concept albums was Emerson, Lake and Palmer's *Tarkus*. True to their prog rock nature, ELP included a set of illustrations to guide listeners through the labyrinth-like tale of *Tarkus*.

The first panel shows a volcanic eruption spewing forth an enormous egg, which cracks and yields the title character who is half armadillo and half Sherman tank. Tarkus roams alone. He approaches a pod city whose citizens send forth a probe. Does the probe come in peace? Does it seek conflict? Tarkus destroys the pod before its intentions are revealed, standing over its smoldering remains, both gun barrels smoking. Then a mecha-pterodactyl, half dinosaur, half B-52 bomber, descends from the clouds. Is he friend? Is he foe? It's irrelevant because Tarkus' anger issues surface again and the mecha-pterodactyl is soon dead, followed by the next causality, a submarine with long grasshopper-like legs. The final foe is the dreaded manticore, a lion with the face of a gorilla and a metallic scorpion tail. Manticore cuts Tarkus' eye and though the winner is unclear, the battle with Manticore takes its toll on Tarkus. As the illustrations come to a close we see Tarkus standing in the surf, the waves gently lapping at his treads. His guns have cooled and he gazes to the horizon, lost in thought.

That explains, or at least accounts for, most of the songs on side one, which ends with an instrumental called *"Aqua*tarkus." After all he has endured, Tarkus, the ultimate terrestrial killing machine/animal moves into the marine world for further mayhem. Having conquered land and sea, could flight be next? Was Interstellar Tarkus to follow? And what did Tarkus seek? Truth? Destruction? A warm embrace to fend off the nagging notion that

we spin randomly in a godless universe? Did he choose to kill or was he programmed that way? Did Tarkus represent mankind?

As with arena rock, prog rock ultimately was an empty experience that left me with questions I didn't want to consider. I could not relate to pre-historic armadillo tanks any more than I could imagine escaping via the Starcruiser Boston. It was time to borrow some records from Leon.

The Revenge of Crothamel's Mules

Tom Crothamel brought a gun on our Boy Scout trip to Highland Forest. It was his grandfather's army pistol, and almost everybody in our troop knew Tom had it, except me and Pete "Cyclo" Willis and maybe our scoutmaster, Mr. Ryan. Crothamel didn't bring the gun for target practice or to earn a merit badge. He brought the gun because he was unstable and my suburban scout troop, chomping at the bit to see a real gun, a hint of danger, even if it wasn't fired, was dying to see Crothamel's latest stunt. Most people think of Boy Scouts helping old ladies across the street or eating sprigs of chickweed to survive in the woods. Troop 320 was different.

I joined Boy Scouts so I could hang out with my friend Josh. He was the funniest guy I knew. He was always quoting Woody Allen movies and episodes of *Police Squad*. He was in eighth grade, a year older than me, and tall for his age. He had a perpetual grin and he loved telling bad jokes, especially if you didn't get the joke or didn't want to hear it. A lot of people thought he was a wise ass. That's definitely the first impression he made on Crothamel. They were playing three-on-three basketball behind the church, just before a scout meeting, when Crothamel drove to the hoop and missed a layup.

"Foul! Give me the ball," he said to Josh, holding up his

hands anticipating a pass.

"No blood, no foul. Let's just keep playing," Josh responded, smiling and dribbling to the top of the key. "Besides you didn't need my help. You dropped that brick all by yourself."

Josh's attempt at a joke annoyed Crothamel. "Your feet weren't in position. I've got two shots coming. Give me the damn ball!"

The other guys got quiet and backed away. They weren't used to seeing Crothamel challenged. He stormed toward Josh.

Josh tried to contain his laughter. "Relax, Kareem. The NBA scouts are running late. Besides, it's just…" He was cut off when Crothamel shoved him. He didn't realize how serious Crothamel was until he was standing nose-to-nose and yelling for the ball.

"Easy, Dr. J., here you go," Josh said, taking a step back, flipping the ball to Crothamel.

Crothamel pushed Josh, making him stumble backwards underneath the basket. The other guys looked around, making sure the scoutmaster was out of sight. Crothamel kept coming.

"All right, all right, lay off," Josh said. Crothamel ignored him, backing Josh against the fence, the ball still between Crothamel's forearm and hip. Josh could have counted each bead of sweat on his nook and cranny face. Instinctively, he slipped his leg behind Crothamel's and pushed. Crothamel went sprawling to the blacktop. No one touched the ball as it popped loose and bounced to midcourt. Josh laughed, surprised to see the old playground trick actually work. He offered to help Crothamel get up.

Crothamel slapped away Josh's hand, sprang to his feet, and punched him in the stomach. Josh doubled over. Crothamel's second punch sent him to the pavement. He stood over Josh, who was curled up on the ground, fighting back tears, and kicked him. "No one screws with me!"

Quickly and painfully Josh learned that Crothamel had a relaxed regard for the Scout law—the helpful, friendly, courteous,

kind, and cheerful parts, anyway.

"Wanna hear a joke?" Josh asked.

No one in the van responded.

Josh continued, unfazed. "What do you call a guy with no arms and no legs in a pile of leaves?"

Cyclo looked at me and I returned the favor.

"Russell," Josh said, eager to give us the punchline. "Get it?"

As Cyclo and I thought about the joke, a hand reached from the far back seat and slapped Josh upside the head.

"That's stupid, Ratner. You're such a moron." The hand, like the comments, belonged to Tom Crothamel, resident thug-in-training. Despite the fight over a year ago, Josh couldn't resist provoking Crothamel. Cyclo and I used to argue whether this made Josh foolish or fearless. I thought Josh had a lot of guts because he'd knew how far he could go without getting beat up again. Cyclo said Josh got beat up once and that proved his point.

"Move out of my way or I'm going to kick your ass again, I gotta use the bathroom." In Crothamel's world, anything—an insult, a slap—equaled an ass kicking.

Crothamel and two of his cronies climbed out of the van behind us. Crothamel glimpsed through the gas station's plate glass window and confirmed that Mr. Ryan, our scoutmaster, was occupied, talking to the attendant, before shoving Cyclo.

"Give me your bag, *Psycho*," Crothamel demanded. "How many times do I have to kick your ass, you freckle-faced freak?"

Cyclo's real name was Pete. As anxious as he was brilliant, we used to call him Encyclo-Pete, like Encyclopedia Brown, because he remembered everything he read: origin stories of obscure superheroes, the prices for cheap mailorder novelty items, the nutritional information on the sides of cereal boxes. But now it was just Cyclo, at least to his friends. I'd known him long before Boy Scouts. He was the first kid in our kindergarten class to read, not just identify letters, but really read. My dad said that Cyclo's

parents pushed him too hard, which is why he did so well in school and probably why he was so anxious. Sometimes he'd have verbal panic attacks, talking out loud and worrying himself into a frenzy, repeatedly running his hands through his feathered, bright red hair. When we took the bus to school he didn't like to sit in the front seat because he had once read that Stevie Wonder lost his sense of taste when a log slid off a truck and through the window of the car he was riding in. In fourth grade Cyclo tried to avoid going outside for recess because he'd been reading about sinkholes and he was convinced that the bedrock beneath our school's playground would give way without warning. Cyclo's parents wanted him in Boy Scouts so he'd be "more rough and tumble" like his older brothers.

"Hurry up, *Psycho*, or I'll pull those Spiderman Underoos over your head!"

"I don't wear Underoos anymore," Cyclo said, handing over his navy blue backpack. Crothamel reached in and took out a pack of Marlboros. Then he and his buddies walked around the back of the gas station.

"So you got cigarette duty," I said. "Maybe Crothamel likes you. I got fireworks, which is better than last time. I thought that bottle of whiskey was going to break in my bag. My dad would have killed me. I don't even know why Crothamel brings fireworks, though. All he ever does is show them off. He never uses them."

When it came to packing for a camping trip, Tom Crothamel didn't restrict himself to standard issue equipment like flashlights, canteens, or mess kits. And until last fall he'd had no problem smuggling an array of cigarettes, booze, pot, and fireworks on our overnight trips. Then at a Regional Scout Jamboree, Crothamel got busted getting high with a bunch of scouts from Binghamton. Mr. Ryan generally looked the other way when it came to vices that he enjoyed—like smoking and drinking—but not drugs, and Crothamel's dad agreed with Mr. Ryan. Mr. Crothamel, a cop, gave his son a genuine ass kicking and let him stay in the troop on the

condition that he and Mr. Ryan checked Crothamel's bags before every trip. Crothamel's solution was to recruit other kids to transport his contrabands.

That's where Josh, Cyclo, and I came in. We weren't comfortable playing the part of Crothamel's couriers, especially since we caught part of *Midnight Express* one night on cable, but we were growing accustomed to our roles. We knew our place in the 320 tribe, which broke down into three types of kids: the fascists, the burnouts, and the losers. The fascists kept their hair cropped short and snapped to attention at the start of the weekly meetings, passionately rendering the oath each time. They knew the Scout handbook inside and out and viewed Boy Scouts as a calling, the beginning of a life serving their country, which they understood to mean "pick on people you dislike." The fascists sought conflict. They loved reminding each other that if the U.S. military fell in the face of foreign invasion, the Boy Scouts were the next line of national defense. They found it easy to look past their goofy neckerchiefs and see themselves as tomorrow's Green Berets. And for reasons they never made clear, they also hated Irish Catholics.

I remember when Crothamel approached me at my first troop meeting, in the basement of St. Charles church. I was one of the new kids and Mr. Ryan had just introduced me before going into the back room to get some paper work.

"Faloon, huh? Sounds okay. Are you R.C. or I.C.?" Crothamel asked, neglecting to introduce himself. He was flanked by two lackeys, Keith Gorman and Bobby Cebeaniac.

Crothamel, ever the astute social scientist, could tell that an answer to his question was not forthcoming. He took a step closer and kindly repeated himself, careful, in the tradition of all great shitheads, to phrase the question in the exact same way, only louder and slower, before tagging on an insult.

"Are you R.C. or I.C.?" he said again. "Answer me!" He

pushed his glasses up the bridge of his nose before adding, "What're you, gay?"

I was transfixed by his enormous glasses, the lenses like a pair of transparent moons and clearly meant for a much larger face. "What's R.C.?" I asked. "Like the soda?"

"*Roman* Catholic or *Irish* Catholic!? What're you stupid, too?" Crothamel's retainer caused him to spray just a bit.

Gorman and Cebeaniac further illuminated their leader's line of inquiry.

Gorman: "What're you, stupid?"

Cebeaniac: "Yeah, fag."

"Well, we used to go to St. Ann's, so I guess we're Catholic." I was nervous, filling the air with words. "I was an altar boy. It was all right when Father Pedzick did the masses—he had a good sense of humor—but I never did like Father Richards. He was always so serious, mean, almost."

Crothamel glared at me, awaiting confirmation that I stood with him or against him in the non-existent battle between Roman Catholics and Irish Catholics, which was like asking someone if they were British or English. I continued before he could say anything.

"I remember this one time, I'd been kneeling—you know the part just before communion—and when I stood up my robe got caught on the backs of my shoes and I almost fell backward. Father Richards got mad at me after mass, really mad. He said I should be more careful."

I was staring at the Life Scout patch stitched on Crothamel's uniform pocket, an inviting sunset orange heart in a sea of stop sign red. I hadn't thought about Father Richards for a long time and I could have gone on all day about him and how my family didn't go to church anymore and when we did my brothers and I fought most of the time, which was really embarrassing, but that wasn't what Crothamel was looking for.

"Shut up, Jesus, shut up," Crothamel said, jabbing his finger into my chest. "We're all Roman Catholic; 320's an R.C. troop, so just be careful, pagan!"

Adhering to cliché, Gorman and Cebeaniak echoed their master's words.

Gorman: "Yeah, we're R.C."

Cebeaniak: "So be careful."

Pagan? What did that mean? Somewhere along the line a little bit of knowledge had done a lot of damage to this kid.

The burnouts, on the other hand, grew their hair as long as their parents would allow and mumbled their way through the oath. They sought escape and viewed Boy Scouts as a chance to get away from home. They were older and they smoked and got drunk and got high, and they listened to rock music. 94-Rock, to be exact, *Syracuse's home for classic rock*. I wasn't even into Top 40 yet. I owned two albums, *The Electric Company* version of Spiderman and K-Tel's *Dumb Ditties*. Rock music frightened me. Everything I knew about it came from rumors and T-shirts, which meant, in my case, that everything I knew about rock music revolved around Ozzy Osbourne, who, according to reputable lunchroom sources, was fond of biting the heads of live bats and appeared on concert T-shirts clutching a cross, crawling past skulls, the blood of innocents dripping from his mouth. I'd only heard one Ozzy song, but I assumed he was a lunatic. All rock stars were lunatics.

Concert T-shirts were a key component of the burnout uniform. They helped present a tough façade, so people would leave them alone in school or at the mall. The effect worked on me, but the burnouts must have looked ridiculous to anyone familiar with music. For every Ozzy or cocaine T-shirt they won at the state fair—the one where "cocaine" is spelled out in the Coca Cola cursive—there were three or four Billy Squier or Foreigner T-shirts.

I was intimidated by the burnouts because they didn't seem to care about anything and there was always the chance that they

would drag me into their debauchery. I scared myself with invented scenarios that were embarrassingly removed from reality. There I am, kneeling beside a quiet brook, filling my canteen, happily humming "The Monster Mash." *Dum, dum...* I hear an ominous bass riff winding through the trees followed by an evil cackle. I turn to see Crothamel walking toward me. *Dum, dum...* There it is again, "Crazy Train" blasting from the boom box perched atop the shoulder of one crony while the other carries a tacklebox filled with drug paraphernalia. Their mission is simple: haul me deep into the woods and turn me into a dope fiend, forcing me to drink PCP—or smoke PCP or inject PCP, or do whatever it was you were supposed to do with PCP, that part of the nightmare was vague. Then it was a cat blood chaser and time to decapitate a canary. The next day I wake up with a pounding headache and my bicep aching because of the thorny red rose tattooed just above my elbow.

Crothamel linked the two factions. The fascists didn't smoke or drink with Crothamel, but they liked his willingness to kick ass and his support of the R.C. cause. The burnouts didn't understand why Crothamel bothered with oaths and badges, but they shared recreational interests.

The third group—Josh, Cyclo, and me—was known as the losers. Isolated by age and a desire to quit we sensed that staying in troop 320 left us bound for one group or the other. Or, like Tom Crothamel, both.

Cyclo knelt on the packed snow that covered the parking lot, poking through his backpack. "Why do you have to tell those lame jokes, Josh, especially in front of Crothamel and them. You know they're going to bother us."

"They're going to pick on us anyway. We might as well have some fun," Josh responded, his familiar smile returning.

"Crap, he did it again." Exasperated, Cyclo pulled a crumpled comic book from his bag, "He ruined the new Fantastic Four."

As Cyclo surveyed the damage, Mr. Ryan walked up to the van rubbing his bald head. He clapped his hands once before unleashing his megaphone voice, deep and raspy from years of filterless cigarettes. "Okay, guys, everybody in. I hope you all went to the bathroom. Just a half hour till we get to Highland Forest."

The rest of the trip was quiet. Mr. Ryan tuned into a college basketball game on the radio. Cyclo fumed and tried to read. I stared out the window and kept wiggling my toes to keep them from going numb.

About a half mile past the entrance to the campgrounds we came to our lodge. It was long and narrow and surrounded on three sides by pine trees. Crunching through the snow, we carried our gear inside.

"It's pretty late, boys, and we've got a big day tomorrow." Mr. Ryan's voice boomed through the lodge as he began setting down an armload of firewood. Mr. Ryan looked pale and frail. His hands sometimes shook when he wasn't holding something, but he had boundless energy despite always being the last one asleep and the first one up. "Choose a bunk and unpack. Lights out in a half hour."

The fireplace was at one end of the lodge with a kitchen off to one side and a bathroom on the other. Mr. Ryan took the bunk closest to the kitchen. Most of the fascists settled near Mr. Ryan while the burnouts went to the opposite end. Josh, Cyclo, and I were stuck in the middle.

Crothamel and company paid us a courtesy call, scout toothbrushes and collapsible drinking cups in hand, as they walked back from the bathroom to their bunks.

"Hey, gaywads, just came to tuck you in," Crothamel said, "and see where your bags are. We might need to borrow something tonight."

Gorman watched for Mr. Ryan. Cebeaniak looked the other way.

Already in bed, and unable to take advantage of Crothamel's

tuck in offer, I rolled over and pointed under my bunk. "My bag's right here."

Cyclo, in the bunk across from mine, pointed to his bag.

Then Josh, on the bunk above Cyclo, chimed in.

"I doubt I have anything you'd want, I forgot both of my dildos, but my bag's next to Cyclo's."

Josh quickly pulled up his blanket as Crothamel smacked at his head, delivering the requisite good night ass kicking.

Soon the only light came from the fading fire and the only sounds came from Mr. Ryan's footsteps as he walked the length of the lodge, pausing periodically to make sure everyone was accounted for. I was asleep shortly after Mr. Ryan began snoring, but I stirred several times during the night as I heard Crothamel rummaging through our bags.

There was a square of sunlight on my blanket when I woke up. I could hear a bunch of guys eating breakfast and planning their activities for the day. I put on my glasses and saw Mr. Ryan check his watch, a sign that he would soon rouse the rest of us.

"Morning," Cyclo groaned, his arm elbow-deep in his bag. "They still have about half a pack for tonight," he said, referring to Crothamel's cigarettes.

"Morning, Cyclo," I replied. "Yeah, I heard Crothamel and them a lot last night. Didn't he say he was going to bring his grandfather's gun this time?"

"He's so full of it," said Cyclo, sitting up as he finished an issue of the Flash.

We dressed and joined Josh for breakfast.

"Morning, boys," Mr. Ryan said between sips of coffee, both hands wrapped around the mug, his voice too loud for the early hour. "The bacon's gone, but there's still plenty of scrambled eggs. You should try to wake up earlier. You don't want to end up like those gentlemen." He pointed to the burnouts, just coming to life at the far end of the lodge.

Mr. Ryan scraped a pile of eggs onto each of our plates.

"You boys going to camp this summer?"

Hell no, I thought to myself, I'm quitting at the end of the year. I'd quit now if I my mom would let me. I had gone to scout camp the previous summer. I'd had a terrible time my first year in Boy Scouts—the Roman Catholic/Irish Catholic interrogation was a relative highlight—and I tried convincing myself that Boy Scouts could be as much fun as Cub Scouts and Webelos, when we used to make goofy crafts out of popsicle sticks and egg cartons.

So I searched my scout handbook for merit badges of interest. I circled a dozen or so merit badges that screamed, *Ostracize me!*—bookbinding, dentistry, and dog care; gardening, plumbing, and reading; stamp collecting, and theater. Even at the height of my scouting ambitions, I wasn't meant for Troop 320. While most of my troop was split between preparing to engage the Russians in hand-to-hand combat and running a hotbed of adolescent hedonism, I was more likely to be drafting the requirements for a Broadway show tunes merit badge—perform before your troop two or more songs from *Singin' in the Rain*; compare and contrast the Broadway and Hollywood cast albums of *West Side Story*; etc. In the end I earned two merit badges that summer, leatherwork and mammals. For the first, I cut two pieces of leather and stitched them together into the lamest of wallets and for the second, I read a stack of *Ranger Rick*s with Cyclo.

Camp was also the week that I first experienced Crothamel the bully. When I first joined the troop, he asked strange questions and made fun of me, and I knew about his fight with Josh, but that summer he was abusive. We arrived on a Sunday. With Josh at baseball camp, Cyclo and I had a tent to ourselves, one of those canvas tents that was set up on a wood platform. The first day we overslept and missed our merit badge classes. Mr. Ryan lectured us, Crothamel standing by his side, nodding in agreement. The next morning, well before wake up, Crothamel took matters into his own hands. Sunlight streamed into the tent and I noticed someone pulling back the front flap. I was aware but not awake.

That changed when Crothamel kicked me, putting the heel of his hiking boot in my groin and yelling at me to get up. The pain was instant and blinding. I tried not to cry. Cyclo opened his eyes a split second before receiving the same. Crothamel said that somebody needed to toughen us up. We had trouble sleeping the rest of the week, waking up before dawn, before Crothamel had a chance to further scramble our gonads. Cyclo and I never talked about it. We never told on him either because we feared things would only get worse.

Mr. Ryan got up from the table. "Wash your dishes there in the sink when you're done, boys. The skis, boots, and poles are out back. We'll see you back here at noon."

Mr. Ryan led a group into the woods to work on their wilderness survival merit badge. Bobby Cebeaniak's dad had driven up for the day. He took a group ice fishing. Josh, Cyclo, and I went cross-country skiing.

We stayed in close proximity for the first two hours, skiing a little bit and throwing a lot of snowballs. Then Cyclo went ahead. He was sitting on a tree stump a stone's throw from the edge of the lake when we caught up.

Josh greeted him. "The world's greatest comic magazine, huh?"

Cyclo exhaled. "Sometimes a man just needs to get away for a smoke and some quality literature," alluding to the smoldering cigarette he held in his left hand and a copy of the Avengers in his right. "Except, this is the Avengers, Earth's Mightiest Heroes. The Fantastic Four is the world's greatest comic magazine."

"I know," Josh replied, "I like to give you the chance to be right once in awhile." He brushed off a snow-covered log next to Cyclo.

The sun broke through and reflected off the frozen lake. The snow muffled our voices.

I always thought it was weird that Cyclo, the ultimate worry wort, liked smoking. "Keep smoking and you're going to be a

burnout," I said.

"Thank you, Father Faloon. I'll be sure to burn for my sins." Cyclo knelt down, put out his cigarette, and made the sign of the cross. "Now for my penance I'd like to see how the Avengers save New Jersey from the wrath of Pyron, the Thermal Man."

Half way across the lake I could see Mr. Cebeaniak and six or seven guys from our troop. They'd drilled four holes in the ice and had their fishing lines in the water.

"It's going to suck without you," I said to Josh. His family was moving across town in a couple weeks and this was his last trip with 320. "Who's going to mouth off to Crothamel?"

"You guys will be fine," Josh said.

"I'm jealous, though. My mom won't let me quit until the end of school. I'm sick of dealing with those guys," I said.

"I'm quitting at the end of the year too," said Cyclo, "but this is my last camping trip. Ever. I'm never going to carry any of Crothamel's crap again."

Cyclo exhaled and went back to the Avengers. Josh took out a candy bar. Watching the lake, I saw Mr. Cebeaniak stand up as he reeled in a fish through a hole in the ice.

Me: "I wish my Uncle Carlton was our Scout Master. He's into ice fishing and hunting and snowmobiling, but he doesn't take things so seriously."

Cyclo: "I'm going to stop smoking the day we graduate. I'll quit before I get cancer."

Me: "My uncle actually lost his two front teeth in a bar fight. It happened up in Maine. He was out with some friends and got into an argument with this guy about the Red Sox or JFK or something. The guy punched my uncle in the mouth and knocked out a couple of teeth, but my uncle ended it with like two punches. Mr. Ryan would be so much cooler if he got into a bar fight."

Josh: "All those guys need to lighten up."

Cyclo: "It only gets better you know. High school, then college. I can't wait. I'm going to college near New York City. It's

110

too dangerous to live in the city, but so much happens there. My cousin goes to college in New York. She loves it. They get all the best movies weeks before we do. You guys should come visit."

Out on the lake I saw five of my troopmates trying to pick up a fish that was flopping on the ice. Mr. Cebeaniak slapped the back of his son's head.

Cyclo: "How can they spend so much time sitting on ice? How do they know there aren't huge cracks under all that snow?"

Me: "My uncle says it only takes three inches of ice to hold a horse and a foot will hold a car. When he goes ice fishing he parks his truck on the ice and him and my aunt sleep there overnight."

Josh: "That's like those mountain climbers who can sleep on the side of a cliff. They hammer a few spikes into the rock and then just hang there all night, nothing below them."

Cyclo: "It's still crazy, if you ask me."

We skied back to the lodge for lunch. We spent the afternoon hiking with Mr. Ryan and most of the burnouts. Then everyone gathered back at the lodge for dinner. It was dark by the time the three of us were doing the dishes.

"I heard Mr. Ryan talking to Crothamel today, saying what a good job he was doing. You know, staying out of trouble. That pisses me off," Cyclo said. "Then I heard the rumor again about Crothamel bringing a gun."

"He wimped out," I said dismissively, rinsing a skillet and handing it to Josh to dry.

"He didn't wimp out," Josh said quietly.

"What do you mean?" Cyclo asked.

"What I mean is that last night, before we left St. Charles, Crothamel put a gun in my bag. A real gun. He said they'd all kick the shit out of me if I didn't take it. I don't think it's loaded, but it's real."

Cyclo and I believed him for a second. Then we laughed.

"I mean it. It's wrapped up in a flannel shirt in the bottom

of my bag. Didn't you notice how many times he came by last night? He wasn't just getting cigarettes or cherry bombs, he was checking on the gun."

Josh kept drying dishes. The lodge seemed to expand as the reality of what he was saying sank in. Even last summer at camp, as awful as that was, Crothamel never tried anything like this, but I could tell Josh wasn't lying. I realized we were too old for the days of making Pinewood Derby cars, but this was messed up. My vision blurred a bit and a gentle weight descended over me, like an x-ray blanket at the dentist.

"We've got to tell Mr. Ryan," Cyclo said, turning to see if anyone could hear us.

I picked up a dirty coffee mug, trying to act casual. "Why didn't you tell us before?"

Cyclo continued. "I know Mr. Ryan is a dick, but he'll take care of this." He stared at Josh, like he was asking for permission.

"I didn't know what to say," Josh explained.

"I can't believe I slept above a gun all night! What if it went off accidentally?" Panic seeped into Cyclo's voice. "There could be a bullet stuck in me right now and the lead is getting into my bloodstream. That happens, you know. Sometimes people get shot but don't realize it for days. It happened to this guy in Chicago. He was eating a roast beef sandwich, which slowed down the bullet and it took him three days to realize he had a bullet in his head. Now I know why I've been aching all over."

"Cyclo—Pete—calm down." Josh tried to interrupt, but Cyclo had too much momentum.

"I bet there's lead in those bullets. That's what ruined the Roman Empire, you know. Lead poisoning. Those big goblets they used to drink wine out of? They were made out of lead, but the Romans didn't know that lead was poisonous. That's what killed Alexander the Great. And it's the worst kind of death. I saw something on the news about one woman—she got lead poisoning from a cereal bowl—she was so weak that she couldn't

even take the weight of a bed sheet on her at night."

"Cyclo is right, we should tell Mr. Ryan," I said, a slight quiver in my voice.

"Cyclo, relax, all right? First of all, Alexander the Great was Greek, not Roman and second, this is the twentieth century, not the Battle of Lexington, okay? There's no lead musket ball in your ass. Trust me, you'd know if you got shot. And we aren't going to say a thing to Mr. Ryan. Not yet," Josh said. "You know Crothamel. He's not going to use it, he just wants to show it off."

As we finished the dishes, Josh tried to make jokes. I jumped when I felt a tap on my shoulder.

"Just wanted you to pass me a couple of plates for S'mores." It was Craig Baker. He usually hung out with the fascists, but he wasn't a bad guy. "Hurry up and finish, Mr. Ryan just got started."

At another Boy Scout troop in some other world, a Scoutmaster might conclude a camping trip by bringing his scouts together, sharing stories and telling jokes to remind his troop that they'd made the right choice by joining the Boy Scouts. Kind of like a football coach congratulating his team after a big win, the activity's over and it's time to build morale. Mr. Ryan had a different approach. He scared us to death. He didn't tell ghost stories, he told horror stories. Everyone would be in a circle and Mr. Ryan's pinched, sunken eyes would scan for the most frightened face, the face he'd focus on the most. He'd suck the cigarette smoke into the deepest recesses of his lungs and lower his voice, the only time he spoke quietly. His tales always seemed to involve someone being buried alive, a person coming to full consciousness a day after being buried and frantically scratching the coffin lid until they'd used up their oxygen and suffocated, their fingers reduced to bloody stubs. One of us would ask how they would even know that a person had been buried alive and Mr. Ryan would go into a detailed account of a local cemetery being relocated, a coffin slipping off a cart and popping open, revealing a scratched up coffin lid and a person's face frozen in the form of

113

their final scream. Then he would talk about how in the old days so many people were accidentally buried alive that some people paid extra to have bells put next to their graves, with a string running inside the coffin so that if they were buried alive they could ring the bell and be dug up before it was too late.

Then, as if I wasn't freaked out enough, Mr. Ryan would keep going, trying to make us feel better by telling us about modern burial techniques. We were lucky, he said, we didn't have to worry about being buried alive any more because nowadays they used embalming fluid, and to use embalming fluid they cut underneath your arm pits and drain your blood before pumping you full of the fluid and there's no way you could go through that and not wake up.

I was too busy thinking about Crothamel and the gun to pay attention to that night's story, but the effect was still the same: I wanted morning to come in a hurry. I ate a couple of S'mores but didn't taste anything.

Crothamel took out his boombox as everyone was getting ready for bed. I heard someone singing off key. It was Gorman: "*I meet those bad girls hanging around.*"

Cebeaniac, pointing to the Foreigner *4* T-shirt he was wearing under his scout uniform, took the next line: "*Never doing what they oughta.*"

The tape had moved onto "Jukebox Hero" by the time Crothamel walked past us on his way to the bathroom. He got right up in Josh's face, using his finger to punctuate each word that he sang—"*Stars! In! His! Eyes! He'll come alive tonight!*" The maniacal look on his face made it clear that he knew that we had heard about his plans.

"Look, dickwads, I've got a special offer tonight. Make sure no one touches my stuff and I won't kick your ass or your ass." He pointed to Cyclo, then me before saying to Josh, "Might still have to kick your ass, though."

At the end of the cabin, I could hear Gorman and Cebeaniac

dueting on "Waiting For a Girl Like You." The homoerotic irony lost on everyone.

"Just keep your eyes open and your mouths shut. Got it?"

"Ya volt, Benito," Josh mumbled.

Crothamel faked that he was going to slap Josh, then smoothed back his own hair. He smirked and walked away.

"I hate that guy."

"Keep it down back there," Mr. Ryan yelled. "Lights out in five minutes. And turn off the music."

Crothamel and company finished singing to side one of the Foreigner tape and a few seconds later the cassette player clicked off.

I never saw the gun. Only Crothamel's allies were invited. A few minutes after Mr. Ryan was snoring, Crothamel walked toward our bunks. I could see Cyclo turn over and face the wall, and I did the same. I couldn't tell who was first to follow Crothamel out the back door. After a few minutes two shadowy figures crept back to their bunks and the next pair of scouts, anxious to see the spectacle, pulled the door open in slow motion. I stared at the half moon and drifted to sleep.

Mr. Ryan did most of the talking on the drive home but I could sense Crothamel's smirk the whole time. He wasn't even a jerk to us that morning, politely asking us to step aside so that he might use the "lavatory" when we stopped for gas.

Most of the parents were waiting for us when we got back to St. Charles, including Cyclo's dad.

"I guess you were right, Josh" Cyclo said, throwing his bag over his shoulder. "I survived again. Thanks for calming me down. Stay in touch, okay? Mike, give me a call this week. Maybe we can go see the new *Superman* movie Saturday?"

Cyclo's dad beeped and waved as they drove off. Mr. Ryan asked if anyone needed to use the bathroom. Josh pulled a paper bag out of his backpack and followed Mr. Ryan into the basement

of the church.

I knew my mom would be late so I sat on the front steps and waited. When I saw Crothamel walking toward me, his sidekicks nowhere to be seen, I unzipped my bookbag and waited for him to take back his fireworks.

Before he said anything to me, Crothamel opened Josh's bag and pulled out the folded flannel shirt. His face crumpled up as he peeled back the shirt. That's when Josh walked up.

"Pretty cool BB gun, right?" Josh said, "feels like a real gun."

Josh's mom drove past us and made a u-turn. She waved to Mr. Ryan and Crothamel's dad who were talking at the far end of the parking lot.

"Be right there, mom," Josh yelled. He turned back to Crothamel. "The BB gun was part of my back up plan. I thought about switching them last night after you went to sleep."

Josh took back the BB gun and put it back in his backpack.

I was as shocked as Crothamel was.

"Where's your gun? I mean, your grandfather's gun?" Josh asked, each word dripping with sarcasm. "It's right over there. Mr. Ryan has it."

When Crothamel turned he saw his dad, Officer David Crothamel, crew cut and a barrel chest that looked like it never exhaled. He also saw Mr. Ryan hand the gun to Mr. Crothamel. The two men looked in our direction.

Mr. Crothamel yelled across the parking lot, "Tom!"

Crothamel looked at me, then Josh. He realized that Josh had just kicked his ass but the worst was yet to come.

"Thomas! Here! Now!" It was Mr. Crothamel again, only louder.

Josh's mom pulled up closer. "Josh, honey, I know you want to say good-bye to your friends, but we have to go now. We're late to your grandparents."

"Be right there," Josh said.

Crothamel's dad yelled again and Josh's mom waited, but

116

Josh and Crothamel just stared at each other. I felt like I was watching an old western. The look on Crothamel's face was straight out the showdown where the villain clutches his wounded chest and draws his last breaths, stunned that the sheriff outdrew him, one realization after another racing through his mind, only Josh had won this duel without even throwing a punch or pulling a trigger.

Crothamel's eyes were wide and pleading. Josh replied with a smile that grew wider as Mr. Crothamel's voice got louder. Josh hoisted up his backpack and extended his hand to me. "See you soon, Mike."

He looked Crothamel in the eyes and held his stare. Josh jerked his hand upward. Crothamel flinched and Josh slowly followed through on his salute, fingers to forehead, and said, "Up yours, douche bag" before clicking his heels together and getting in the car.

Kung Fu Sex Shop

Lisa knew it was ball four. The umpire's gesture toward first base was a matter of ceremony. "Aw, come on!" She wasn't disputing the call. She had no issue with the man in blue positioned behind the plate. Her disgust was directed at the Mets relief pitcher responsible for loading the bases, jeopardizing the team's two-run lead with no outs in the bottom of the ninth. Lisa looked around the bar. Conversations stopped. Strangers looked over. I knew that she was just looking for support. But to onlookers she could have been scoping the room for someone to mop the floor with.

Her husband, Brian, redirected the conversation, trying to calm Lisa. Without knowing it he was also keeping my mind off the party I'd left a short while ago.

"Are you free next Friday?" he asked. "My brother and I are going to see this Genesis tribute band play all of *The Lamb Lies Down on Broadway*. They have all of the original props and costumes, and the singer sounds just like Peter Gabriel." He went on to explain that he was going to see the Exploited the next night. He had an extra ticket to each show.

Earlier that night, taking a commuter train into New York City, I had not expected to see Lisa and Brian. I was going to another friend's birthday party. Most of the ominous signs were

there as I waited for the southbound train, the chill in the air, the steady drizzle. It had been a long week at work and I thought about turning back but I hadn't seen Tony in years. Our bands played the same East Village dives and we had stayed in touch.

The party started well. We met in a familiar bar on St. Marks. Tony greeted me with a hug and a pint. I was one of the first people there and we indulged in nostalgic stories about the sound guys from those East Village clubs. The mild-mannered dude from the Continental who was forever flipping his ponytail from one shoulder to the other. The jovial bug-eyed guy from the Spiral who worked the soundboard with one hand and devoured a deli sandwich with the other. Tony and I didn't have the Great Depression to bond over. We'd never had an experience as harrowing as huddling in a foxhole either. Instead we reminisced about acid casualties scarfing down pastrami on rye sandwiches while trying to put more vocals in the monitors.

It had been a long way to travel for a party. I was living north of New York at the time, but I had recently moved back to the area from the midwest and I wanted to reconnect with friends. After the initial conversation with Tony the mood at the party was melancholy. Turnout was low because of the weather and talk among the six of us kept returning to the recent death of the drummer of Tony's current band. He had overdosed. Talk shifted back and forth between cursing his indulgences and remembering his talents. The shifts in conversation were tsunami-sudden, swift and unpredictable, and difficult to navigate for someone like me who had never met the deceased. I stayed to be supportive and the party-cum-wake broke up shortly after eleven.

I left the bar depressed and in need of company and more aware of my mortality than I cared to be on a Friday night. I intended to go straight to the subway station. Lisa and Brian were the perfect people to run into. They abandoned their plans to go home and suggested that we get a drink. I didn't say much about Tony's party.

We stepped into the nearest bar, duct tape on the seats, the game on television, no signs of a crowd. We were working through our second round when the Mets lost in extra innings. The bartender put on a mix CD and by the fourth round I was awash in great conversation while the Jam, the Buzzcocks, and the Clash played in the background. When I noticed that it was quarter after one I said good-bye and headed to the subway. The night air cleared my head a bit and I realized that I only had fifteen minutes to catch the 1:30 train, the last one leaving Grand Central for the night.

I ran onto the platform just in time to see the taillights of the departing train fade into the tunnel. The public address system announced that Grand Central was closing for the night. Service would resume the following morning at six. I needed another way home or a place to stay. My night was just beginning.

The trains didn't adhere to Fred Ebb's famous line about the town that never sleeps, but maybe the lyricist had taxis in mind when he wrote "New York, New York." Cabs go all night. Leaving Grand Central I spotted an on-duty cab driver and asked how much it would be to Pound Ridge, the tiny upstate town where my wife and I lived.

"Never heard of it," he said. "What's it near?"

"Mount Kisco, which is right next to Bedford, if that helps."

"Never heard of them either, let me look it up."

As he reached into his glove compartment, a second cab driver, who was parked behind the first, got out of his car, walked over and asked where I was going. Seated Cabbie glared at Standing Cabbie. I was about to learn that bidding wars are not accepted practice in the cab-driving world.

"Damn it, what are you doing, man? You can't talk to him, he's my fare," Seated Cabbie said.

"Where are you going?" Standing Cabbie repeated to me.

"Don't tell him," said Seated Cabbie, frantically flipping through his book of maps. He leaned across the front seat of his

cab and called out to a cop standing on the curb. "He can't do that! He knows he can't do that, and you know he can't do that."

The cop stood with one foot on the ground, the other pushing on the side of a newspaper box. He rolled his eyes. "What's the problem?"

"I missed my train," I explained, "I'm just trying to get upstate as cheaply as possible."

The cop shrugged and stepped back on the curb. As the cabbies tried to find Pound Ridge, I worked out my plan. I'd get a ride to Pound Ridge and stop at an ATM along the way to get the cash. I'd heard that cab rides upstate could cost $50-$75. I decided to err toward the high end of the range; it was worth that much to get home.

That's when seated cabbie called out, "$180, that's what it'll cost."

The auction was over. I said thanks and headed across town to the bus station at Port Authority. Walking west on 42nd Street, I thought of whom I could call. My wife was out of town. I couldn't get in touch with my friends. My hopes hinged on catching a bus. They rose when I saw that Greyhound was open. The guy at the counter was friendly and knowledgeable, a rare combination in my bus-riding experiences. My hopes continued to ascend.

"The next bus to White Plains is 4:45," he said. That was earlier than the morning train but would only get me half way home. I'd have to take a cab the rest of the way.

No train, no cab, no bus. It was quarter past two and the reality of a night on the streets was sinking in. With a bit of self-pity for good measure. Walking back toward Times Square I saw people filtering out of a movie theater. It reminded me of those scenes in seventies movies where the urban loner takes in a late show to pass the time. Like in *Taxi Driver*, only I didn't share Travis Bickle's taste in movies. Once inside the lobby I saw that the theater had no more screenings that night. I explained my situation to two police officers standing near the doors. I asked if they knew

of any theaters still showing movies at that time of the night.

Officer number one chuckled and advised me to "get a girl."

I played along, pointing to my wedding ring and saying that I was married.

Officer number two said, "So spend more!" He slapped officer number one on the shoulder as they doubled over in laughter.

I smiled, not because I thought it was funny but because I knew that at home, sandwiched between CDs by Blur and the Bomb Bassets, is a copy of Body Count's self-titled CD, the uncensored version which contains "Cop Killer." The record is terrible. The song is worse. I'd long regretted spending $13.99 for it upon its release, but that Body Count disc paid for itself ten-fold in that moment. If only I'd listened to it a second time I might have been able to recall some of the lyrics.

My revenge fantasy passed quickly and I came to my next realization: I was broke. Two more realizations followed in quick succession: I was thirsty and I needed to use a bathroom. I walked into an all-night pizza place, got a cup of water and asked where the bathroom was.

It had been just over an hour since I missed my train and for the first time, I had nothing to do. I had exhausted all of the escape routes I could think of and I needed to stay awake. I kept walking. The crowds thinned as I headed south on Eighth Avenue. After four or five blocks I spotted a sign that said "Kung Fu Movies For Sale." It wasn't unreasonable to think that wiser minds than mine had passed considerable amounts of time examining the covers of Jackie Chan and Jet Li videos. Florescent lights framed the store's doorway. They were open for business. I stepped inside. As fate would have it the phrase "kung fu movies," which I had previously taken to mean something along the lines of "films in which one or more performers engage in the use of martial arts, primarily the art of kung fu," actually translates, in the wee hours of a New York night, as "porn." In this case, aisle upon

brightly lit aisle of porn movies. It looked like a grocery store. This was not my domain. I wanted to explain my mistake to the guy behind the counter. I'm uncomfortable talking about sex with anyone other than my wife. Looking at sex in public? Forget it. Being seen looking at sex in public? Time to leave.

As I walked out I realized that no matter what kind of spin I put on this, no one would believe that I'd accidentally stumbled into the kung fu/porn palace. It was like the time my friend Eric convinced me to drive him to an in-store calendar signing by a swimsuit model. He bought two calendars and asked me to get in line with him so that I could get one of his calendars autographed for him. I did it, nervously talking to Eric the whole time, racking my brain for ways to distance myself from the line of losers in which we stood. I never noticed the cameras from the local TV station. I didn't hear about those until my dad said he'd seen me on the eleven o'clock news. When I tried to explain my side of the story, that I'd only gone because Eric needed a ride, and I was only in line because Eric wanted to get two calendars signed, my dad only replied that Eric didn't make it onto the news, just me.

At that point in the night I would have killed to have someone disbelieve me, or simply notice me. I was lonely and tired and my legs ached from two hours of late night walking. There was no one else in sight. That's when New York is creepiest. I thought about muggings. More specifically, I thought of my friend Paul, not much bigger than me, who had survived a couple of muggings—one as a kid, one as an adult. He's the only person I know who got revenge for a mugging. His first assault happened when he was eight or nine. He'd been in the park, momentarily away from his parents, when two older kids jumped him. That one passed without revenge. It was the second mugging, about twenty years later, when he got even.

A few months after the attack, Paul ran into his mugger again. But this time it was broad daylight and Paul was with a very large friend. They approached the mugger, reminded him of the

prior incident, and insisted that he hand over $60, the amount he had stolen from Paul. The guy was shocked and scared enough of Paul's friend that he opened his wallet and removed its contents, $20. Paul and his friend strongly encouraged the mugger, now muggee, to go to the nearest ATM and take out the balance.

I thought about Paul's story a lot when I first moved to New York. I was an upstate suburbanite convinced that random, brutal violence waited on every street corner. I wanted a plan, some sense of control, a systematic response to my inevitable mugging. My coping strategies didn't border on pathetic, they had a room with a view in the heart of downtown Patheticvilleburg. I walked as far away from buildings as possible, in the street if the choice presented itself. I kept an extra twenty dollar bill, mugger money, that I could throw in one direction, say, toward the perpetrator, while fleeing in the opposite direction. And I spent a great deal of time worrying, rehearsing my dialogue with my assailant. If he was armed, I played for pity. No weapon, well, I played for pity then too.

About a month after moving to Astoria, Queens I bumped into a guy outside a furniture store three blocks from my apartment. He called me an asshole. I thought I had pissed off the wrong guy on the wrong day. Joe Pesci in *Goodfellas*. I saw myself bound and gagged in the trunk of a Lincoln Town Car. I didn't understand why he didn't kick my ass, couldn't comprehend how he had failed to act on his New Yorker instincts, violently using my hide to send a message to the neighborhood, but I left nothing to chance. I avoided the area for weeks and wore a baseball hat whenever I walked to or from the subway. I imbued this guy with high-level Mafia connections and yet I thought a Mets cap would mask my identity and provide ample security.

By now I had doubled back to Grand Central and saw that inside one of the entrances, there was a small section roped off and occupied by eight other guys who had missed their last trains home. Shirt tails wrinkled, neckties loosened, sweatshirts pulled

over heads, these were my people. My drank-too-much-and-misjudged-time people. Clearly exhausted, probably drunk, likely disappointed, and in no mood to talk about the mistake of the night. We ranged in age from early twenties to early fifties, and while some were dressed in suits and others in jeans, there were no illusions of hierarchy. If any one of us had any significant social standing we would have splurged for the overpriced cab ride or the hotel room, anything other than the floor of Grand Central.

That was my last coherent thought of the night. I sat down, leaned against the marble wall and began drifting in and out of an awkward sleep. I remember checking my watch at 3:35 and again an hour later. I dreamt about Andy Kaufman. He paid off my parents just before faking his death in 1984 and, in early 1985, returned to society as me, a high school sophomore living in Central New York. I'd been so successful in adapting to the fake persona that it was not until this night in Grand Central that I realized the whole thing had been a ruse and that I was, in fact, Andy Kaufman.

I'd just come to terms with this scenario—abandoning my own identity to take on Andy Kaufman's—when I heard the click of the gate opening. I slowly unfolded myself and stood. My body ached in places that I didn't know had nerve cells. Stumbling toward my dearly beloved northbound train a song, "Gold Star" by the Jennifers, emerged from the recesses of my barely functioning mind: "*That which doesn't kill me, can still hurt a lot.*" I mumbled the lyrics to myself, my lips moving but my voice audible to no one else. Then I slumped into my seat and slept.

Glowsticks Optional

There's a hand on my shoulder. I flinch and turn to face a stranger whose greasy hair spills out from beneath a Phish hat. His glasses, thick and black, look familiar. "Dude, you are *not* an asshole!"

"To what do I owe the honor?" I ask.

"You're listening to *me* talk to *you* about *this* festival!" He unrolls a concert flyer. "It's in Atlanta. Ten minutes from my front door." He notices that the flyer is upside down and rights it. "Atlanta does not suck. People from L.A. and New York say it does, but Atlanta's a cool city."

I start to explain that I once went to nearby Athens, Georgia. Phish Hat keeps talking. Typically I would walk away from an unkempt and unfamiliar hippy. Tonight is different. "Look at these bands—Phil Lesh, Moe, the Thievery Corporation! Come to the festival and *I* won't call *you* an asshole. *I* remember faces." He turns his flashlight from the flyer to his face. His eyes widen and his forehead wrinkles in mock horror. "Remember mine!"

We're standing in a field in upstate New York on a warm August night. Looking over Phish Hat's shoulder I see glowsticks cascading in the audience. A Hell's Angel rolls by on a four-wheeler. It's my second night at Camp Bisco, a festival named for the Disco Biscuits, a jam band now playing their first set of the

night. But I didn't come for the music. My friend Bake, who talked me into coming, knows I don't like jam bands. He said I should focus on the fans instead of making fun of the music. It's like when my uncle told me to watch the movement of the outfielders—not the flight of the ball on a line drive. It's a slight but significant shift. I had taken another break from the music to wander and eat when Phish Hat pulled me into his roadblock.

He waves his flashlight like a saber, slicing and dicing the night air as he introduces himself, calling out each nickname. "Some people call me Hush. Some people call me Babbles. Some people call me Shut the Hell Up. Some people call me…" He holds the light steady on himself, and takes off his hat. "…*Jerry Potter!*" Indeed he looks like a cross between Jerry Garcia and Harry Potter, which explains the glasses. "Or you can call me Scott. Just come to the festival."

There are four of us camping together this weekend. My friend Bake is our ringleader. We used to work together. He looks like a Caucasian version of Bake McBride, a baseball player from the seventies. It's the big, bushy hair more than anything. Rounding out the quartet are Sully, another former co-worker— tall, bald, and talkative—and the Colonel, a high school friend of Bake's whom I've never met. When Bake called earlier that day they were en route to picking me up. "We're running late, but we're feeling great except that I have diarrhea. The Colonel here calls it DIAAD, drug ingestion anticipation anxiety disorder. Are you ready for Camp Bisco?"

Bake asks me to look up the previous night's Disco Biscuits set list. He sends me to a website called PhantasyTours.com. I find offers for cheap flights to Tuscany. Then I try PhantasyTour.com. Singular. The first page has a word search comprised of words from last night's set list. It isn't an extensive word search because the band only played three songs.

The Disco Biscuits are a jam band, descendents of the

Grateful Dead and Phish. They play rock songs with long improvised passages. Bake has played a lot of Disco Biscuits songs for me over the years. He argues that they distinguish themselves by incorporating techno into their jams. This is akin to being offered a plate of two unappealing foods like, say, ground duck livers in a heavy pesto sauce. But I admire Bake's tenacity. He is convinced that there exists a Disco Biscuits song that will unlock my appreciation for the band.

PhantasyTour.com also lists the online names of 824 fans who attended last night's show. One of them is named Funglejunk. I check out the rest of the site anyway and come across a set list from two nights ago in Brooklyn. The Disco Biscuits encored with a cover of the Ramones "I Wanna Be Sedated." Worlds were colliding, perhaps in my favor.

It started with "Turn the Page." Bake, Sully, and I were working together in New York. Over time we began frequenting a happy hour bar around the corner from our office. One night there was an acoustic cover band. They broke into "Turn the Page," Bob Seger's mournful tune about a misunderstood rock star whose long hair is ridiculed while on tour in Nebraska. The song is saturated in self-pity, begging listeners to feel the burden of drivin', playin', and makin' time with the ladies. It's self absorption on par with a pre-teen sobbing in his pillow, convinced that no one in history has felt such pain. *Go ahead, name another who suffers such as I! Egyptian galley slaves withering in chains? Falsely accused Puritans crushed by stone? Bah! I have to play a concert tonight, for which I will be compensated with money and the affections of an adoring public, and then—and this is the real kicker—I have to do it again tomorrow night!*

When I recognized what the acoustic duo was unleashing I told Bake and Sully that it was the worst song ever.

Bake was surprised, confused by my animosity. He kind of liked "Turn the Page," in fact. Sully sided with me, if not quite as emphatically. Then the band played "Hotel California," the

second worst song ever. Bake and Sully switched roles. I joined Bake in making fun of the lyrics while Sully sang along, his voice growing louder as we grew more heated in voicing our contempt for pink champagne and beast-slaying steely knives. That night we realized that the three of us agreed on no song, artist, or genre. Bake liked classic rock and jam bands. Sully listened to R&B and jazz. I preferred punk and power pop. Our friendship was forged by making fun of each other's music.

We tried to convert one another. The first mix tapes we exchanged, plastic-shelled olive branches, were politely returned with heartfelt explanations. Subsequent tapes were thrown out in disgust.

Since leaving the job we've met up once a year. Bake has persisted in making a case for the Disco Biscuits. He mentioned the band's festival as a chance to hang out for a weekend rather than just a night. I never expected to find myself purchasing a pass to Camp Bisco VI.

Bake and Sully are seated up front as we drive to the festival. They are having a battle of the MP3 players. I'm sitting in back with the Colonel, Bake's friend from high school. The Colonel wears a baseball cap and sunglasses. Despite the car's very efficient air conditioning system he is shirtless. He looks like he used to run arms for the Contras. The Colonel and I talk about music. He asks about my job and family. I return the favor and he tells me that he is a former corporate recruiter. One day getting ready for work he looked in the mirror and decided he was done. He quit, moved to San Francisco, and became a carpenter.

The Colonel and I don't talk much after that. He spends the rest of the drive drinking from an enormous, three-gallon container of water. The Camp Bisco website has a list of items people should not bring to the festival. "NO GLASS CONTAINERS OF ANY SORT" is the first and last item on the list. It's in the middle, too. The Colonel, a veteran of five Camps

Bisco, has ignored these warnings and brought three bottles of wine. He needs an empty container to pour his wine into but doesn't want to waste the water, so he drinks all three gallons, swallowing the last drop as we arrive at the Indian Lookout Country Club in Mariaville, New York.

"Christ, will you hurry up," Bake says. For a moment I think the tension is genuine. Then I realize that he is the first of us to make the carpenter/water-into-wine connection.

Hundreds of vehicles have arrived over the past two days, matting the tall grass in the field. The car at the front of the security line is spread eagle, its doors and trunk open wide. A burly security guy searches backpacks and camping equipment. The Colonel calmly pours his wine into the plastic bottle.

"Connecticut? I have more trouble with people from Connecticut than any other state." Our security check is under way. The woman looking through our bags is referring to the license plates on Sully's car. I want to point out that while my friends are from the Constitution State I am from New York, but she makes it clear that I'm to speak when spoken to. "I'm Twisted Megan. Be honest with me and this will go real fast." Twisted Megan's enormous coiffeur flows out of her petite body like a fountain. Hers is a hair-to-body ratio rarely seen beyond the world of trolls. "Do you guys have any weed? Any pills? Don't lie to me. I'll find it."

Drugs. Right. I've been so fixated on my aversion to the music I've almost forgotten about those. I tell her that I don't have anything. I've never so much as smoked a joint. The other guys also say they're empty handed. Then Twisted Megan finds a bottle of pills in the Colonel's bag. She also finds a bag of weed. She calls over a big biker turned security guard. He's enormous. He looks like he's swallowed a barrel. He takes the Colonel aside. The Colonel shows him his driver's license. I hear the Colonel mention a head injury but can't decipher any more of the conversation.

Meanwhile Twisted Megan pokes through bags and opens

coolers. She mocks the Colonel's stash. "That's all you have? For four of you? For the weekend?" Bake says he is planning to buy what he needs once we are inside. Twisted Megan cautions him. "It's not worth it to buy from people you don't know." She closes the last of our coolers and informs us that we're all set. "Been nice working with you. Just be glad you didn't get my daughter, Evil Bitch." She points to a woman, twenty-something, stationed at the wristband tent. Evil Bitch smiles and waves.

"Now just drive straight." Twisted Megan points to the dirt road ahead. "The guy with the flag will direct you." We drive on, discussing Twisted Megan and Evil Bitch and the contents of the Colonel's pill bottle, which contains Vicadin, Ritalin, Motrin, and Ibuprofen. Half way to the flagger Twisted Megan yells, "I can hear you!" We laugh and then because we believe her, we change subjects.

The Mariaville Country Club is set on 200 acres just west of Albany. It is not a country club in the sense of ascots and stock tips. No golf course, no tennis courts, no fancy clubhouse. An aerial view shows narrow tree lines separating three large rectangular tracts of land, like a trio of dominoes laid end to end. Mariaville hosts a number of festivals each year, including an annual Harley Davidson gathering. Bikers also provide the security, cruising the grounds on a fleet of four-wheelers.

Sully rolls down his window as we approach the flagger whose beard matches his grey and white bandana and who may, in fact, answer to the name Wavy Gravy. The old man tells us to "follow the yellow brick road and look for the wizard." I see a sign in my mind's eye: "Now leaving Kansas."

We drive to the back field and set up camp in a corner lot. The main stage is nearly a half mile away. We are at the furthest point from the bands. Still I wonder if the distance is enough. Can I withstand hour-long songs about garden gnomes? What's going to happen when spontaneous freestyle footbaggin' breaks out?

Sully and I unpack the car while Bake and the Colonel

assemble the tents. Bake notices music playing in the distance and sets down the tent poles he's been assembling.

"Is this the Biscuits? These guys sound just like the Biscuits."

"It's either the Biscuits," the Colonel replies, "or it's not."

Five minutes pass. Bake looks up from pounding a stake into the ground. "Whoever it is this jam is hot. It sounds like Barber on guitar."

The Colonel is dubious. "This can't be them. They're not scheduled to play until tonight."

Fifteen minutes later Bake and the Colonel establish that the Disco Biscuits are playing. Only a jam band could noodle away for this long before their fans could identify their music.

Bake and the Colonel head to the main stage. I stay back with Sully, who likes jam bands as much as I do. He opens one of the coolers.

I won't see the Colonel again until Sunday morning. Our quartet is now a trio.

Shortly after five we hear a Queen song blasting from the main stage. Queen is one of my favorite bands. As they are not a jam band, I am able to identify their songs quickly. This one is "Another One Bites the Dust." But it's not being played by a band. It's being scratched by a DJ. Slick Rick has started. The hip hop semi-legend, an anomaly among the weekend's performers, is on stage despite the INS's renewed efforts to deport him to his native England.

Sully and I walk to the main stage. The path through the middle field is lined with cars, behind which are tents. Most are no more than a few strides from their nearest neighbor. It's Hooverville dense, less the rust and desperation. The far field, on the other hand, the one with the main stage, is *Field of Dreams* spacious. The right side is lined with RVs (cars aren't allowed here) belonging to the people who spent an extra $175 for the VIP Package. They receive discounted drinks and access to the VIP Lounge—complimentary massages and catered lunches—in

addition to the premium parking.

Fortunately for Sully and me not many people are interested in late-afternoon hip hop. We walk right up to the near-front—the very front is blocked off for VIP holders—and see Slick Rick in all his eye patch and bountiful bling glory.

Sully hands me a beer and begins wandering. I follow as he approaches strangers and asks about the origins of Slick Rick's eye patch. I think of Bake's advice to focus on the fans but I'm clinging a bit, grateful for Sully's social skills, unsure about walking around on my own. My mind drifts. Do I want a weekend immersed in this culture? Of watching guys like the one at the edge of the VIP barrier, wearing a headband and trying to focus his crazed Marty Feldman eyes on the joint he's rolling? Of seeing T-shirts that read "*Although the trees grow huge / The falling leaves return to the roots*"? Of watching guys, outnumbering the ladies three to one, wearing backwards baseball caps, Billabong shorts, and patchy facial hair, the skinny ones looking like Shaggy from *Scooby Doo*, the pudgy ones looking like Turtle from *Entourage*?

After Slick's set, Sully and I walk to the side stage. It's half the area of the main stage but twice as crowded. We see four guys on stage standing along a table. Each of them is hunched over a laptop, staring at the screens while hopping from foot to foot like a kid begging to use the bathroom. This cluster of Radio Shack clerks is the band. Shouldn't there be something else that draws the audience's attention? It's kind of like sitting in a movie theatre and watching the projectionist rather than the screen. We're hungry and having a difficult time hearing each other, so we head back to the campsite. We are ready to mock Bake—our way of thanking him for inviting us to the festival—but he gets in the first word upon our return.

"Before we start talking I want you to know that I ate chocolate mushrooms and I am tripping my balls off." Bake's sunglasses nearly fall off as he cracks himself up. "And Slick Rick sucked, I could tell from here." Like the set of a seventies-era talk

show, our campsite will have many unscheduled guest appearances this weekend. The first arrives before Sully and I can defend the eye-patch wearing rapper.

His beard is scraggly and his hat is off center. He pulls back the hood on his sweatshirt and asks if we need any acid. He and Bake work out a deal. Bake offers him a beer. He introduces himself as Arthur, accepts the beer, and sits on a cooler. We look and we sip and we nod. It's quiet. I'm surprised to hear myself ask Arthur how it's going.

"I quit my job a week ago. I used to work for the kabob guy. I was supposed to be working this fest, but I was, like, screw that. I'm tired of working eighteen-hour days."

Arthur's head is turned in my direction, but his stare is fixed on the ground.

"I live in Burlington and I drove to festivals in Kansas and Virginia for that guy. He reimbursed for the gas but not for the time it took to drive there." Arthur's mind skips tracks. "I've heard that the pizza dude at Bonnaroo makes half a million a day. He only works four festivals a year."

I try to bond with Arthur around class politics, talk about life in food service, but his mind shifts to personal matters.

"That shit is stressful on your life. I have a girlfriend in Burlington." Arthur sips his beer and sighs. He lights up when Bake mentions the Disco Biscuits.

"The Biscuits are my favorite band," Arthur says. "I can't wait to see them again. That's why I quit my job. I'm here to see the Biscuits." Bake asks Arthur about last night's set. "They sucked, dude. The jams were lame. They were forgetting lyrics. They have to be better tonight. I'm going broke to see those guys."

Meanwhile Sully's tent is glowing. He emerges holding a candle, just extinguished and now smoking.

"Why do you have a candle in your tent?" Bake is alarmed and amused.

Sully grins. "Listen, even if I knock it over the wax will put

out the flame before it can do any damage. Besides the tent is flame retardant, it might burn a hole but it won't burn the tent down."

"Why would it stop with a hole? It would keep burning. That's what flammable materials do." Arthur, our inebriated, broken-hearted acid dealer, has emerged as the voice of reason. "Are you crazy, man?"

The first drops of rain interrupt our candle conversation. Arthur returns to his campsite. It's downpouring as we scramble to put covers on the tents. We pile into Sully's car and watch gusts of wind blow over nearby tents. Only the Colonel is missing. He sends Bake a text message, the first of many, from the main stage: "bring rain gear."

Bake puts in a CD and lights up a pipe. He hands it to Sully who starts the car, turns on the heat, and passes me a beer. I'm told that this is a clambake.

Conversation turns to our neighbors, Andy and Kim, who are from Brooklyn.

"Listen, I want to end up sleeping with Kim," Sully says. "I'm going to pursue that aggressively."

I remind him about Andy.

"They're just friends. She told me and he was right there when she said it."

The rain lets up after a half hour, leaving behind a chill in the air. It's nearly eleven. My hands are stuffed in the pockets of my sweatshirt as we walk to the main stage. Bake tells me that music will go until about three. I assume it will be an early night for me.

Walking toward the stage I ask Bake how many tabs he bought from Arthur.

He pauses. "Somewhere between three and twenty."

People stream toward the stage from all directions. Lying in the field, motionless amidst the flocking Biscoheads, is a girl. She appears unaware of the people walking past her. Bake asks if she's okay and helps her up. She puts her arm around his neck and says,

"I'll follow you anywhere." Her eyes are vacant. Bake says he's going to the stage. She responds, "okay," and heads in the opposite direction. Sully turns to follow her. She kisses him and walks away.

A single star pokes through the clouds and hangs above the Camp Bisco sign that spans the stage. There is a slight breeze and the ground isn't as wet as we expected. A butterfly kite flutters at the end of a long plastic pole. I have no idea when one song ends and another begins, but we are far enough away from the stage that we're able to talk. Bake shares footnotes and etiquette tips.

He and the Colonel exchange text messages. "We like to call the next song," Bake says. "I got this song early, I saw it coming a mile away. Some people hear music. I see it!" The Disco Biscuits are playing a song called "Munchkin Invasion." First, I picture hordes of marauding little people. Then a Venn diagram pops into my mind. On the left, my current circumstances. On the right, a *Magic: The Gathering* tournament at the local Best Western. The circles inch closer together. Bake explains that the band is playing an inverted version of the song. They start with the middle of the song, play the end, and close with the beginning. I understand why he took Ritalin.

Jam bands do stuff like this all the time. I think it only draws attention to the disposable nature of their original designs. Still, I'm curious about obviously flawed ideas. I used to listen to Rush Limbaugh's show. I've seen Louis Farrakhan speak in person. When I've confessed such decisions to friends they have never demonstrated the disgust, the contempt, that greeted my Camp Bisco plans. Were I addicted to booze or ponies or internet porn, I'd receive a mix of shame and sympathy from friends and family. *He's troubled but it's not his fault.* Going to a jam band festival, on the other hand, is my fault. I can't chalk that up to chromosomes. I chose to go. Jam bands and their fans are easy and obvious targets, and sometimes I doubt the cultural mapmakers, I need to survey situations for myself.

The band plays on and I catch myself thinking too much,

letting Limbaugh and Farrakhan pinball in my mind. Bake wants to move closer to the stage so Sully and I eat, drink, and talk as we wander the grounds.

It's nearly one o'clock by the time we make our way back to Bake. The Biscuits are finishing their second set. Bake says that he's going to the side stage to see Orchard Lounge. Sully and I join him. Along the way Bake checks his phone. There's another text message from the Colonel: "Taking a leak. Back soon."

I sober up over the next two hours, becoming more aware of my surroundings, the chill in the air, the Swiss cheese-like tarps that hang overhead. Bake is immersed in the band while Sully talks and talks and, just because we're there and in need of something to do, he continues talking. He monologues well, though, talking about Don Siegel movies and a blind friend who tried to teach himself echolocation.

The next morning sunlight filters through the tent's nylon fabric. Apparently we gained neighbors during the night because I hear a girl say, "Our tent's still here," and then a guy adds, "How did that not blow away?" I don't hear any signs of Bake, Sully, or the Colonel, so I read and enjoy the warmth of my sleeping bag. About a half hour later Bake calls out in a groggy voice from his tent, "Somebody say, 'Go, Slick Rick, Go, Slick Rick, Go!'"

Sully responds, "Go, Slick Rick, Go, Slick Rick, Go!"

We start the day light, drinking juice and eating slightly stale snacks. I'm about to go for a walk when we are visited by our first roving drug dealer of the day. Brad the Evangelist. He sells chocolate mushrooms. He is clean-shaven and wearing hiking boots. His Widespread Panic T-shirt is tucked in and his smile beams bright. He is a whistle and clipboard short of being a camp counselor. We decline his wares yet he continues selling the psychedelic experience, talking with religious fervor.

"This whole weekend is a chance to reflect on where you've been and when you open those doors there's nothing looking back

but yourself." He is like a happy go lucky door-to-door salesman serving the public's psychedelic needs.

Brad the Evangelist leaves and minutes later Arthur returns, forlorn. "I can't believe I missed the Biscuits. I fell asleep." He inquires about our acid needs, but he is thinking about last night. This is a personal call, not business. "My boys said they'd wake me up. I smoked opium, which I usually don't do." He pauses, shakes his head. "I don't like opium." Again, a pause, a shake. "I don't like people who sell it and I usually don't smoke it and I really don't like it but I missed the Biscuits!" He asks Bake if they played "Magellan."

"They did, but it was spacey."

"I love a spacey 'Magellan'!"

I like Arthur. Admittedly a part of me laughs at his predicament and another part wants to say, "Don't smoke opium, dumbass!" but I feel for the guy. He quit his job to see this band and all he needed to do was walk across a field at any point during their three-hour set. He is endearing in his failure, like Charlie Brown trying in vain to kick the football, though in all fairness to Charlie Brown, Arthur plays the Lucy role in this scenario, too.

Bake receives the Colonel's next text message: "Don't die on the shitter."

Arthur leaves. He wants to make more money before the bigger bands play. He vows not to miss the Disco Biscuits tonight. Bake and Sully are drinking and settled comfortably in their chairs. So far I haven't had to test Bake's advice about focusing on the people rather than the music. He and Sully have been great company. They renew an old argument: which superpowers would you rather have?

"The ability to fly would be the best," Bake says. "The flexibility, the mobility. Imagine what you could see. People have been trying to fly for forever. People dream about flying."

"They dream about it," Sully says, "but they don't think it through. Flying is a very visible ability. Everyone will know you can fly. At some point somebody is going to capture you and study you, and you'll be tested and poked and prodded. Transportation isn't as important as communication. If I could have any superpower I would be able to speak all languages fluently."

"Thanks, C3PO," Bake says.

Music from the two stages drifts by. Across the way a guy with stretched ear piercings is teaching a guy who looks like Alex P. Keaton how to hula hoop when our next drop-in visitors approach. They say they are aliens. Like Brad the Evangelist, they are clean cut—sneakers, gym shorts, tank tops. The taller of the two talks. The shorter stands about ten feet away and nods. The talker offers pot brownies and we decline. Johnny Carson had drop-ins from Don Rickles and Angie Dickinson. We have the aliens. Make lemonade, I think to myself. I offer them each a beer.

"My race dropped me here and said there was biodiversity and good chemicals," says the tall one, "and I haven't even gotten high yet."

He is cagey, elusive. I like this in an alien. I infer that he is passing on the beer. I notice that he's holding a water bottle and suggest something stronger if indeed intoxication is what he seeks. My facetious tone fails to register.

"I've tried everything you people have to offer and my friends drank all my Heineken." His face tenses and his voice becomes stern, resentful. "We live longer than you. We're the Plenetions. We live 300 years. We don't smoke like you idiots." I notice that no one in the vicinity is smoking but before I am able to inquire the Plenetions storm off like we have broken a promise to them, violated a time-honored pact written by our forefathers.

The sun sets on day two. The Colonel checks in via text message, working his magic with the obvious: "Night begins at dusk."

The four of us walk different paths as we prepare for another night of music. Bake is on mushrooms. He's pretty sure that the Colonel, whereabouts unclear, is on acid. I stay with beer and Sully tries ecstasy. Bake tells him that if all goes well he, Sully, will be peaking by the time the band plays. Sully has a false alarm after twenty minutes. He thinks he sees worms crawling on Bake's arm but it turns out that what he thinks are worms are just leaves on a tree in a distant field. By the time we walk to the main stage Sully is an hour into his anticipated trip. He says that he feels normal, that he has conquered ecstasy. He doesn't say another word all night. Our trio is now, in effect, a duo.

The Disco Biscuits are playing their first set of the night. We're standing toward the back of the crowd. One guy jogs toward the stage waving a pirate flag. Another holds aloft a light saber and leads a squad of longhairs closer to the stage. The moon is obscured by clouds. We are guided forward by the pulsating beams of stage lights. It is easy to maneuver through the clusters of people, most of whom are doing some variation of what I'm calling the Ground Search dance, jogging in place, eyes locked on terra firma.

Bake leads us forward, settling in alongside the soundboard. Sully looms quietly, his head slowly bobbing. Hunger takes over and I wander toward the food vendors looking for something with melted cheese. I think I tell Bake and Sully that I'm leaving, but being on my feet all day has dulled my sense of what I have intended to do versus what I have done. Then I forget about eating and I roam. I talk plumbing with Brian, the guy maintaining the bathroom and shower facilities who has spent the past two hours carrying buckets of water to wash out the urinals that aren't flushing properly. The Mets hat that I'm wearing leads to three or four hi-fives from fellow members of the Flushing Faithful who pass by. The guy at the French fry stand denies me service because

of the same hat. He's joking. We talk baseball until I'm half way through my order of fries. Later I encounter Jerry Potter. I've never been so social in my life. Bake's advice is making sense. I question the group mindset in terms of taste in music and intoxicants but the people are friendly.

I resume my search for melted cheese. I feel a tap on my shoulder. It's one of our neighbors, Kim. She's waiting for the guy she's with, Andy, to return from the bathroom. I tell her of my quest for food. She leads me to the nearest food stand and asks me to trust her. She is persuasive and I'm intoxicated by the smell of fried food. She orders a fried dough calzone for me and we find seats at a picnic table inside a nearby tent. The calzone warms my hands through the paper plate and it tastes divine. I say so numerous times. Kim keeps talking as I savor each bite.

"I lied about living in Brooklyn. I'm from New Jersey."

Kim's smile is radiant, her hair long and curly, and her skin coffee-colored. Her admission only adds to her charms. At the very least she seems to be seeking good conversation. I could not be any less useful. I'm a married man enjoying a momentary talent crush on the Pakistani gentlemen who crafted my calzone. I wonder where Sully is. He'd be much more attentive.

"Andy and I are just friends but it's confusing," Kim says, "We're going to couples therapy for non-couples."

I see Sully walking past the tent and wave him over. His expression is blank and he is still not talking. He's a good listener, though. He and Kim could be a good idea. If I could get the two of them conversing I could remove the grain of guilt tainting my calzone visionquest, but I'm unable to get their parallel tracks to converge. They sit next to each other, Kim and her therapy, Sully and his botched ecstasy experiment. She talks. He stares. I nod. No one connects.

Eventually Kim's not-boyfriend, Andy, joins us in the tent. I decide to celebrate my calzone with another drink. I offer to buy a round but Kim and Andy want to watch the band. So does Sully

who seeks out Bake. Standing in line, I think of the part in *Fear and Loathing in Las Vegas* where Hunter S. Thompson says that hallucinogens weren't necessary in Vegas because the reality of the city was so twisted. The reality of Camp Bisco, conversely, isn't that twisted. It's not much different than the way my dad spent his Sunday afternoons when I was a kid. He had a recliner, Matts beer, Ritz crackers, and NFL games. At Camp Bisco it's beach chairs, psychedelics, and a parade of Blue Light Special performance art. The citizens of Camp Bisco, with their roving drug dealers and various two-for-one drug/munchie combos—pot Rice Krispy treats in addition to the pot brownies and chocolate mushrooms—have gone a step further, though, because they put the intoxicants in the snacks. (It's an idea that will make it to the mainstream before too long. Coming soon: booze baked into pizza crusts—*Dudes, remember jello shots? Now Jack Daniels and Dominoes are teaming up with a wicked new way to get wasted: Crusts O'Whiskey, a twelve-inch pie with a delicious whiskey-soaked crust.*)

I expected lots of overt "dig the waving of my freak flag" behavior—Dr. Seuss hats and painted faces—but it hasn't been that way. I have seen only two hacky sacks. No stilt walkers or Uncle Sam costumes. Bake says it's a chill crowd and he's right. People are laid back, introverted, polite in most cases. The one guy I saw vomiting chose to do so in the woods. Camp Bisco is not a statement of how life could be. It is not a display of a collective lifestyle, nor a blueprint for an alternative. It is like a sustainable Woodstock: enough freedom to have a good time for a weekend but not so weird as to jeopardize the festival reoccurring—do your thing, have fun, we'll see you next year.

I find Bake just before the band begins their final song. He recognizes it before I do. It's "I Wanna Be Sedated," the Disco Biscuits covering the Ramones. Bake's band is covering my music. He's beaming, happy for me, himself, and the universe. The crowd responds with polite applause. I pick up glowsticks, five or six, from the ground. Then the Biscuits break into a jam. They can't

help themselves. It is their nature. They don't have to be liked, but they can't be blamed any more than a shark can be blamed for preying on a seal. It's the natural order of things. "I Wanna Be Sedated," two and a half minutes by design, one of punk rock's flawless gems, is stretched into fifteen minutes of jamming. Like a horrific car accident I want to shield my eyes but I keep watching. I drop the glowsticks, looking around to make sure that neither my infraction nor my retraction were witnessed. I've made the mistake of shifting my attention to the music.

The Disco Biscuits leave out the song's perfect "bam bam ba bam/ba bam bam ba bam" closing. Then it dawns on me. They weren't covering a Ramones song. They are covering a song with a drug reference in the title. What was I expecting? I'm ready to click my heels and go home.

My throat is dry when I wake up Sunday morning. I sip water and read in bed waiting for the others to rise. Bake is bleary eyed and quiet as he emerges from his tent. Sully looks more alert but is no more talkative when he steps out of his car a few minutes later. There is no sign of the Colonel. I propose breakfast burritos but I am outvoted in favor of leaving immediately. We pack without talking.

From a few sites away I hear a guy yell to no one in particular, "Who's got my jumper cables so that I can get the hell out of here!" The jumper cable dude, like Bake and Sully and other passing strangers, seems burned out, annoyed to find himself at Camp Bisco this morning.

I keep to myself comments about the warmth of the sun and the promise of another day. I want to ease into the day and survey the damage, see if anyone else is relishing the last moments. I appear to be alone in thinking this.

Arthur walks by. I ask if he saw the Biscuits last night. He does not look up. He just mutters, "How am I going to get through this day?" and keeps walking.

We quietly pack the rest of the gear. As we're finishing the Colonel appears. He's wearing the same outfit—visor, flip flops, shorts, and sunglasses. He tosses his bag in the front seat and climbs in. The four of us are together for the first time since Friday night. Sully takes a deep breath and starts the car. Bake and I sit in back. I see the Colonel tap a text message. Bake's phone rings. He shows me the message he's just received from the Colonel: "I have risen. Let's roll."

The Anarchy Eight

My mom didn't blame everything on George Carlin. But she wanted to. She said that I was swearing a lot more ever since my friend Pete and I saw the comedian in concert. But she knew as well as I did that everything I knew about using "that kind of language" came from my dad. Same went for Pete. Plus, even back in the eighties, pre-Columbine, it was easier to hold a stand up comic responsible than to accept the fact that, according to at least one school official, her son might be a budding terrorist.

After reading the letter sent home by my high school, my mom also knew that my talking like a sailor on shore leave was the least of her concerns. In the letter my principal claimed that I had been involved in a conspiracy. There was truth to that. The "harass and intimidate" part was a bit much, though.

My mom could have blamed my history teacher, Ms. Baylor, just as easily. It had been a year since I was in Ms. Baylor's class but she's the one who got me started on Nixon. Ms. Baylor was a rebel with a clearly defined cause: teach the American history that she found compelling. The extent to which that history corresponded with the district's curriculum was not her concern. A photo of Ms. Baylor would show an older woman with a scrunched up face and dangling bifocals, her hair black going gray, short, spiky those first days after a vacation when she'd come back with a haircut. Her

lined flannel shirts reminded me of my grandfather's hunting clothes. Her appearance was half lumberjack, half librarian. In class she sat in the front row and turned a desk to face us, sipping coffee as she introduced the day's topic. Then she stood and paced, rolling and unrolling her shirt sleeves as she ranted. Her best days were pure drama, rise and fall, punctuated with book recommendations by the dozens. *What was Roosevelt waiting for? He needed Pearl Harbor as a wake up call? Hogwash! He knew the Axis powers couldn't be appeased. He was listening too much to the damn isolationists. He was putting off the inevitable. You need to read* At Dawn We Slept. *Gordon Prange. Best book on Pearl Harbor I've found. P-R-A-N-G-E. Write it down.*

We knew class was ending when she sat down and pulled out her cigarettes. There must have been tests or projects or papers but I don't remember any. To Ms. Baylor, history was on-going and high-stakes. She held the heroes up on high and raked the scoundrels over the coals—them most of all. Ms. Baylor was at her most electric when shaking her fists at the bullies of the world, whether it was Richard Nixon, then twelve years removed from office, or our school's principal, E. Clyde Cullum. Ms. Baylor said E. Clyde didn't know his place. She called him The Idiot. She spoke of walking into the copy room and seeing E. Clyde down on all fours tugging on a paper jam. "If the Idiot would just leave the damn thing alone it'd work just fine. He can't keep his hands off of things." She failed to see why E. Clyde would not cease interfering with her teaching. She once ripped the intercom speaker out of the ceiling when one of E. Clyde's announcements interrupted a particularly stirring lecture on the League of Nations. For the rest of the year the speaker sat face down on a bookshelf, wires sprawling. No one dared to throw out its remains. They served as Ms. Baylor's warning to unwelcome intrusions.

A native of Arkansas, Ms. Baylor frequently spoke of her annual summer trips back home, replaying the dinner discussions she'd had with her father. *The first time dad and I disagreed was*

Vietnam. Now dad didn't support LBJ, he was a GOP man, but dad was a hawk through and through so he supported our policy in Southeast Asia. The Domino Theory. First Russia and China, then Korea. By '61 he was convinced that Vietnam was the next to fall. He thought the Russians and the Chinese would join forces, but I knew you couldn't get them to agree on how to change a light bulb much less how to export communism. To get dad's side read The Stages of Growth *by Walt Rostow. R-O-S-T-O-W. For my point-of-view try* The Truman Doctrine and the Origins of McCarthyism *by Richard Freeland. Spelled just like it sounds.*

From the Marshall Plan to Reaganomics she replayed the highlights of twenty-five years of disagreements with her father. Nixon was the only person they agreed on. Ms. Baylor felt it was her duty to deliver to us a clear understanding of Nixon's crimes; to hell with the state's curriculum and the end-of-year Regents exam. I grew up in a household where my parents didn't discuss who they voted for. Outside of an Ayatollah Khomeini dartboard on our refrigerator, current events didn't surface. Passion and politics didn't merge until I took Ms. Baylor's class and in time, her enemies became my enemies. My buddy Pete's too. He was also in Ms. Baylor's class.

Pete and I had known each other since I was in seventh grade, but it wasn't until high school that we started hanging out. Pete's family was from Lebanon. His skin was dark and, in an otherwise all-white school, that made Pete stand out. He was accustomed to it, to the way people looked at him when he walked into a room or were surprised to hear him speak with an upstate accent. I first became aware of Pete during an argument on the school bus. I was sitting in the seat between Pete and Adam Leofsky when they started debating who was more popular, Rick James or Elvis Presley. Pete was adamant: Rick James could kick Elvis' ass. Rick James could fill the Carrier Dome. Rick James' last big hit, "Superfreak," was full of funk and fun and it was much better than Elvis' last big hit, "Suspicious Minds," on which the King needed the support of a string section and back up singers.

Pete's argument went no further than his preference for Rick James over Elvis. He was aware of this and after awhile abandoned the rational approach, opting instead to keep singing that line, *"The kind you don't bring home to mother,"* drowning out the Adam's feeble retorts.

"Elvis has sold millions more records!"

"The kind you don't bring home to mother!

"Elvis has people impersonating him all over the country!"

"The kind you don't bring home to mother!"

Pete was standing now, singing louder and grinning wider as Adam became more annoyed.

"Rick James wears red leather pants!"

Pete ignored the obvious response—that Elvis wore leather pants, too, probably red ones at some point—and stuck to his game plan, leaning into Adam's face. *"The kind you don't bring home to mother!"*

"Rick James wears braids, for god's sake!"

"The kind you don't bring home to mother!"

Despite being only a year older, Pete was a mentor in many ways. He was the first kid I knew who was into punk rock. He dressed the same every day—Chuck Taylors, ripped jeans, leather jacket. He quoted the local scene reports from *Maximum Rocknroll* and ordered demo tapes from all over the world. By ninth grade he was going to high school keg parties at the nearby park, stopping by my house on his way home to tell me about the party and to eat peanut butter thinking it covered the beer on his breath. I aided and abetted, but I kept my distance, intimidated by both punk rock and high school kids.

It wasn't too long into Ms. Baylor's class that Pete and I realized how much our emerging political Venn diagrams overlapped, raving liberals united by self-righteous views on South Africa and the death penalty and, despite living in Central New York in the mid-eighties over ten years removed from the break in

and subsequent cover up, Watergate. We had a red-hot contempt for Richard Nixon and his cronies, and after hearing Ms. Baylor's lectures, we couldn't stop thinking about Watergate. We were fascinated by the exploits of Magruder, Colson, and Ehrlichman. We rented the movie *All the President's Men* repeatedly and we checked out the record albums of the infamous Watergate tapes from the library.

One night we were hanging out at Pete's, watching an episode of *M.A.S.H.* in which Hawkeye and his buddies created a fictitious solider, a person who existed only on paper. They convinced the Army brass that their creation was a high-ranking officer and had a fine oak desk and a side of beef, among other extravagant supplies, helicoptered to their unit. Combined with our interest in Watergate, the show sparked a craving to pull a prank of our own. We wanted to be involved in a cover up. We wanted to possess knowledge worth hiding. We couldn't think of any place in school worth breaking into and we didn't have a clue as to how we could make up a fake student, so we came up with the idea of leaving notes around the school with cryptic references to a random date, May 25—notes that read, "Remember, May 25 is coming," "May 25 is just around the corner," and "Hey, what are you doing on May 25?" We wanted the teachers to find the notes and wonder what would happen on that day. Pete said we should present the prank to a bunch of his fellow seniors as a last joke before graduation, and with their help we would figure out what to do on May 25. Pete suggested that we put the plan to the test by sleeping on it for a night. If the idea still sounded good in the morning, we'd move ahead.

I woke up early the next day and called Pete. As usual, he was already ahead of me, drafting a letter to the effect of, "*Seniors, we're about to graduate, let's go out with a bang. Here's an idea for a prank…*" To make it funnier, I suggested quoting George Carlin's seven words you can't say on television. They were funny in concert.

Why not them to the letter? We thought working blue was funny. There was no anger, no malice. We didn't intend to frighten the faculty.

Despite having no plan for May 25, the idea was well received. Six other guys signed on, making us a group of eight. To heighten the joke, we each took on the name of a Watergate conspirator. But we didn't go for the obvious guys like G. Gordon Liddy or Howard Hunt. We went for the obscure guys. Pete became H. R. Haldeman. I became John Dean. Other friends opted for Frederick LaRue and Lawrence Higby. We also decided that all of the notes would carry Haldeman's initials, H.R.H.

The fun began on a Monday morning. May 25 notes began showing up all over school. Pete strolled the crowed hallways between classes casually dropping notes. I was too anxious to leave any notes, it was a self-induced paralysis that seemed to cloud everything in those days. Pete vouched for me, though, credited me as his collaborator. At lunch I started sitting with Pete and the rest of the Anarchy Eight, as we were soon to be known. I was used to the far corner table, sitting with a revolving cast of track teammates and guys who couldn't schedule their orchestra or band lessons for lunchtime. Pete's table was in the middle of the cafeteria. People stopped by and our prank dominated conversation. One of the guys, Marcus Miflin, was the main supplier of hand-written May 25 memo pad notes. Steve Carroll left a note on each of his teachers' desks, including the one in the never-left-unattended science lecture hall. But after a week of snickering at lunchtime, the prank was forgotten. The appeal withered because no one could think of something to do on May 25. Bring flowers to the teachers? Skip school? We lacked a punchline worthy of the set up. To make matters worse, not one of the teachers reacted to the notes. As far as we knew no one was paying attention.

We were completely wrong. The school's faculty was very aware of May 25. A couple weeks after the notes had stopped we

were sitting at lunch and Pete, my punk rock friend, the guy with Fascist Pope and Black Flag posters and anarchy symbols all over his locker, was standing in the cafeteria doorway, weeping. He stopped by our table, mumbled something about being called down to the office, and left. Alan and Steve tried to rally the troops, reminding us to deny everything, just like Watergate. Panic swept the table. What chance did we have of concealing the truth if Pete Anderson had broken down?

After lunch I went to health class. I was sweating and out-of-body nervous. I couldn't sit still and my mind raced, yet it's the only discussion from health class that I remember. Mrs. Walsh was talking about pizza as a health food. The conversation drifted from diet to exercise. Mrs. Walsh mentioned that exercise is good for you because it quickens your heart rate, which strengthens your respiratory system. Then Lenny King—I still recall looking at his Grateful Dead T-shirt and trying to figure out how to pronounce *Aoxomoxoa*—said, "Cigarettes increase your heart rate, right? That means smoking is a respiratory workout too, only it's better because I don't have to change into my gym clothes or get all sweaty. Smoking is relaxing."

Just as Lenny was building his case, the principal, E. Clyde Cullum, came over the loud speaker.

"Mrs. Davis, please send Mike Faloon to my office *immediately*."

Most of the kids in my health class didn't know my name. They were surprised to see the quiet kid in the back leave the room.

I knew why I was being called down, and even though the joke had only lasted for a week, I knew what to do: deny everything. Stay calm. Be polite. Listen carefully. Say no. Just like the guys in Watergate. Just like we had planned.

E. Clyde was sitting at his desk when I entered the office. The guidance counselor, Mr. O'Neill, paced in front of the window. E. Clyde leaned forward, elbows on desktop. I wasn't sure

he noticed me. Then he asked how I was. He talked about the weather. He asked about my plans after graduation. I reminded him that I still had a year to go.

Mr. O'Neill seemed impatient. He stopped walking back and forth and rolled his eyes at E. Clyde. Then he took the reigns.

"What Mr. Cullum is getting at is that we've got a situation here at school. A lot of people are concerned." His eyes shifted from E. Clyde to me. "A lot of teachers are concerned and we could use your help. We don't want you to get in trouble for something you didn't do. Do you know anything about this May 25 joke?"

"No, I don't, Mr. O'Neill."

"Hmm. Do you know anything about kids passing out notes to teachers?"

"No." Deny everything, I reminded myself.

"That's interesting. I hope it's true." Mr. O'Neill picked up a clipboard. E. Clyde shuffled papers. "Do you know anything about a letter sent out to students about a practical joke?"

"No."

Mr. O'Neill flipped through the papers on his clipboard. I thought I saw a copy of one of Pete's letters. "Did you know that every typewriter makes distinctive marks? They're like fingerprints. The F.B.I. can trace a letter back to the typewriter that produced it. It's a remarkably accurate process. Are you sure you don't know anything that we should know about?

"No." I cleared my throat. "I mean, yes, I am sure."

Mr. O'Neill glanced at E. Clyde. They nodded and paused. I waited. And that was it.

"We will get to the bottom of this and you should know that permanent records will be affected," said E. Clyde. "College is coming up. Think about that and let us know if you remember anything we should know. You can go back to class."

I was thrown by the typewriter question and distressed by the reference to permanent records but I didn't name names. It was

clear, however, that they knew more than they were revealing. After school I learned that about a dozen guys had been called down. They asked questions. We denied. Heads were nodded. They sent us back to class. Except Pete. They lowered the boom on him. E. Clyde and Mr. O'Neill played bad cop/bad cop. They threatened to press charges. Pete walked out to his truck, got the remaining copies of the original letter and the last of his notes, and told them everything he knew. That night Pete called and filled me in. He wanted me to know that there was no use in further denial. He felt guilty and was ready to be the fall guy. None of us blamed him. If Pete couldn't handle the pressure, we accepted the fact that for all of our intentions, we would have caved too.

Over the next couple of weeks how we got caught leaked out. Turns out one of the Anarchy Eight, Marcus Miflin, the dumb bastard, had written "Be Aware" on the art teacher's desk calendar, and of course, he wrote it on May 25. The art teacher recognized Marcus' distinctive lettering and shared this observation at the next staff meeting—the teachers were having weekly staff meetings to decode the mystery of May 25—and then they watched who Joey talked to between classes and ate lunch with. The teachers collected the notes. They analyzed the handwriting and watched for suspicious behavior. They pieced together most of the puzzle but they never figured out what H.R.H. stood for. They ran the initials through the school's computers, the district's computers, and the state's computers but no matches were found. It's too bad we had no agenda because we certainly had their attention.

The second time I was called down to the office they didn't ask any questions. They dangled a bunch of unpleasant possibilities in my face—being kicked out of school, having to transfer to a private school, ruining my permanent record, which would prevent me from getting into a good college and could limit my job options in the future. I had never thought of my job options until I was told they were in jeopardy. To make me squirm

they said they would let me know their decision in a day or so. I skipped dinner that night. I went up to my room, put my speakers in the window frame, and climbed onto the roof. I put on the longest, quietest songs I could find. After a couple of records I climbed into bed but I didn't sleep well. I spent a lot of time wondering which branch of the military I would be entering.

The next day I was called down to E. Clyde's office, again during health class. He told me that I was being suspended for a day. I waited for the other shoe to fall, the part about having to go to summer school or perform community service or transfer, but it never came. After all of my worrying, my punishment was to stay home for a day.

That afternoon I was inducted into the National Honor Society. I couldn't get over the irony of standing on stage in the darkened auditorium—the only light coming from the thin candles we held—and, the day before my suspension, pledging to uphold the "high purposes" of our school's chapter of the National Honor Society.

When I came back to school word about the Anarchy Eight was out. Everyone wanted to know what had happened. It was hard to get near Pete's locker that week because there were so many people hanging around. Anarchy symbols started showing up all over the school. Pete joined a band and they started playing parties. He could have run for class president.

Pete received the most attention but there was plenty to go around. I got my share too. Heads turned and people whispered as I walked down the hall. I was no longer anonymous. Kids treated me like a returning war hero. Grins from girls I didn't know, pats on the back from jocks that hadn't spoken to me since junior high. They asked a lot of questions. *What was it like? How pissed are your parents? Why did Pete get suspended for three days and the rest of you only got one day?* Teachers, on the other hand, treated me like a war criminal. For days I dodged their cold stares. The harshest judgments seemed to come from teachers I'd never had. I knew

that when they looked into their proverbial crystal balls they saw a deadbeat in the making, a guy with a litany of mug shots, finger printings, and criminal background checks paving his way to Sing Sing.

Ms. Baylor was the only teacher who spoke to me about the incident. I wasn't in her class at the time, but about a week after my suspension she stopped me in the hallway.

"Listen," she drawled, pausing to sip her coffee and make certain she had my attention, "everyone makes mistakes. Make sure you learn from yours."

For years, as May 25 approached, I thought about Pete and Ms. Baylor. I thought about E. Clyde, too, and wondered about my permanent record. It wasn't until I became a teacher, and was required to submit to an FBI background check, that I knew for certain that E. Clyde had been bluffing.

Sex, Drugs, and Pre-Cooked Sausage

I am not impressing the Wendy's manager. Not in the least. She's not saying much as she reads my application. She's not looking at me either. I try to interpret the loud sniffs and nasal exhalations that rise and fall between her curt questions. The message is clear: I am not going to get the job. I press on. I smile. I resist the urge to drum my fingers on the table or tap out a beat with my sneakers. I have rent to pay. College is over and my savings are low. I've waited weeks for an interview of any kind. I can make this work. Then she asks about my hair.

"We don't allow hairnets. Are you willing to cut your hair?"

"No," I reply, more in surprise than in defense of my shoulder-length locks.

"Well, then that concludes our interview."

"I guess it does."

She stacks her papers and shakes my hand, and I walk out in disbelief. I don't care about my hair, but I can't believe that I'll have to make compromises in order to work a deep fryer and fill Frosties. I didn't expect there to be any effort involved in landing a job that pays four bucks an hour. This is supposed to be a stepping stone to the real job that awaits me. I have no idea what the real world is looking for.

My next interview is at the Pizza Palace. I meet my prospective manager in the booth closest to the front door. His name is Carl. He has a gap-toothed smile and a disheveled Beatle haircut. As I approach the booth I think I overhear him singing a Kiss song. Carl seems distracted as he introduces himself, watching a woman at the salad bar.

"Now she's pretty, right? Not K-Mart pretty, but real pretty. Don't you think?"

I try to picture K-Mart pretty while Carl reads my application.

"I see you've worked in restaurants before. Inn of the Seasons in Syracuse—sounds nice. Ithaca College dining halls—that'll help."

He reads and nods.

"What do you listen to?"

He looks up and sees the confusion on my face.

"You know, for music?" His eyes leave our conversation as a waitress walks by with a tray of drinks.

"I've been into *Dressed to Kill* lately," he continues. "Kiss. '75. 'Room Service,' 'Getaway,' 'Rock'n'Roll All Nite'—kicks ass from head to toe, except the crummy acoustic song at the end of the first side. I've always liked Kiss better than Led Zeppelin. Who do you want to party with: the guys who totally kick ass *and* dress like superheroes, or the guys who kind of kick ass but also sing about misty mountain tops and houses of the holy? Who the hell needs that? I want to rock not meditate."

I can't fault the man's logic. I tell him I agree.

"Cool. Someone quit yesterday. You've worked in food service. You've got good taste in music. When can you start?"

The next afternoon I fill out paperwork, pick up my hat, shirt, and apron, and watch a series of training videos. If all goes well, the videos inform me, I'll soon rise to the rank of certified Dough Master.

I've been working at the Pizza Palace for about a month when I pick up a double shift. I need the money and I have a couple of days off coming up. My girlfriend and I are going to visit her parents, so it'll be easy to recover from the 16-hour day. The morning of the double shift, Doug, one of the managers, greets me at the door with questions and a scowl.

"Why are you here?"

"I'm working today," I yell.

"No, that's not right." We're still conducting the conversation through the locked glass door. "Carl said you aren't coming in until this afternoon."

I have to argue my way into work. This has become a routine with Doug. He sees himself as the ultimate pizza-making machine, one whose efficiency is compromised by the presence of others. He functions best alone; I only get in the way. He is the Pizza Palace Rambo. He wants to show Carl that his shift is the most cost effective, the one on which people clock the fewest hours. My goal is to work for 16 hours, to keep busy enough to avoid being sent home. In his estimation I am like the South Vietnamese, an ally only on paper.

Once convinced that I am on the day's schedule, that I am there on official Pizza Palace business, as opposed to showing up unannounced at seven in the morning to undermine his mission, Doug relents and opens the door. "Start greasing pans." He talks to me over his shoulder as he scurries back to the prep table, barking out orders like we are an EVAC unit coming under heavy fire. "We're low on mediums and personals. Hit the mediums and personals!"

Doug. Nineteen. Married, a father of two. He resembles a rain-soaked sheepdog, tall and heavy set with greasy black hair matted to his forehead. He acts more like a junkyard dog, feisty and protective. I ask if he needs help making dough.

"Just grease pans like I told you. You're not ready for making dough."

As I press the plunger on the grease bottle, covering the bottom of each empty pan with oil, Doug cuts and weighs dough for the various sizes of pizza. He makes the process look like sleight of hand. When he needs six ounces for a personal pizza, he lops off a piece of dough, tosses it on the scale and sends the needle to exactly six ounces, never needing to add or remove dough from his first attempt.

Doug and I work side-by-side through the morning. We don't talk. We don't listen to music either. Doug is distracted by music.

While I am "timing the ghost," checking the oven by sending an empty pizza pan, aka the "ghost pan," through the oven and verifying that its journey takes precisely six minutes, the first waitress, Nan, checks in. She flips on the local college radio station and puts on a pot of coffee as she sings along with the oldies show. Everything about Nan is long: her face, her legs, her curly waist-length hair. Nan is constant motion, like she has a slinky for a spine. She dropped out of college to follow the Grateful Dead and ran out of money in Ithaca.

"'*Hold on, I'm coming'*…I *love* this show!"

Nan and I have worked together before. She freaks out when I told her I used to work at the college station. I tell her about the time I had the shift before the oldies show, but she wants to know about Rude Boy, the station's reggae host.

I don't have the heart to tell her that the raspy-voiced Rude Boy, the guy who comes across the airwaves like the second coming of Bob Marley, ready to lead listeners out of Babylon, is a nerdy Long Island kid named Mitch who drives a Saab, so I just say he's a nice guy.

Nan takes this to mean, "I smoke pot by the pound and I purchase vast quantities routinely." My distant connection to Rude Boy convinces her that I have a Keith Richards-like appetite for chemicals, and once she believes that we are pharmaceutical fellow travelers, the floodgates open. She introduces me to her dealer when he comes by the back entrance one morning, acting as if it

is the neighborly thing to do, like she is introducing me to the mailman or letting me borrow a cup of sugar. Nan is also the first person I ever see do cocaine. She sets up a line on a piece of tin foil—right there on the prep table as I am filling up the sausage bin—making no effort to conceal anything. I decline her offer to "party."

Nan also has the habit of disclosing details about her life that I'd rather not know about. This day is no different. As I wipe down the prep table, she approaches me shaking her head, laughing at the tale she is about to tell. She is looking down at her chest, cupping her breasts through her uniform. She calls Doug over, too.

"Last night I was having sex with my old man and he gets this funny look on his face and he starts laughing, right? He says my boobs remind him of a day at Disney World so he names them. I want you to meet Mickey and Donald." She lifts each breast as she makes the proper introduction, thus reducing the chance that we might confuse Mickey with Donald or vice versa. That could get awkward.

Doug says that Carl wouldn't approve and goes back to work. Apparently he and I know different sides of Carl. Nan walks to the waitress station, still laughing and cupping.

By 2:00 the lunch rush is over. I'm seven hours into my double shift. This is the first pause of the day. I go for the mop bucket before Doug can say a word about sending me home early. Then he and I do most of the prep work for the dinner shift, while Nan and two other waitresses wait tables. I walk down to the basement for my meal break. A few minutes later Nan joins me.

"Doing the dreaded double, huh? What was it like working with Doug this morning? Weird guy, right? Has he told you where he lives? He told you about dropping out of high school and getting married when he was 17, right? Well, his wife, Nancy, they met here—she used to be a waitress—her parents wouldn't let them get married unless Doug and Nancy lived on their property.

You know, so they could keep an eye on them. They had a log cabin built but, get this, they don't have a phone—it's 1991 and they don't have a phone! They live about 200 yards from Nancy's parents and they use a HAM radio to talk to each other. No one can ever get a hold of Doug because you have to call his in-laws who radio Doug who then comes over to use the phone. They're freaks! That's probably why Doug didn't know about you coming in this morning; he probably didn't get the message."

I picture Doug and his wife living in a log cabin, him clad in buckskin, her churning butter and curing squirrel meat for the winter months.

My first month at the Palace has been odd but my duties are what I expect from a fast food job, preparing food when it is busy, cleaning up food when it is slow. I realized that the difference between a fast food joint and a restaurant is not how quickly your food is prepared or the absence or presence of wait service, it's whether or not the people who make your food also haul the garbage out to the dumpster.

After lunch I fold pizza boxes. I finish and ask Doug if I should make up the next batch of dough. He just shakes his head. He is about to clock out when he sees me reach for a red toppings cup while working on a medium pizza. He sets his coat on the front counter and huffs over to the prep table.

"Always use the *medium* cup when measuring toppings for a medium pizza," Doug instructs me, disgusted. He holds up the blue medium size cup next to the red large size cup to illustrate his point. Doug thinks I am brain damaged.

"The large cup," he says, gently shaking the object in question, "is for large pizzas only."

I want to point out that 2/3 of the large cup is equal to the medium cup. I've checked. I use the red cup for everything to reduce steps, work a bit faster.

Despite this I am the slowest employee at the Pizza Palace. I can only guess that Doug attributes this to my diminished mental

capacity. He repeats his explanations, distilling his directions down to the adjectives.

"Remember, the blue cup is for mediums and the red cup is for larges. Blue, medium; red, large. Got it?" He watches me place chunks of sausage and sprinkle green peppers on the medium pizza I'd started before his lecture, verifying my compliance before shaking his head and leaving.

Typically by this point in the afternoon I'm tired and ready to leave, watching the minute hand slowly swing across the final minutes of my shift. But the thought of having three days off brings a second wave of energy. Before leaving Doug tells me that the next manager is running late, so in the meantime Tex is in charge.

Tex really is from Texas, though I can't believe he has actually accepted "Tex" as a nickname. I never learn his real name, first or last. We've probably worked together a dozen times. He never makes eye contact with me. He always looks over my shoulder rather than at me. This habit reminds me of Al Pacino. I try to convince coworkers to change Tex's nickname to Al or Pacino or Corleone or Serpico or Heat. I probably deserve the subsequent blank stares.

I hear Def Leppard blasting from the kitchen. Tex has arrived. We have tried sharing the boom box in the kitchen, a side of his tape, then one of mine, but we both cheat. He listens to the same tape for days at a time. Lately it is Def Leppard's *Hysteria*. I've come to know it well. I know that "Love Bites" isn't the last song but I lunge for the eject button anyway, desperate to avoid "Pour Some Sugar on Me."

"What's up, dude?" Tex whines, throwing my cassette over his shoulder and returning his tape to the boombox. He grabs a sauce ladle and belts out the lyrics, eyes closed tight, fist pumping. Picture Will Ferrell with a mullet and a dirty blonde Hitler moustache, hips quivering like a power line is clipped to his gonads.

Tex moved from Houston to work at the Pizza Palace. He'd been working at a hardware store and moved to Ithaca when his cousin, a former manager, told him he had connections at the Palace. Tex spent three hundred dollars on airfare and moved half way across the country to reap the benefits of a fifty-cent raise. He would have to work six hundred hours to make up the difference, and that was before taxes. Yet this Fortune 500 dynamo has been granted Dough Master clearance and sits a notch above me on the Pizza Palace totem pole.

Like Doug, Tex works incredibly fast and he thinks I am incompetent. After going to his car to retrieve more tapes, Tex returns to the sight of me holding a red cup, slightly overflowing with onions.

"Give me that, college boy. You have to make sure all of your toppings—your onions, your peppers, everything—never go over the top of your cup. Carl's picky about that. You should use your finger to level off the toppings. Like this. Watch." He assumes I can't follow his description and demonstrates his patented move-your-finger-across-the-top-of-the-cup-in-order-to-push-the-excess-diced-onions-into-the-bin move. "And double check your pepperoni counts," he says, eyeing the ticket for the next order, "Carl's crazy about keeping the counts down on sliced meats."

I'm surprised that Tex is so concerned about onions. I find it even harder to believe that Carl, the guy who hired me because I liked Kiss a little more than Led Zeppelin, cares enough to tabulate the actual number of individual meat slices used each day, but I do my best to comply.

This is true of everything that I'm asked to do at the Pizza Palace, but I have been unsuccessful in changing the perception that I am a moron. Never once am I allowed to handle money, take an order, answer the phone, or speak to a customer. I am like the clinically insane brother the family keeps hidden away in the attic for his own good. Several times I ask to be trained in the ways of the Dough Master and the response is always, "We're not ready for

that yet."

To put myself at ease I think about my search for a real job. With no small sense of arrogance I tell myself that it doesn't matter how well I perform at the Pizza Palace. My coworkers are destined to stay at the Palace while I am bound for better things because I am smarter and despite my performance at the Palace, I think I am more capable, too.

I've had worse jobs. When I worked at a recycling plant I came home every night with black soot dripping out of my nose from the dust I had inhaled, caked a quarter inch thick on the old pamphlets and brochures dropped off from a nearby military base. The break room had no heat and the seats were old van benches set on cinder blocks. But I held my own. I knew I was only there for a limited time; I could point to my last day on the calendar. My job at the Palace is the first time I am working without a set departure date, an upcoming semester or break to signal that it's time to move on. That coupled with my relative incompetence is frustrating and humiliating. If I am so smart why haven't I figured out how to cut dough as accurately as Doug and top pies as fast as Tex? Why can't I be trusted to interact with the public like Nan the coked up Deadhead? Why am I still denied Dough Master status?

As the dinner rush approaches, Tex clocks out and I prepare for my first night shift. Despite the late hour I am looking forward to the experience, a chance to work with different people, a break from the day shift loony bin.

The shadows are growing long when I take out the next round of garbage. It's five o'clock. Six hours left. The morbid music coming from the kitchen catches me off guard. I don't recognize the guy standing near the prep table, checking the order slips. His face is freckled and he keeps checking the part in his hair, combing his hand through his red locks. He is humming along with the song, which I later learn is Amy Grant's "El Shaddai." Like a young Ward Cleaver he wears a button up sweater and

sensible loafers.

He introduces himself as Bradley. He is the night manager. He offers me a piece of garlic bread and asks me to mop the entrance. He is polite and he has offered me food outside the parameters of a meal break. This is a welcome change.

Only a handful of tables are occupied and the phones are quiet. We talk as the night goes on. Bradley dropped out of high school the year before and proposed to his girlfriend. He is working on his G.E.D.

I am seeing a different side of the Pizza Palace. Bradley even shows me how to run the register. About a half hour before closing, the Palace devoid of customers, we sit in a booth eating a take-out order that wasn't picked up. One of the waitresses, Diane, joins us. She is down to earth, like Bradley. I'm curious to know what they think of Doug and Nan and Tex and Carl. Especially Carl.

Diane thought Carl was all right at first. Then she walked in on him having sex with Nan. "His pants were at his ankles and her bare butt was on the prep table. It was so gross."

Bradley added that he had walked in on Carl with other waitresses. Though repulsed by the tales of workplace sex romps, I am relieved to learn that I am not alone, that someone else at the Palace shares my perspective. "*Our* co-workers are nuts" feels better than "*My* co-workers are nuts." Less elitist and judgmental.

At this point I drop my guard and talk about the time I saw Nan doing lines of coke. Both Diane and Bradley respond, but not like I expect them to.

Diane does coke, but "only during hockey season." She parties with guys from the minor league team in nearby Binghamton. "It always snows when a guy gets called up to New York."

Bradley talks about the first time he got high. "We were hanging out in my buddy's basement and his older brother offered us a joint. I got so messed up when I was walking home I tripped

and fell. I wound up sleeping in the woods all afternoon. I remember waking up scared of my own shadow. I stumbled home and crawled into bed. It was awful. A couple days later my friend told me that his brother gave us a joint with PCP in it."

Prior to that night I was certain the PCP-laced joint was a legend, the sort of myth cooked up by the people who gave us "This is your brain on drugs." But Bradley set me straight. Apparently the night shift is like the Pizza Palace retirement home, a place for employees who have slowed down or mellowed a bit, a *Love Boat* for Pizza Palace people.

I am exhausted when I punch out that night, propped up only by the sight of 16 hours on my timecard. I change into clothes that don't smell like the dishroom and toss my apron, hat, and uniform into the trunk of my car, thinking about the times I have explained my bizarro job to friends. When they eat at the Pizza Palace the service is friendly and prompt, and the food is fine. There isn't a ripple on the pond. And that's the rub, for all of their behind the scenes decadence, everyone at the Palace does their job pretty well. I would like to say that there are consequences to living like Caligula, but the Pizza Palace offers no evidence. Life outside of the Palace doesn't impact my co-workers' ability to make and sell reasonably priced pizza and pizza-related products.

I should point out that the task being withheld from me, that of Dough Master, the job that was placed on the highest shelf and kept beyond my reach like a bottle of Drano, is, in fact, 100% idiot proof. The process of making dough at the Pizza Palace has been broken down into a color-coded system that requires minimal strength and only the weakest sense of sight. Literacy is not a prerequisite. If you can distinguish blue from red, then you qualify. It is a procedure you could have done while taking a break from finger painting back in kindergarten.

The Dough Master duties go like this: Pour the blue bag of dough mix into the mixing bowl, fill the water pitcher to the blue

line, turn the dial on the mixer to "medium," which is written in half-inch blue letters, and press the start button. No need to watch the clock because the mixer has an automatic timer. Blue bag, blue line, blue letters, start—I am Dough Master, hear me roar. Or at least I would be if any one of my superiors had the slightest bit of confidence in me. I don't care about the Dough Master pin that the official Dough Masters wear on their Pizza Palace hats, but I can't figure out what else to do in order to be upgraded to "competent."

I try to imagine the worse case scenario envisioned by my Pizza Palace managers as they gather before banks of computers in their war room to simulate pizza making maneuvers gone wrong, the horrifying possibilities that led them to thinking, "Faloon? Dough Master? Impossible!" Here is the worst scenario I can picture.

Setting out to make a medium batch of dough, I pour the blue bag of mix into the mixing bowl. I fill the pitcher to the blue line. But then I become so enthralled by the sight of that big mixer that I lose focus, basking in the aura of that enormous, claw-like mixing hook and all its wondrous ability to turn ordinary water and dough mix—be it a green, blue, *or* red bag of dough mix— into perfect dough that I set the dial to red, not blue; large, not medium. A tragedy is set in motion. The dough is mixed for two minutes longer than prescribed. The customers are none the wiser, but Pizza Palace and its stockholders are forced to fund an additional two minutes of electricity. I cannot imagine anything worse happening, and I never get to find out because I am soon fired.

A couple of days after my double shift, while we are visiting her parents, my girlfriend comes down with the flu. I call in sick so we can stay an extra day. My girlfriend doesn't want me to miss a shift. Neither did her parents, who offer to buy me a plane ticket. Spending a couple of hundred dollars to make thirty bucks at the Pizza Palace doesn't make sense to me. Carl disagrees.

When I get back to my apartment there is a message from Carl asking me to come into work as soon as possible.

"You're supposed to get someone to cover your shift," he tells me as we sit in his office. "You can't just call in sick and not show up. It doesn't work that way. We no longer have any work to offer you."

I try explaining the situation—about being four hours away, my girlfriend being sick, about not having phone numbers for the other employees—but Carl cuts me off.

"We no longer have any work for you. You can go now."

The Carl who fired me isn't the Carl who hired me. I have experienced Carl, Ogler of Woman, and Carl, Fan of Classic Rock, but prior to getting fired Carl, Taskmaster has remained a distant myth, a figure I've heard about but never encountered.

In the days to come I try to make sense of Carl's contradictions. He may work hard to make the time go by faster or keep his bosses off his back, maybe even hope for a promotion, but Carl is not a company man, he is a Carl man. He does what he needs to do and no more, just like everyone else at the Pizza Palace. For me, working at the Palace is like being behind the scenes with a moderately successful touring band or semi-successful pro sports team—people's habits haven't caught up with them, don't affect their performance. They can shake off life outside of the Palace, switch on autopilot, and deliver what is expected of them, and their audience is none the wiser. These might not be the employees that are chosen to appear in training videos or flown to Topeka to lead seminars, but they get the job done.

As I walk out of the Pizza Palace for the last time Carl fills out paperwork and sings to himself. He's paraphrasing a Kiss song. "I want to rock'n'roll all night and just get through every day."

Leon Tries Anyway

Robbie clutched the mic stand with both hands and screeched. "Good afternoon, Split Rock High!" Leon's opening guitar chord followed. A bit of faux British accent slipped into Robbie's voice. "We are the Queenhaters! AND WE HATE THE BLOODY QUEEN!" He ripped off the Donald Duck hand puppet, previously duct taped to his garbage bag toga, and tore the toy to bits. As the trombone played "Ol' Brittania" all eight members of the audience, judges for the upcoming talent show, watched the bits of tattered duck fall at their feet. The drummer swatted four beats on the hi hat and the band kicked in, Robbie, graceful as a pile driver, stomping around as if the force of his feet on the floorboards could make everything right. The Queenhaters were in public for the first time. They were no longer crammed into Leon's basement, surrounded by his dad's sprawling electric train. The band was swallowed up by the expanse of the stage. They felt small, like a grain of sand before Mt. Rushmore, so they played loud. This was their chance to redeem Leon, who focused on his fret board and pretended not to notice Katie among the judges. The yearbooks had come out that day—complete with Leon's confession—just three days after Katie was startled by the appearance of a dozen roses on her front porch.

* * *

Robbie watched the speedometer needle climb as the van sailed through another green light.

"Six down, 12 to go," he yelled over the music. "We're going to set the record."

Leon and Robbie were driving to the university district. It was several months before they started the Queenhaters. Leon wanted to buy the new record by the Shoplifters, a local punk band. Robbie hated punk. He wanted to trawl the used record stores for cheap party albums—AC/DC, Molly Hatchet, Aerosmith. Robbie also wanted to make all eighteen traffic lights between Salina and Marshall streets.

Leon turned down the stereo. "Just don't kill us before I get that Shoplifters record."

The Shoplifters had recently released their debut EP, *Shoplifting Is Not a Crime*. It was not being sold in stores. The Shoplifters' apartment was the only place in town one could buy a copy. Danny Shoplifter was a punk purist who refused to let Shoplifters records fall into the hands of poseurs or preppies or worst of all, metalheads. He interviewed potential buyers to insure that they were worthy of owning the band's record.

Leon had heard the rumors about Danny. If Danny approved of a potential fan, he would sell the record for three or four dollars. If he wasn't sure he might test someone on punk history or refuse to sell the record. If he was pissed off, Danny, a military history buff, would pose a series of questions about the Peloponnesian Wars, take twenty dollars for the record regardless of how accurately his questions were answered, then kick the person out of the apartment empty handed.

The van's cassette deck made an audible click, reversing the tape's direction and returning to side one. Leon pressed eject and tried putting in a mix tape his older brother had given him.

"That last one was nine, right? This is ten?" Robbie counted the traffic lights aloud. "Pay attention here, Leon, you're witnessing history, like *You Were There*, but this is better than

watching Eli Whitney drone on about the cotton gin."

"This next one is eleven," Leon said, the cassette deck ejecting his tape.

"It knows what kind of crap you're trying to put in there," Robbie joked. "Is this the punk song about puking or is this the punk song about stabbing?"

Leon pushed in the cassette once more. "This is the Shoplifters."

Robbie listened. "What are they singing?"

"'I wanna work for Ed Meese.'"

"The guy who worked for Reagan? How long do these guys hold a grudge?"

"They're kidding."

"They're also about five years behind the times. You're going to get sick of this, just like you did with Dylan."

Early sophomore year, not long after his stint with Wrenchy Barnello's band, Leon's tunnel vision had latched on to Bob Dylan. He obsessed over Dylan for months, especially the early folk records like *The Times They Are A-Changin'* and *Freewheelin'*, with its cover of Dylan and his girlfriend huddled together, walking in the streets of New York on a winter morning. Dylan's cocky smile saying, "I've got everything you'll ever want, kid. Figure it out for yourself."

Leon swore off rock music. He gave away his albums, including his coveted copy of Jethro Tull's *Stand Up*, the gatefold version with a paper pop-up of the band members. He traded his Fender Strat for an acoustic, and he started wearing a cap and tucking in his flannel shirts. Next stop: Greenwich Village, a high-minded working stiff on the scene at Café Wha?, taking a break from bussing the people's tables to strum a few message-laden songs, slaying the fascists with earnest insights about life as a working man.

Robbie had no interest in listening to songs about striking coal miners and he told Leon that the cap made him look like a

171

tugboat captain. Robbie considered Dylan a sonic earwig, possessor of the most irritating voice to ever infest an album. To Leon that had been the substance-over-style point.

The eighteenth traffic light turned yellow before Robbie entered the intersection. The next light was red so he pulled into a parking space. He pounded on the steering wheel, celebrating, as Leon got out and fed the meter.

"The Shoplifters' apartment is on the way to that used record store I was telling you about," Leon said.

"This is what serial killers do," Robbie said as they climbed the rickety stairs to the band's second floor walk up. "They lure teenage boys to their love nests and the next thing you know you're being sliced and diced and stored in the guy's freezer next to a box of fish sticks."

Leon knocked on the door. "I'm just going to buy a record. Don't be so dramatic." The words were just out of his mouth when the door opened, its frame suddenly filled with the sight of a young man, not much older than themselves, bare-chested and sporting a red Mohawk.

"The hell you want, whitey?"

"I want to buy a Shoplifters record."

"Danny! Customer!" yelled Red Mohawk, still sizing up Leon and Robbie. "Have a seat. Don't interrupt the movie."

Leon and Robbie sat at the kitchen table, the only area in the Shoplifters' apartment devoid of filth. The little sunlight that crept into the apartment fell upon walls covered with photocopied flyers. Beneath them were layers of phone numbers and song lyrics and drunken scribblings best described as Robert Crumb without the tact. The exception, centered floor to ceiling behind the television, was a confusing though stunningly rendered composite superhero—Thor's winged head had been placed on the massive jade body of the Hulk who was wearing the Black Canary's fishnet stockings and lifting his arms to reveal Spiderman's armpit webs. The floor was thick with empty cans

and pizza boxes and broken drum sticks. The sink coughed up stacks of dirty pots and plates encrusted with what might once have been mac and cheese.

Taxi Driver played in the next room. At first neither Leon nor Robbie noticed the other guy on the couch, the one with a curly powder blue coif.

"At least Jeffrey Dahmer kept a clean house," Robbie whispered. "That's all I'm saying."

Powder Blue Coif rewound the movie. Travis Bickle held a closed fist over an open flame. Powder Blue Coif stared at Leon and Robbie and rewound the movie again.

There was a flush and Danny Shoplifter emerged from the bathroom yelling at Red Mohawk. "The floor's wet again, Eric. You said you'd tighten those bolts on the toilet." Danny pulled up his suspenders and wiped his bald dome with a handkerchief before joining Leon and Robbie at the table, his back to the television. "Why should I take your money?"

"My brother put some of your stuff on a mix tape," Leon replied, "and I can't get that Ed Meese song out of my head."

"So, your brother stole my music."

"I, uh…"

"Why the hell do you want to buy the record if you already have the songs on tape? Do you have a vinyl fetish?" Danny asked.

"A what?" said Leon.

"Are you a materialist?" Danny demanded.

"Shut up and give him the record, Danny. There's five hundred of them under the sink," Red Mohawk shouted. "We're watching a movie."

Danny dodged a drum stick launched from the TV room.

Leon felt the record slipping away. "I heard that you guys put the record out yourselves, and I want to do my part to help you raise the money to release another one."

"So you're a boy scout."

"We should just take a record," Robbie said. "They're called

173

the Shoplifters, right?"

Danny grinned.

"Who's your brother?"

"Jeff Rayner."

Danny got up from the table. He pulled a cardboard box out from beneath the sink.

"He drove us to a show in Buffalo once. Good guy. Tell him to fix the heat in his van." Danny handed Leon a copy of *Shoplifting Is Not a Crime.* "Three bucks."

Leon pulled the money from his wallet and thanked Danny. He turned the record from front to back, then again, ignoring Robbie's serial killer jokes as they descended the stairs.

Fluorescent lights illuminated the cafeteria at Split Rock High School. Bed sheet banners announced an upcoming dance, a pep rally for the lacrosse team—the Birds of Prey were vying for their fifth straight county championship—and the following week's talent show auditions. A custodian used a snow shovel to push milk cartons and junk food wrappers across the tile floor. Robbie sat alone at a hexagon-shaped table in the back corner of the crowded cafeteria, nearest the garbage cans. He pushed up the sleeves of his sweatshirt and turned the page of a magazine. He kept reading as he reached into a bag of potato chips. He didn't notice Leon approaching.

"I've got a title for our next album," Leon said, sitting down and opening a spiral-bound notebook. Few noted Leon's sharp facial features or his arms, which were probably a little longer than they should be. Most people, teachers and classmates alike, were distracted by his eyebrows, nearly white and jutting across his forehead at forty-five degree angles.

"I've got some too," Robbie responded. He wiped his hands on his shorts and pulled out a folded sheet of paper from his back pocket.

"What do you think of these?" Leon asked. "*Jocks at the Mall*

174

or *Too Many Crooks in the Kitchen*."

Robbie looked back at Leon blankly.

"How about *Out of the Heat and Into the Defying Pan*?" Leon offered.

"I don't get that: *Defying Pan*? *Defiant Pan,* maybe."

Leon was trying to convince Robbie to start a new band. He already had a name, the Angry Customers, and a sound, punk rock, loud, fast, and simple. Like their previous bands, the Tangerine Zip Code, a psychedelic folk band, and the David Bowie-inspired Whitey and the Midgets, named for Leon's prematurely graying hair, the Angry Customers existed only on paper, song titles, album titles, design concepts, and tour itineraries crammed in the margins of notebooks and on kitchen counter notepads.

Robbie seemed an unlikely ally. He didn't play an instrument and he didn't like punk. Leon, on the other hand, played guitar, though he hadn't been in a band for a couple of years.

Back in tenth grade Leon played a party with Wrenchy Barnello's band. They rehearsed once, a couple of hours before the party, got high enough to think that a twenty-minute rendering of "Crossroads" would be well-received, and wound up treating a basement full of teenagers—who started the night dancing and yelling and drinking and banging their heads—to a forty-five-minute epic. Wrenchy's band reduced a once packed room to a single sophomore passed out on the washing machine. Leon didn't get kicked out of the band because they had cleared the room— to a man all four members considered it a great show—but rather because Wrenchy found another guitarist, someone who could score cheap weed. Even after Leon converted to punk rock, that party, that chance to perform in front of other people, remained his ideal, the place he wanted to return to.

"'*Defying*,' '*Defiant*,' either way it sounds like a concept album about rebellious cookware," Robbie said. "Were you really hungry when you thought of these?"

"You made your point," Leon said. "Read some of yours."

"Here's one I just thought of: *Anarchy in the Silverware Drawer.*"

"C'mon, Robbie."

"Ok, I have two: *Rock'n'Roll Schmucks* and *Sponsored by Pepsi.*"

Leon shook his head in disgust as Chris Duncan walked past their table.

"I was kidding."

"Not you. I was shaking my head at Chris," Leon said. "He was flirting with Mrs. Hidy again."

"Who?" Robbie asked.

"Chris and Mrs. Hidy. They were talking about healthy dating practices in bio."

"You should ignore all dating advice from people who wear bifocals and smell like moth balls." Robbie waited for a laugh that wasn't forthcoming, then continued. "You can't let that stuff get to you. Chris is a suck up. Yesterday in calc he was talking about red wines with Mr. Fahey. The more time they waste the less work we have to do. It's their public service."

"It's like these popular kids remind them of the popular kids who ignored them when they were in high school," Leon said.

"What?"

"Never mind."

Robbie caught sight of the talent show banner as he opened a package of peanut butter bars. "So what do you think about auditioning?"

"We can't learn a song in a week and I already told you I don't want to lip synch."

"You have a guitar. I'll sing. Tim can borrow his brother's drum set. And Bean will play bass if we ask him to."

"Neither one of those guys can play an instrument."

"Tim used to play tuba. Besides we're just lip synching, Leon."

"It's too cheesy."

"We can start a real band some other time. We've been doing

these fake bands forever." Robbie crumpled his lunch bag and tossed it toward the nearest garbage can. He turned away when it missed and landed on another kid's tray. "At least lip synching will get us on stage. It's a dumb idea but you can't spend your whole life hanging out in your bedroom."

Leon sipped his milk.

"Tim's coming over to my house tonight," Robbie said. "We'll give you a call."

Mrs. Griggs sat on a stool, her cup of coffee cooling on the kitchen counter. "Robbie, turn it back to channel five." She coiled a dog's leash and set it atop a Pisa-like stack of magazines and junk mail. "Here's some space for you, Tim, make yourself a sandwich. I'm sorry it's such a mess around here. Aren't you chilly with no sleeves on that shirt?"

Tim wasn't hungry but he made a turkey sandwich anyway, getting a bit of mayonnaise on his fatigues. All of Robbie's friends knew better than to refuse Mrs. Griggs.

Robbie asked his mom again to borrow the van.

"Will you turn it back to the news?" she snapped.

Robbie thought his mom was avoiding him. He thought that a lot. The closest thing to bonding with his family came from watching TV with his dad, wrestling and westerns, mostly. Robbie relished rooting for the wrong side, audience baiters like the Iron Sheik and Nikolai Volkoff or the flawed heroes of Sam Peckinpah's blood-soaked morality tales.

Mrs. Griggs yelled at the family poodle, penned in the living room, then offered Tim a glass of soda.

"Mom, we need to pick up Bean Dip at the mall," said Robbie, referring to his friend and future bass player. He flipped the dial on the countertop television.

A new voice entered the fray, calling out from the bathroom down the hallway. "We're out of toilet paper again!" It was Mr. Griggs. "And will someone make that dog shut up."

"Close the door," Mrs. Griggs said to her husband, exasperated. "There are napkins on the back of the toilet."

"Mom, the van?" Robbie added a hint of whine for effect.

"Napkins are for my mouth," said Mr. Griggs. "They're orifice-specific. I need toilet paper!"

"Robbie, get some toilet paper for your father, and have the van back by midnight. And let the dog out."

The poodle ran ahead of Robbie and Tim, its barks fading as they stepped into the van.

"Dude, your dad used the phrase 'orifice-specific,'" Tim said.

Robbie shrugged. "They argue about whether we should keep the ketchup in the cupboard or the fridge." He changed the topic as he put the van in gear. "The talent show. What do you think? I'll sing. Bean Dip on bass. Leon playing guitar, and you can borrow your brother's drums. We'll do that Blues Brothers song I told you about."

"Dude, didn't the Blues Brothers have two singers?" Tim asked.

"You know I do a great Belushi. I'll borrow my dad's suit."

"Didn't the Blues Brothers have a horn section?"

"Do you want to do this or not?"

"I'm just busting your chops," Tim said, "you know I've always wanted to be in a band but Leon's never going to lip synch."

There are three entrances to the food court at the Split Rock mall, each marked by a fifteen-foot eating utensil, a fork to the west, a knife to the north, and a spoon to the east. A fountain lay to the south. At the base of the enormous fork, Bean Dip swiveled in a legless plastic chair. He slurped an Orange Julius and waited for Robbie and Tim.

Two hours earlier Bean Dip had been fired from Tracy's Cards and Such. Bean held jobs like sieves hold water. His personal crusades were to blame. He lost his job at Red Rooster

Mini-Golf because of a vow of silence. He'd been protesting the reinstatement of the draft though he never revealed the direct correlation between mandatory conscription and speaking with customers when handing out putters and stubby pencils without erasers. His latest obsession was the Electoral College. That's why his manager had refused to allow him to clock in for his shift.

"We're casual about attire, Bean, and we love the ponytail. We've compromised on the way your fellow employees address you, but as I've said before the nametags are not negotiable. They are not to be used for political purposes."

Bean Dip pushed back his hair and absentlymindedly fondled the three nametags pinned to his vest. They read, "Electoral College! Equals! Fascism!"

"The first time was a warning, Bean. We're going to have to let you go if you refuse to wear a proper name tag."

Bean Dip raised his cup, greeting Robbie and Tim, recognizing the latter's crew cut as soon as he rounded the corner.

"On this eve," Bean Dip said, "I was relieved of my professional obligations."

"Dude, again?" Tim asked.

Robbie and Tim sat down at the table and started eating the slices of pizza that Bean Dip had bought for them.

"Why did you ever get a mall job in the first place?" said Robbie. "Are there some Trotsky-ites you conspire with? Some Maoists over at the Earring Pagoda?"

"'Tis within the confines of the system that one must labor," Bean Dip said. He had the habit of speaking like his favorite fictional characters. He'd spoken like Captain Nemo for weeks after reading *20,000 Leagues Under the Sea*. Lately he was in the throws of *Dracula*.

Robbie sang sarcastically. "*Imagine all the people/Saving 25% on unicorn snow globes.*" Then he saw Maddie Rivers behind the counter of The Pretzel Shoppe. "How are things with Maddie, Tim?"

"I'm telling you, dude, she did like me," Tim protested.

"She held a door for you once," Robbie chided, "and you were carrying a tuba at the time."

They ate in silence for a minute. The quiet finally got to Tim.

"The other day Leon said girls are like math." He ate the last bite of his pizza. "Math's been part of school your whole life, but then one day you can't just add and subtract numbers anymore. It turns into calculus, and stuff that seemed normal one day gets really abstract and complicated. It's the same thing with girls. You've been in school with them since you were five years old but then one day you can't understand them anymore."

"Girls are like math? Are you serious?" Robbie said excitedly. "That's like comparing ice cream and leukemia."

"Dude, relax. I'm just telling you what Leon said." Tim mentioned the talent show as they threw out their plates.

"As we speak, the knowledge of where one might procure an affordable bass escapes me and the subsequent matter of performing compositions musical upon said device is a significant conundrum," Bean Dip said, "but the willful participation of friend Leon shall prove to be an obstacle most considerable in the formation of this ensemble."

The three walked past the giant spoon as they exited.

"What the hell was that, Bean? Really. Was there a 'yes' buried in that avalanche of 'I never want a girl to talk to me'?" Robbie asked.

"I think I know where we can get you a bass," Tim said.

Plans had changed two days later when Robbie arrived in Leon's basement, also known as Train Town—the walls wood-paneled, the carpet like a putting green—for the Queenhater's first practice. Leon sat on a folding chair, tuning a bass recently acquired from his cousin.

"How's it going, Snow White," Robbie greeted Leon.

"Check it out." Leon held up the bass for inspection.

"Twenty-five dollars. The neck is warped but it sounds all right." Leon was anxious to get started. "We've got to learn this song by Friday."

Leon had convinced the others to perform live. Rather than lip synch to the Blues Brothers they were going to cover the Queenhaters, a punk parody band from SCTV. Robbie, Bean Dip, and Tim, longtime fans of the reruns they taped from the local PBS station, loved "I Hate the Bloody Queen" for its lyrics, a satire of the simple minded side of punk's politics. Plus, it only had two chords. It would be easy to learn. Leon was thrilled. After years of drafting blueprints for bands, he was on the verge of pushing one of his contraptions off a cliff. He fought off black and white images of failed flying machines, backyard aviators with bushy eyebrows and crazy in their eyes; their dreams of flight resting in homemade canvas wings or quadruple decker devices that seemed all too willing to do gravity's bidding. The Queenhaters could work. And the talent show might go well with his plan to ask out Katie.

Robbie dropped his book bag and took out a videotape with the SCTV episode and a lyric sheet. He was mumbling the words to himself when the stairs creaked under the weight of a figure he expected to be Tim, with his borrowed drums, but was, instead, about six inches taller and a hundred pounds heavier. It was Leon's dad, Mr. Rayner.

"Hello, boys. Congratulations on the band." Mr. Rayner's voice rumbled, deep and deliberate. "Be careful with those amplifiers. They've got Russian tubes and I haven't changed them in years."

"We need to practice, dad. We only have five days to learn this song," Leon said.

Mr. Rayner stroked his beard. To an innocent bystander his smile suggested the consideration of adjustments to the placement of the amplifiers. Experience denied Leon and Robbie the privilege of such bliss.

"So, Mr. Rayner, what's new in Train Town?" Robbie asked, inviting the inevitable.

Train Town was Mr. Rayner's designation for the model train set that occupied the perimeter of the family's basement. "I took out all of the plastic buildings here on Main Street and replaced them with wood. They hold the paint better." He gently picked up the general store, blowing on its porch to verify that the paint was dry.

Leon leaned his guitar against the wall and rolled his eyes. "Dad, we need to get started."

Robbie sat down. Mr. Rayner continued.

"I've also been enjoying this." He handed Robbie an album titled *Authentic Sounds of the Ohio Central Railroad.* "You have a minute, right? The other boys aren't even here yet."

Leon was relieved to hear the basement door open. His mom announced Tim's arrival.

"Are all of these drums coming inside, Leon?"

Tim raised the drawbridge and set down the kick drum.

Leon and Tim went upstairs to get the rest of the kit.

"Lower the bridge on your way up, Leon," Mr. Rayner said. He lowered the needle on to the record, closed the dust cover, and turned his attention toward Robbie. "Wait for it…Wait for it…" He eyed the locomotive as it eased into motion. Mr. Rayner put on a conductor's hat. He offered one to Robbie who felt it was only polite to accept. "If we time it just right, we'll hear the sound effects just as the train rolls across that eastern trestle and returns to solid ground." The record and the train synched up perfectly.

Mr. Rayner nodded with satisfaction. "That's a wonderful thing."

Leon and Tim returned, between them a snare drum, cymbals, and hi-hat stand. Leon's younger sister followed, aerobic socks pulled to her knees, deeley boppers bouncing on her head.

"Bev, can you go upstairs?"

"Your sister's going to have to hear you anyway," Mrs. Rayner

said, standing in the doorway. "She may as well be able to see you. You need to get use to having an audience."

Robbie returned the conductor's hat to Mr. Rayner.

"Let's go, Bev, seems that they're not ready for fans yet," Mr. Rayner said, following his daughter. "But remember, Leon, you have to be done by eight so you can watch your sister while your mother and I go out."

A chorus of crickets masked Leon and Robbie's whispers. The streetlight, set to a timer that buzzed thirty feet overhead, turned off and Robbie peered over the hood of the parked car again. "There's not a light on anywhere in the house. What are you afraid of, Leon? Katie's dad isn't a lunatic with a shotgun. He owns a candy store. What's he going to do, bludgeon you with Chiclets?"

Leon sat in the shadow of the car, cross-legged, a dozen roses resting in his lap. He and Robbie were across the street from Katie's house, hiding behind a neighbor's car. Robbie's van was around the corner.

"I owe you big time," Leon said, looking at his watch.

Robbie crouched down. He was losing patience waiting for Leon to deliver the flowers. "You can't sit here all night and think about how this'll backfire. This isn't the time to freeze up. Do you want me to do it?"

The flowers were the first part of Leon's plan. He was hoping that Katie would discover the roses, read his poem, and then call him to say something like, "Thanks for the flowers and the poem. Dinner and a movie sounds good." Leon didn't want to set his hopes too high. The one constant in his plan, many times revised, was giving Katie the option of contacting him. That's why he closed with "Give me a call if you want." He thought it would put less pressure on her.

"We're way past you doing my homework, Casper." Robbie hoped that a little joking would spur Leon into action, but his friend didn't budge. A moment passed, then Robbie took the

flowers. The crinkling of cellophane startled Leon.

When the streetlight flickered back to life Robbie was halfway to Katie's house, crouched over like he was dodging gunfire. He shifted from jog to sprint, which did little to quiet his hoarse whispers.

"Chiclets or not, Leon, I'm not getting caught and if I get back to the van first, I'm leaving without you."

Leon ran back to the car ahead of Robbie. He was buckling his seat belt, still laughing at the sight of Robbie's jiggling torso, when Robbie opened the driver's door.

"Are you sure the card is still attached? She'd never guess it's from me. I haven't talked to her much this year, not as much as I wanted to. Except this one time when she called about homework. We didn't talk long. I couldn't keep her on the phone. I didn't know what to say. It would be different if the yearbooks were already out. I should have talked to her more."

"Stop worrying," Robbie said, pulling away from the curb. "Or else I'll strap you to that wicker chair and you can wait there all night and talk to Katie in the morning, and her mom and her dad and her sister and whoever else happens to see a six-foot albino sitting on their front porch with a bouquet of flowers strapped to his head."

Leon laughed. His plan was inching closer to completion and to revealing its numerous flaws.

"Keep counting—1-2-3-4, 1-2-3-4—but only hit the snare on two and four."

Three days before the auditions the Queenhaters were back in Train Town for their second rehearsal. Leon had begged his parents to go to the movies. His sister was at a friend's house. This left two hours to teach Tim to stop playing on one and three, giving the song more stomp, less lurch.

Bean Dip concentrated on both of the song's notes, his eyes closed, his fingers slowly sliding between E and D. Robbie quietly

sang to himself trying to finish the second verse without looking at the words.

Tim dropped a drum stick, clutched his crew cut, and cursed. He threw the other stick to the floor.

"Guys, can you stop for a sec?" Leon said patiently. "We've almost got it here."

Robbie and Bean Dip listened to Tim's backbeat wobble and collapse again.

"What are you going to wear on Friday?" Robbie asked Bean Dip.

Bean Dip's eyes scanned his arm from wrist to shoulder, wondering how the issue was in question. "This apparel *suits* me in matters daily, if you will be so kind as to excuse the pun. I hardly see sufficient cause for variation."

"Stephanie's giving me a Mohawk, but I don't know what I'm going to wear yet," Robbie said. "She's bringing a camcorder, too."

Again Leon and Tim plodded through the song's intro, Tim's beat pulling slightly ahead of Leon's strumming the way an escalator's handrail moves a bit faster than its stairs.

"A date you bring?" Bean Dip asked.

"You realize that sounds more like Yoda than Dracula, right?" Robbie replied.

"Van Helsing."

"Van Helsing, Van Halen. Whatever. It's not a date. We're just hanging out."

Tim set down his sticks. "Leon, you're not going to ask out Katie are you, dude?"

"Too late," Robbie interjected. "He gave her flowers last night."

"Robbie, you're a dick," Leon said.

Bean Dip reminded Leon of the forces working against him. "Friend Leon, Madam Katie is popular. You, less so. What manner of activity shall you embark upon in order that you should win her favor?"

Robbie beat Leon to the punch. "Do you really want to take tips from a guy who joined student government to meet girls?"

"What is this of which you speak?" Bean Dip protested.

"Lane Desantis, sophomore year. You ran for treasurer because she ran for president. Like planning pep rallies and selling no-bake cookies was going to turn her on?"

"What if she says yes? What would you talk about?" Tim continued. "What do you know about her that's not listed in the yearbook? It's not like in class where you can talk about what a pain the homework is. It's not like hanging out with us. She doesn't want to hear TV trivia. She doesn't care who played the husband on *Maude*."

Leon's nod said "you're right." His eyes said otherwise. He picked up his guitar. "Let's try it again."

The yearbooks came out the morning of the talent show auditions. Leon's entry was the second part of his plan. Robbie stood in the school's main hallway, flipping through his copy, waiting in line with Tim.

Bean Dip approached as the line inched forward. "Gentlemen, I trust this morn finds you in good stead. Allow me to expedite your quest for comic gems in this year's annual." He tugged his glasses to the tip of his nose. "Representing the jocks, to use your parlance, we have Charlie 'The Keeper' Lundblad, page 53." Bean Dip cleared his throat. "'Go to college. Play lax in college. Study business in college. Revenge against Liverpool—they shall know defeat. Thanks, Coach Frenette. I love you. You taught me to be a winner. I shall discover, I shall conquer, I shall rule! Eric Clapton, Greatful Dead—that's Grateful, *e-a-t*, of course—Benny Mardones. After college, make lots of dollar signs, get a job in the field of business. J.P. and D.S. – Dunk time!'"

Bean Dip didn't receive the anticipated laughter. He turned back several pages. "And should you turn to pagination twenty and seven we have a member of the 'brains,' Kimmie Balestra. 'Key

Club, Honor Society, Wind Ensemble, Horticulture, Crazy times at Arbys, Another chem. lab error (105%?!?), Death by Chocolate...French Club trip to Paris (*Merci, Madame*!!! *Comme Elise – j'adore la langue francais a'cause de vous*! *J'ai adore la France Cest au revoir pas*! *Adieu*!)...The most violent storms yield the brightest rainbows...*Adieu, Split Rock, Je serai 'en Europe*!'"

"You talk like you're in Victorian England," said Robbie, "and you make fun of a girl for mentioning her trip to France?"

Tim noticed Katie seated behind the table tallying the receipts. He elbowed Bean Dip who eyebrowed Robbie's attention in Katie's direction.

"The best ones are the stoners who don't even try to hide it." Robbie was trying to keep the conversation away from Leon and Katie. "Find Mark Wicker's. 'Always remember herbal life at Cedarvale Road.' Or Lori Widrik—'Toastal wailage at Gilmore's house.' Or Jim Williams—'Always rippin' with the Mummy Crew,' 'Cruzin' in the Buzz Mobile,' and 'Rippin' and cruzin' in the Warlock Vette.'"

Bean Dip was waiting for Robbie and Tim to read his entry. He was still shocked that his quote from the *The Anarchist's Cookbook* had been accepted.

Robbie read his own entry aloud as Tim bought a yearbook from Katie. "What do you guys think? 'Attendance Club, Fire Drill Club, Sound Morals Club, nausea, molting, rigorous outdoor sports. Life goal: meet Morey Amsterdam.'"

They decided not to read Leon's entry.

That afternoon the Queenhaters gathered in the chemistry lab-turned-dressing room. Robbie sat on a stool. He wore a garbage bag with a Donald Duck hand puppet taped to the chest and "Love Me!" written in masking tape across the back. His hair was dyed pink. Stephanie stood in the corner peering through a camcorder's viewfinder. She had just finished shaping his hair into liberty spikes. Tim wore army fatigues and Bean Dip came in his

usual garb, white T-shirt, cut-offs, and sandals. Leon arrived in ripped jeans and a Meat Puppets T-shirt. Also with them, to play the opening of the song, making the band a five piece, was Dan Stoodley on trombone. For the first time the Queenhaters felt like a band.

Gathering their gear backstage they listened to Cindy Kent's "Tears of a Clown"/"Send in the Clowns" medley. The Piano Men followed with an a cappella medley of Billy Joel songs.

Taking the stage the band spread out like gaseous molecules, threatening to weaken the bonds developed during the past week. Leon had forgotten to bring extension chords so he and Bean Dip had to plug their amps into the wall sockets nearest the curtains. This pulled them to extreme stage left and right. At the back Dan stood next to Tim, who was perched behind his hi hat and snare drum, leaving the rest of the acreage to Robbie.

The opening trombone part, "Old Britannia," traditionally reserved for greeting the queen, ricocheted in the rafters as Leon's guitar barreled in like a drunken party crasher, followed in rapid succession by Bean Dip's surprisingly steady eight beats to the bar and Tim's sloppy but effective hi-hat/snare drum exchange. It was a good start. The band made it to the break in unison and dropped out for Tim's solo, a single tap on a triangle. Tim counted out four beats, cueing Leon to reenter. Then it happened. Leon made eye contact with Katie. She was one of the judges, sitting in the first row. He didn't mean to. He'd been looking down the whole time trying to avoid looking at Katie. He stopped playing. The pause in the song dissolved into a near perfect silence, stained only by the buzz of stage lights. The Queenhaters had come to a cartilage-free halt.

Leon blushed. His shoulders sagged and his back slumped. The band waited for the chord that cued their reentrance. The judges stared too. The flowers had backfired last week. The yearbooks had come out that morning and now this, on-stage paralysis. A chair creaked and everyone—judges, teachers,

Queenhaters—turned toward Katie as she shifted in her seat, pretending to look at her clipboard. Everyone looked back at Leon. Robbie scanned the band, looking for signs of life, waiting for someone to move. He pictured the end of *The Wild Bunch*, which he'd watched so many times with his dad. Ernest Borgnine surveys the damage, committed and pending. He looks to the rest of his posse and grins, acknowledging their fate. This was the Queenhaters' *Wild Bunch* moment, less the peril and the dust and the blazing Mexican sun. They were going down together. Too bad his dad wasn't there to see it, Robbie thought.

He turned to the judges and smiled. "Good night, Split Rock. We are the Queenhaters. We're done." He saved the loudest for last. "AND WE STILL HATE THE BLOODY QUEEN!"

The band was quiet walking back to the chemistry room. Robbie and Bean Dip lightened the mood by joking about solo projects, Robbie's lounge act, Bean's collection of sitar instrumentals.

Leon put his guitar in its case and slowly dropped against the wall.

The rest of the band packed up the equipment. They didn't hear the Duncan brothers perform their medley of the *Rocky* theme, "Saturday in the Park," and "Takin' Care of Business." Nor did they see the brothers Duncan pelted by duck debris and ground beef.

Katie hadn't called after receiving the flowers and poem. She didn't mention the yearbook either. Leon never heard from her. His yearbook entry, which said, among other things, "K.A., I love you. I hope you know by now" had put his feelings on display, to Katie and everyone, all at once. She wasn't cruel about it; she probably just hoped the situation would go away. Leon never found out whether or not she voted for the Queenhaters.

Bean and Tim carried the first load of drums and amplifiers

out to Robbie's car. Leon sat cross-legged on the floor of the chemistry lab and wiped down his guitar strings.

"We're going over to Tim's. He's got beer and his parents aren't home," Robbie said. "Come on, before you scorch yourself with a Bunsen burner or something."

Leon thought about going to school on Monday morning. Two more months of walking those hallways before graduation.

"Next time you cook up one of these Kamikaze stunts to get a girlfriend," Robbie said, "you should talk to the girl before sending her flowers and poetry and proclaiming your love in 3,000 copies of a yearbook."

"Or maybe serenade her with a love song instead of 'I Hate the Bloody Queen,'" Leon added.

Footsteps echoed in the hallway. Leon and Robbie turned to see Bean standing in the doorway.

"The judges thought the whole thing was a joke," Bean said, dropping the Victorian vernacular from his speech. "We're in the talent show. They thought we planned everything."

"Are you kidding?" Robbie asked. "We went over like an IRS audit."

"Of course, I'm kidding," Bean said. "We didn't even get through the song." He noticed that his joke had gone over much like the band's performance. "Seriously, everyone's talking about this guy who got kicked out for throwing stuff at Chris Duncan and his brothers while they were on stage."

Leon and Robbie looked at each other.

"Some guy came running out of nowhere and started throwing raw meat on stage. Then he picked up your duck and started throwing that. Stephanie taped the whole thing. She's bringing the video to Tim's."

Leon turned to Robbie. "Danny Shoplifter?"

"I sent a letter to their P.O. box, but I didn't think he'd show up."

"He wants to talk to you, Leon," Bean said. "He came up to

us in the parking lot. He wants us to open for his band. I think he's had a few."

"Easy there, Leon, I can see the gears spinning in your head. We don't need any more big schemes," Robbie cautioned.

"I know, I know." Leon had forgotten about Katie for a moment. "He probably won't remember any of this but maybe we could finish a song. That's all I'm saying."